Exploring Folk Art
Twenty Years of Thought
on Craft, Work, and Aesthetics

American Material Culture and Folklife

Simon J. Bronner, Series Editor

Associate Professor of Folklore and American Studies
The Pennsylvania State University at Harrisburg

Other Titles in This Series

Exploring Folk Art
Twenty Years of Thought on Craft, Work, and Aesthetics

by
Michael Owen Jones

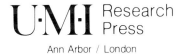
U·M·I Research Press

Ann Arbor / London

Produced and distributed by
UMI Research Press
an imprint of
University Microfilms, Inc.
Ann Arbor, Michigan 48106

Library of Congress Cataloging in Publication Data

Jones, Michael Owen.
Exploring folk art.

(American material culture and folklife. Masters of
material culture)
Includes bibliographies and index.
1. Folk art—United States. 2. Material culture
—United States. 3. United States—Social life and
customs. 4. Folklore—United States. I. Title.
II. Series.
NK805.J665 1987 306'.47 87-14657
ISBN 0-8357-1815-8 (alk. paper)

British Library CIP data is available

Contents

Part Four: Methods and Concepts

Foreword

In the forest of studies on American material culture and folklife lie a few giant redwoods that consistently provide inspiration for generations of students. This volume initiates a set of books within the American Material Culture and Folklife Series that offer an appreciation of the "masters" who have planted these redwoods and have had much to do with shaping the scholarly landscape. The books have the historical purpose of showing the development of scholarship over an important era; they bring together essays that represent a master's contributions over time. In addition, the books invite the authors to say something about themselves as well as their studies. The books link people's works with their lives and the institutions with which they have been associated. The masters contributing to this set of books have a chance to reflect on their past work and offer a prospectus for the future of their discipline.

Such volumes have been lacking in the field of material culture studies, although it boasts its own cast of leading men and women. Several considerations make their need in scholarship even more paramount. The centennials of several scholarly societies contributing to American material culture studies—folklore (1988), history (1984), and language (1983)—bring with them reflection on the history and philosophy of study. Several interdisciplinary conferences on material culture studies during the 1980s at Cooperstown, New York; Winterthur, Delaware; St. John's, Newfoundland; New York City; and Washington, D.C. pointed up the need for collections of essays that would allow students to appreciate and analyze the contributions of the field's leaders and their disciplinary homes. With the end of the twentieth century in view, there is also a sense of closing a productive chapter in interdisciplinary studies on art and artifacts. The period from the 1960s to the 1980s witnessed a tremendous surge of colleges, museums, institutes, and endowments devoted to the study of American material culture and folklife studies. With a new generation of students and a learned public eager to move forward, the object lessons gained from this period deserve, indeed demand, renewed attention.

We begin, appropriately I think, with the work of Michael Owen Jones. His book *The Hand Made Object and Its Maker* (1975) is one of those

redwoods that students look up to. Coming at a time of preoccupation with reconstructing the past through artifacts, his book broke new ground by bringing study back to the present. It asked exciting questions of the relations between craftsworkers and their products and communities. Observing living craftsmen at work and recording life histories, Jones showed art and creativity, and indeed tradition, to be dynamic processes requiring reexamination of previously held assumptions. Since he introduced his ideas, Jones can lay claim to a long list of books and articles in material culture studies informed by his perspectives.

Yet the celebration of his book can obscure the contributions he has made to other areas besides crafts—foodways, workers' lore, medical belief, language, play, organizational culture, and fieldwork technique. This volume allows Jones to integrate some of these studies, to view their underlying themes, to comment on their development. He brings his own philosophical and historical perspective to bear on his unifying concern for "Exploring Folk Art."

For many, the main contribution of this and other volumes will be easy access to the masters' work. The essays included in the volume are often difficult to find; they are drawn from conference papers, regional journals, festschriften, and symposium reports. Some have been published earlier; many have not. But each represents an important contribution. The author himself may wonder why he once said what he did in some of his essays, but I have asked the author to preserve the integrity of the originals to allow readers to see that scholarship, like art, is subject to change. Some alterations to correct errors or to smooth out phrasing have been allowed, but the essays generally stand as originally written. Adding to the value of the essays in this volume, however, are Jones's headnotes, in which he explains what led to the writing of the essays and the ideas that they contained. Indeed, as he has been devoted to understanding kinds of artistic behavior in context, so he has put his writing—his expressive behavior, one might say—in the context of the organizations and endeavors of which he has been a part.

The gathering together here of these papers certainly does not signal the end of Jones's scholarly production, but it does allow him, and us, to take stock of a distinctive period of scholarship leading up to this pivotal point of American material culture and folklife studies. It also allows a chance to look once more at an interesting array of behavior—from crafting a "strange rocking chair" to arranging the trash—and ask anew about meanings in material culture.

Simon J. Bronner

Prologue

Several years before I began exploring folk art, first as a graduate student in folklore at Indiana University and later as a professor of history and folklore at UCLA, I was an undergraduate student (1960–64) at the University of Kansas in Lawrence. During the spring semester of my freshman year I heard about a class being taught by someone named Stith Thompson, who was a visiting professor from Indiana University; the course concerned "folklore." Although intrigued, I could not take the course because it was an upper division one; in addition, I had begun an art major which absorbed my attention.

When I was a sophomore at the University of Kansas, I met someone who told me excitedly about this class he was taking on "folklore." It was being taught by someone named Butler Waugh, who was completing his graduate work at Indiana University. The folklore course sounded interesting; however, I was still taking art courses and had just started a history major as well.

By my third year at the University of Kansas I had completed most of the requirements for my history and art majors and also had begun taking courses for a third major in international relations. One day somebody mentioned an exciting course on "folklore" that he was taking. The instructor was Alan Dundes, who had recently completed graduate work at Indiana University. Vowing then and there that I would take the folklore course my senior year, I made an appointment to talk with Dundes.

I vividly recall walking up the several flights of stairs in old Frazer Hall to reach Dundes's office in one of the towers (the building was razed later as unsafe, and replaced with a modern edifice more or less reminiscent of the original building in outward appearance but having none of its charm and sense of history). I explained to Dundes that during the years I had been majoring in other subjects I had heard about a course on "folklore." I was anxious to take the course, I said, and looked forward to seeing him in the fall. He wouldn't be there, he told me, since he had just accepted a position in the

Anthropology Department at the University of California at Berkeley. I was crestfallen. After having heard about this course for three years, and looking forward to taking it at last, I was apparently too late.

Fortunately for me, the course would be offered by Dundes's successor at the University of Kansas, Robert A. Georges, who was just completing his Ph.D. degree in folklore from Indiana University. I knew nothing about Georges or the Folklore Department at Indiana University. My concern at the moment was that in my last year at the University of Kansas I would be taking that much-talked-about introductory folklore course in fall semester, 1963. After the first lecture, I knew that the wait had been worth it. I began to realize why I had taken several majors; I was seeking something. What I had been looking for I now had found: folklore studies. In spring semester I took the only other course on folklore that was offered, a graduate-level class on the folktale taught by Georges. And I applied, and was admitted, to the graduate program in folklore at Indiana University, later earning an M.A. in folklore and a Ph.D. in folklore and American studies.

Stith Thompson had founded the Folklore Department at Indiana University. After earning his Ph.D. in folklore, Butler Waugh accepted a teaching position in the English Department at the University of Florida (he became editor of *Southern Folklore Quarterly,* in which I published several essays in the late 1960s and early 1970s). Dundes remained at Berkeley. In 1966, Georges accepted a position in the English Department at UCLA to teach folklore courses exclusively. Later, one of my classmates at Indiana University—Robert J. Smith, a specialist on festivals—was hired by the University of Kansas to teach anthropology and folklore courses. In 1968, I was offered a position in history and folklore at UCLA, where I began teaching courses on fieldwork, American folklore, and what was then called the folklore of material culture (a course rarely taught but considered by others to be my specialty, which is one reason I was hired).

I mention this experience not only to pay tribute to those who inspired me to take up folklore studies, the discipline from which I derive my professional identity and to the development of which I have dedicated my efforts for the past two decades, but also as a reminder that inquiry is a matter of personal choice and conviction. Set within the general framework of material culture studies and research on folklore, my explorations of folk art have been affected both by the works of others and by my own beliefs, assumptions, and concerns. It seems appropriate, therefore, not simply to publish essays that were penned over the past 20 years but to suggest something of the disciplinary and personal contexts in which they were written.

Material Culture Studies and Folklore

During the past quarter of a century many scholarly fields, subfields, and specialties have developed that either did not exist when I was an undergraduate student or were so new that I was unaware of them. One of these is American material culture studies. A loosely knit group, material culturists include representatives of (among other specialties) cultural geography, art history, American studies, the history of science and technology, architectural history, popular culture studies, historical archeology, and folklife studies and folklore research. They publish articles in journals in their respective disciplines, of course; but there are also two periodicals whose titles testify to the existence of material culture studies as a distinct subject of study. One is *Winterthur Portfolio: A Journal of American Material Culture;* the other is *Material Culture: Journal of the Pioneer America Society.*

Obviously the term "*material* culture" focuses attention on things, objects and artifacts. Writes Simon J. Bronner: "Material culture is made up of tangible things crafted, shaped, altered, and used across time and across space. It is inherently personal and social, mental and physical. It is art, architecture, food, clothing, and furnishing" (Bronner 1985a:3). Twenty-five years ago one art historian complained about "the bristling ugliness of 'material culture'" (Kubler 1962:9), but the term persisted and now dominates. Perhaps this is because no other name more completely embraces the totality of the objects studied. It also might be because the term does not require treating objects only as aesthetic phenomena (art), exclusively as products of industry (science and technology), or principally as the built environment (architecture, cultural geography). Rather, "material culture" is general enough to allow research combining all of these conceptions and foci.

The label "material *culture*" directs attention to something else, which might also account for the popularity of this appellation. Writes Thomas J. Schlereth: "A second axiom is the belief that a link exists between material and culture" (Schlereth 1985b:4). Continuing his definition of material culture, Bronner writes: "But more so [than just including the objects mentioned], it is the weave of these objects in the everyday lives of individuals and communities. It is the migration and settlement, custom and practice, production and consumption that is American history and culture. It is the gestures and processes that extend ideas and feelings into three-dimensional form" (Bronner 1985a:3). "Material culture," then, seems to be a shortening of the expression "material manifestations of culture" (Jones 1970a:47–48). Certainly many researchers use the culture construct,

connecting the objects they study to other aspects of social life. As Jules David Prown defined it, "Material culture is the study through artifacts of the beliefs—values, ideas, attitudes, and assumptions—of a particular community or society at a given time" (Prown 1982:1 and 1985:77).

A fundamental tenet of material culturists is that objects do not exist in a vacuum. Made and used by people, artifacts relate to human values, concerns, needs, and desires both past and present. They may reflect the spirit of an age, the beliefs of a society or a subgroup, or the experiences of an individual. They can embody notions of how to survive in the physical world, serve as indexes of social relations, or be forms of projection that express longings, fantasies, and feelings, thereby helping people cope or adjust emotionally. Their use may be wholly instrumental and utilitarian, sensory and aesthetic, or symbolic—or a combination of these. Thus, both the manufacture and use of artifacts are rooted in historical, sociocultural, and psychological conditions and processes.

Early research on objects in several fields was largely descriptive. Then artifacts were used as supplementary data and corroborative evidence of ideas derived from an analysis of other sources of information. Eventually man-made objects were viewed as links to socioeconomic structures and cultural values. To some scholars now they are symbolic expressions (Mayo 1980:597; see also essays in Schlereth 1985a). The value of studying objects is suggested by such phrases in recent article titles as "learning from looking" (Lewis 1985), "the power of things" (Upton 1985b), "the stuff of everyday life" (Ames 1985), and "visible proofs" (Bronner 1985b). "Whatever else they might be, artifacts are at the deepest level expressive forms," writes Dell Upton. "The manufacture of an artifact is an act of creation equal to, rather than reflective of, the manufacture of a social system or an intellectual concept," he continues. "All are part of the symbolic process that continuously recreates the world by imposing meaning and order on it. As a primary phenomenon equal to social structure and intellectual reasoning, the artifact must be questioned on its own terms" (Upton 1985a:87).

As objects were given more attention in understanding history, society, culture, and cognition, and examined in their own right, the range of artifacts broadened and now includes the plastic and graphic arts, applied arts or utilitarian art forms including the decorative arts, modifications of the environment, personal adornment, machinery and technology, forms of diversions or entertainment, and the accoutrements of human subsistence (see Prown 1982:3). More importantly perhaps, the scope enlarged to embrace not only (or principally) avant-garde and upper-class aesthetic objects and major inventions but also "traditional" material culture (Roberts 1985) and the "ordinary things" in "the daily lives of ordinary people" (Vlach 1985:82). There is, writes Schlereth, a "new populist emphasis ... on vernacular,

commonplace, and mass-style objects, as opposed to that which is unique, elite, or high-style ... " (Schlereth 1985b:25).

The "democratization of American objects studied" (Schlereth 1985b:25) owes much to the "new social history" emphasizing minority populations, laboring classes, "common men and women," and others ignored previously (Vlach 1985:82) in combination with the use of photographic materials, oral history techniques, and similar resources that help fill in gaps in the written record (Mayo 1980:595; Wise 1979:323). Paralleling these trends in historical research is a movement away from the overarching "myth-and-symbol school" in American studies to microcosmic studies at the local and regional level (Schlereth 1985a:xiii; Berkhofer, Jr. 1979). Contributing also is the development of research on objects in folklore studies. Once ignored in favor of verbal genres, folk art and material culture now hold their own in American folkloristics.

Folk Art and Material Culture

"The folklore of material culture is one of the most neglected fields of American folklore study," observed Wayland D. Hand in his presidential address to the American Folklore Society in 1958. Later published in the society's journal, his address was titled "American Folklore after Seventy Years: Survey and Prospect," *Journal of American Folklore* 73 (1960):1–9. Elaborating on the neglect of material culture research, he wrote: "This work has fallen largely to museum people, who follow it as a collateral interest; and the society has been notably backward in supplying leadership in this important field" (p. 4).

Two years earlier, in a paper entitled "Folklore of Material Culture on the Rocky Mountain Frontier" presented at a meeting of the Philological Association of the Pacific Coast, Austin E. Fife speculated about the reasons why "the folklore of material culture has been neglected." According to Fife, "It derives from the fact that the pursuit of folkloric research has largely been an appendage to literary and linguistic studies. This means that the folk tale, the folk song and ballad, the proverb, and many other forms of literary folklore have made first demands on our interest." He continued: "Engineers, architects, farmers, domestic economists, artists, etc. have remained peculiarly uninterested in the historic or folk aspect of their respective domains" (Fife 1957:110).

The past three decades have witnessed an astonishing growth in folklore studies in research on objects and their makers and users.[1] Indicative of the increasing importance of objects, material culture, and folklife is the fact that at the annual meeting of the American Folklore Society in 1986 nearly 60 people spoke on the subject in a dozen forums and sessions of papers. Some of

the range of interests is suggested by session titles, e.g., "Building a Place," "Verbal and Visual Art," "Maritime Folk Life," "Folk Design," "Heirloom Gardening," "Folk Art in Texas: A Preliminary Assessment," and "Folk Art, Emblems, and Iconization." (This listing does not include sessions on food-ways or individual papers on folk art in other sessions on organizational folklore, the physical environment, native American traditions, and so on.) One set of papers called "Social Aspects of Material Culture" concerned ways in which rugs, buildings, and mailboxes express identity, values, and lifestyles. A forum explored "The Dynamics of Folklore and Urban Planning." Participants in "Coming to Terms with 'Urban' 'Folk' Art," "Beyond the Boundaries of Folk Art," and "Rethinking the Study of Folk Architecture" challenged longstanding assumptions and grappled with basic concepts and methods.

Once there was a dearth of research; now there is a plethora of papers. But many of the same issues of yesteryear command attention today. How do you study folk art? That is, what are the essential concepts, the most defensi-ble assumptions, the appropriate questions to ask? How are forms generated and why are they perpetuated, altered, or abandoned? What do forms and designs mean or symbolize? How do various objects (or the making of them) function for the individual who constructs or uses them or for the network of people among whom they are manifested? Why study traditions and the aesthetic impulse in everyday life?

These questions persist for several reasons. First, they typify concerns in the field of folklore studies. If you examine textbooks or a few volumes of folklore journals, you will see that authors define folklore, delineate the characteristics of one or another genre (by style, structure, or content), posit solutions to problems of origins, raise questions about continuity or change over time and space, suggest meanings and functions of forms, and review concepts and methods of folklore study. Second, members of each new generation of researchers pose questions asked before as part of the process of forming their identity as folklorists and because they have unique con-tributions to make to an existing body of literature. Third, established folklor-ists sometimes take stock of the field, reflecting on directions of which they have been a part and speculating about what the future holds.

The Personal Element in Scholarship

A couple of years ago Martha Teall Oyler wrote to me requesting a current bibliography and a vita. "I am a graduate student in American Studies/Museum Studies," she began her letter, "and have recently been introduced to your work through a course with John Vlach at the George Washington University." She had read two of my books, *The Hand Made*

Object and Its Maker (Berkeley and Los Angeles: University of California Press, 1975), and (with Robert A. Georges) *People Studying People: The Human Element in Fieldwork* (Berkeley and Los Angeles, University of California Press, 1980). Because she was preparing a paper on contemporary methods in folklore studies, she asked for my bibiliography and vita. She added, "I would be interested in your revealing those writings, scholars or experiences which you feel have directly or indirectly influenced your thoughts."

I contemplated which people and publications inspired my earlier work through positive or negative example, recalled situations or experiences that might have influenced my beliefs, and considered why I had addressed some of the issues that I had written about during the past 20 years. I sent Martha Oyler a 3,300-word summary of my reflections, in which I remarked on folk art study, fieldwork, and other research topics including folk medicine, architecture, foodways, and work life.

While I have written about different forms of expressive behavior and various circumstances in which those forms are manifested, "there is a thread of continuity through my research and writing," I wrote to Ms. Oyler, "one of concern, of philosophy and of focus."

Developing the methods of folklore studies has been a principal concern. Although folklore research is closely related to such disciplines as anthropology, psychology, sociology, and literature or art history, the field of folklore studies has its own concepts, assumptions, and issues. Identifying these is not always easy because of the interdisciplinary nature of our field and the changing emphases over the past 175 years. A result of doing so, however, is to extend the application of folklore studies to other areas of inquiry. This is one reason that I have written about a behavioral history, a behavioral architecture, and the relationship of folklore studies to management and to behavioral and organizational science.

I believe we should apply hypotheses and inferences from our research about the human condition to improve the conditions in which human beings act and under which they must function. "It should come as no surprise, then," I wrote to Ms. Oyler regarding some of my papers, "that I suggest ways in which a study of folk medicine, traditional architecture or expressive behavior at work can enhance the quality of professional therapy, housing and urban design or organization development." I concluded my letter to Martha Teall Oyler with the statement, "Whatever the subject, my focus has always been on the aesthetically satisfying and on quality-of-life matters in celebration of what human beings can achieve."

More recently, Simon J. Bronner, editor of this series, asked me to take part. I was flattered to be considered. I was also perplexed. What would I include? There are more than 30 articles and review essays and a dozen

unpublished papers on folk art from which to select—not to mention many essays on other topics. Dating back 20 years, some of the articles reflect my present concerns or represent my current research while others do not. Moreover, what is the purpose? Is it sufficient simply to make available unpublished essays or works printed in sources now difficult to locate? I think not.

Some scholars reprint earlier articles, perhaps adding new works, revolving around a particular subject, perspective, or idea. Essays might have been novel when first published, influential later, or still provocative today. Or together they might provide a well-rounded examination of a topic or the initial statement, elaboration, and final summing up of an interpretation. Or they might demonstrate changing viewpoints and the evolving understanding of an issue. Whatever the nature of the volume, a question raised for some readers (but answered by few authors) is that of why the essays were written initially.

I have prepared this volume with the personal element in scholarship in mind. Introductions to the 11 articles give some of the background on the reasons for writing a paper, the issues it addressed, or its relation to my research interests as they developed over time. Although brief, these introductions suggest the scholarly and personal contexts in which the essays were originally prepared and highlight some of the matters that have interested me most.

Themes in This Volume

A major concern in many of my writings is that of methods. How do you study folk art; and why document and interpret aesthetic forms? I believe that the field of folklore studies, which includes the documentation and analysis of objects, has its own methods. Were this not so, then there would be no journals of folklore, no college degrees in folklore (or folklore and mythology, folk studies, or folklore and folklife) and no American Folklore Society with its centennial celebration in 1987–88.

I am also convinced that a craving for tradition and an aesthetic impulse inform our lives. Familiarity vies with novelty for our attention and appreciation. And even the most prosaic of utilitarian forms can be, and often are, imbued with aesthetic value.

I believe there is more to the study of folk art than a preoccupation with the objects or an attempt to set the makers within a cultural context as simply transmitters of tradition. It is individuals who make things. Why do they make the things they do? How do they conceptualize form? What experiences affect their creativity, the way they proceed in construction, the forms they

produce? What do the items—and the making of them—mean, express, or symbolize? What values inform manufacture, selection, and use; why?

Finally, I think the answers to some of these questions cannot be found by focusing on objects—or even by studying the making and use of objects. Rather, we need to take into account other manifestations of the aesthetic impulse and the craving for tradition. Hence, some of the examples in this volume are of expressive behavior instead of only material outputs of behavioral processes.

To conclude, I want to thank Martha Teall Oyler for having asked me to contemplate "those writings, scholars or experiences which you feel have directly or indirectly influenced your thoughts." And I appreciate Simon Bronner's urging me to set forth those reflections in this volume, focusing them on particular essays I wrote over the past two decades as I explored folk art. These papers on craft, work, and aesthetics—together with the introductions to them as well as the epilogue—set forth some of the issues that I considered important earlier and that I believe will require attention in future. Answers to these questions may change over time; the problems themselves, however, are probably perennial.

Notes

1. Among the many researchers in recent years contributing to folklore studies of objects and their manufacture and use are: Elizabeth Mosby Adler, Thomas Adler, Kenneth L. Ames, Simon J. Bronner, Peggy Bulger, Hal Cannon, Thomas Carter, Jennie Chinn, Varick Chittenden, Kristin G. Congdon, C. Kurt Dewhurst, Elaine Eff, Deirdre Evans-Pritchard, Susan Fagan, Sara Selene Faulds, Burt Feintuck, William R. Ferris, Henry Glassie, Verni Greenfield, Mary Hufford, Joyce Ice, Margaret Johnson, Louis C. Jones, Suzi Jones, Yvonne Lockwood, Marsha MacDowell, Robert S. McCarl, Eugene Metcalf, Steven Ohrn, Daniel Patterson, Gerald L. Pocius, Leslie Prosterman, Warren L. Roberts, Brian Rusted, Amy Skillman, Paul Smith, Nancy Solomon, David Taylor, Robert Teske, Gerald Thomas, Dell Upton, John Michael Vlach, Don Yoder, M. Jane Young, Charles Zug, III, and Egle Victoria Žygas.

Part One

Making Things

Violations of Standards of Excellence and Preference in Utilitarian Art

In August of 1965, I headed for southeastern Kentucky in search of a chairmaker named Chester Cornett. Warren Roberts, from whom I had had a folk art course my first year of graduate study at Indiana University, had seen a brief article about him in the *Louisville Courier-Journal*. Aware that one of my undergraduate degrees was in art history, he urged me to find out more about this craftsman and the chairs he made.

I had no knowledge of and little interest in utilitarian art forms. My previous research had concerned painting, sculpture, and photography as art. But the weeks I spent interviewing and observing Chester at work, as well as locating chairs he had made earlier, convinced me that there was much creativity in the use of traditional tools and techniques to construct practical things. Whether or not a chair "sets good" and "rocks good" depends as much on aesthetic concerns, imagination in designing, and skill in construction as on utilitarian considerations.

I returned to southeastern Kentucky in November of 1965, again in August of 1966, and yet again the summer of 1967. I spent time with a dozen chairmakers, among whom Chester seemed both the most innovative in the range of designs he made and the most traditional in his choice of tools and techniques. I talked with customers, noting not only what they said about the chairs and chairmakers but also where they kept the chairs and how they treated them. My questions for research focused on why the chairs exhibited particular features of construction and design, what the craftsmen's conceptions of themselves were (especially in regard to the activity of making chairs), how craftsmen and their works were viewed by other people (including customers), and what the specific circumstances were in which various chairs had been made.

On the basis of my earliest research on the technology that Chester used to make settin' chairs and rocking chairs, I published a descriptive piece called "A Traditional Craftsman at Work" (1967c). Feeling that the study of folklore in art deserved attention (e.g., the paintings and lithographs of Thomas Hart Benton that were based on traditional songs and stories), and convinced that folk art vied with

This article originally appeared in *Western Folklore* 32 (1973): 19–32. Reprinted by permission of the California Folklore Society.

so-called high art in its complexity of analysis and in what it revealed about the human condition, I wrote "Two Directions for Folkloristics in the Study of American Art" (1968).

In between these articles I published several reviews and also an essay called "The Study of Traditional Furniture: Review and Preview" (1967b). The latter sets forth a theme that was to recur for several years. At this time, most publications on folk art concentrated on museum specimens surviving from the past; they did not consider contemporary craftsmen who had been interviewed or observed at work. This object orientation, particularly in regard to "country furniture," was often accompanied by an attitude of condescension, and it led to incorrect statements and false impressions. Country joiners and cabinetmakers were said to be mere imitators of high-style examples and their works were considered simple, unsophisticated, and even crude. There was no investigation of the context of manufacture and use of objects, process was neglected in deference to form, the human component was ignored, and American folk arts and crafts were said over and over again to be a thing of the past.

As a consequence, I found myself reading widely in the anthropological literature, paying particular attention to the writings of Boas (1927), Bidney (1967), Bunzel (1972), Crowley (1958), Firth (1929;1936), Gerbrands (1957), Himmelheber et al. (1963), Merriam (1964a; 1964b), Ray (1961), Sieber (1965), and Sayce (1963). I also drew on sociological writings including works by Barnett (1958), Becker (1952), Gotshalk (1962), MacIver (1964), Morris (1958), and Nash (1956–57). The difficulty was that of not attempting to become an anthropologist or a sociologist. As important as the constructs of culture, society, group, and institution are, they do not and should not dominate folklore studies, a discipline that focuses on traditions and expressive forms whose origins, nature, and purposes depend on a multiplicity of historical, sociocultural, psychological, and behavioral factors.

After surveying the then-current approach to country furniture in my article reviewing and previewing the subject, I described the kind of research that was needed in future. A study of traditional furniture making would begin with information about the cultural, economic, and social circumstances of craft production in the area. This would provide a framework within which to summarize the origin and development of the craft. Next would be a treatment of the technical aspects of furniture construction, including a taxonomy of items, the tools and techniques of construction, materials, and the process of making an object. The artist also was to be considered—his experiences, values, and self-concept among other matters. There would be a focus on the creative process and the artist's imagining forms, implementing designs, revising his conception of the form, self-criticism, and so on. Another area of inquiry would be art production as a business, because the process of attraction and stipulation affect the nature of the product created. This would lead to a treatment of style, the relationship between artist and consumer, and the question of aesthetics and taste. Throughout the article I suggested techniques to use in fieldwork to obtain this information.

The article guided much of my own research, resulting in the completion of a thousand-page dissertation. Called "Chairmaking in Appalachia: A Study in Style

and Creative Imagination in American Folk Art" (1970a), my dissertation elaborated all of the areas previewed in the short article of 1967. It also contained the seeds of many papers and articles that I was to write during the next few years.

"'I Bet That's His Trademark': 'Anonymity' in 'Folk' Utilitarian Art Production" (1971b) took issue with a characteristic often cited as a criterion of "folk" art. It challenged the propensity in folklore studies at the time to focus on diffusion of texts and objects, ignoring the individual artist. It also questioned the success of some anthropologists who were just beginning to write about "individual hands," "tradition and creativity in tribal art," and "the individual in society."

At the time I wrote "'There's Gotta Be New Designs Once in Awhile': Culture Change and the 'Folk' Arts" (1972b), I wanted to counter the prevailing notion that folklore is dying out and offer an antidote to most commentary by anthropologists and museum personnel that art forms affected by tourism are degenerate atrocities. This issue was addressed more thoroughly later by Nelson H. H. Graburn in a book he edited called *Ethnic and Tourist Arts: Culture of the Fourth World* (1976).

On a related theme is my article "Folk Craft Production and the Folklorist's Obligation" (1970b). Based on my personal experiences conducting fieldwork among craftsmen of the Cumberlands, I argued that folklorists had the obligation of assisting those who gave them information. For craftsmen this might take the form of assistance in marketing their products. I was influenced in part by Nelson Graburn's essay, "The Eskimos and 'Airport Art,'" (1967), in which he describes his helping Eskimos market soapstone carvings. With the growth of public sector folklife and applied folklore, the issue has become a dominant one. It was addressed recently by Rosemary O. Joyce in "'Fame Don't Make the Sun Any Cooler': Folk Artists and the Marketplace" (1986a) and also in a double issue of *New York Folklore* (1986b) edited by Joyce.

Whether craftsmen construct objects and then seek consumers attracted to the forms and designs they have made, or whether they make things according to customer stipulation, has a significant impact on what they produce and why these objects possess certain traits. Because economic matters may be crucial to understanding the nature of traditional crafts, I published a three-part article called "'If You Make a Simple Thing, You Gotta Sell It at a Simple Price': Folk Art Production as a Business" (1972, 1973). A more extensive treatment of the effects of economic factors and varied consumer influences is given by Charles Briggs in *The Wood Carvers of Cordova, New Mexico: Social Dimensions of an Artistic Revival* (1980).

In many of my essays at this time I quoted a craftsman or customer in the title. This was in part a reaction to the then-fashionable functionalist analysis, which held that only the researchers (not the subjects) could infer the sociocultural meanings and functions of things or acts, and to the dominant assumption in writings by museum personnel that folk art was simple and the artists unsophisticated. Also, I often put the word "folk" in quotation marks, feeling ill at ease using a term that still carried negative connotations in many circles.

My concern in "'They Made Them for the Lasting Part': A 'Folk' Typology of Traditional Furniture Makers" (1971c) is how residents of an area conceptualize

craftsmen's motives, abilities, and commitment, and therefore how this information can generate in the researcher greater understanding of and appreciation for a craft and its craftsmen.

In "The Useful and the Useless in Folk Art" (1973a), I devoted several pages to local craftsmen and consumers' conceptions of "art." I also examined the practical and aesthetic as *integral* components of utilitarian folk art, distinguishing the interrelated elements to which users respond and remarking on aesthetic principles. At about this time I published a series of three related articles: "The Concept of 'Aesthetic' in the Traditional Arts" (1971a) and "'For Myself I Like a *Decent,* Plain-made Chair': The Concept of Taste and the Traditional Arts in America" (1972a) were the first two. The third (1973b) is reprinted below. I have shortened the introduction and added headings as well as four illustrations.

"Violations of Standards of Excellence and Preference in Utilitarian Art" (1973) draws on many of the other articles I published during this period. It brings together ideas regarding "aesthetics" and "taste," the importance of folk art as a business, the local typology of craftsmen based on motivation and commitment, the relationship between craftsmen and consumers, creativity, and "folk." Although not intended to be a summary of my earlier work, it is cumulative in a sense. It also marks "the end of an era," for in 1973 I ceased writing individual papers based on my studies of craftsmen of the Cumberlands and instead began work on a book. Published two years later, it was called *The Hand Made Object and Its Maker* (1975).

I wrote the article below because of a curious situation. A museum director had declined the opportunity to purchase some of Byron's chairs for the museum's collection; they seemed to be too refined and to exhibit too much finesse. He thought Chester's unsanded and unvarnished chairs epitomized folk things. In contrast, the owner of a bookstore and gallery of folk art chose not to purchase Chester's chairs; the sophistication of design and utility of Chester's work did not correspond to her notion of what folk craft objects ought to be. She bought the chairs of someone else less committed to craftwork. Both people were seeking something degraded; they differed in regard to whose works were sufficiently debased to be folk.

At this time the literature on primitive art tended to eulogize the objects (with the exception of "airport" art). It seemed as if all makers of masks, canoe prows, or carved poles in a meeting house succeeded equally in perfecting these forms. The literature by some museum personnel, however, considered examples of American folk art and craft naive, unsophisticated, and imitative of high-style works; at best, these objects were complimented for being "honest" and "forthright."

My research on contemporary chairmaking in southeastern Kentucky indicated that there was a range of construction quality in objects and design versatility among craftsmen. There were also many standards of excellence and varied reasons for preferences. Different customers had their values. Even an individual craftsman might violate his own standards sometimes. In this article, therefore, I examined several instances in which somebody's (whose?) standards were violated in some way (how? why?).

* * *

The interrelated problems of the violation of technical and aesthetic standards in an American traditional utilitarian art form and the nature of taste and aesthetics are aspects of artistic creativity that have not been examined in the depth and detail that their complexity warrants. The phrase "violations of standards" may even suggest that certain individuals lack both technical skill and artistic talent. The present topic, therefore, might appear incongruous when associated with concerns about "creativity" as that term is usually used in reference to material art forms, namely, the ability to fashion an object in adherence to established artistic principles in order to generate an aesthetic experience in the percipient. As I shall demonstrate, however, such violations may not always be attributed to an absence of creative vision or a lack of technical mastery, nor must the producer always be held solely responsible for the breach of technical and aesthetic standards. In addition, and perhaps more significantly, alleged violations may be of great importance to the researcher in gaining insights into taste, creative processes, and the network of social relations in which art is produced, for matters of taste among various consumer publics and standards of preference and excellence exert pressure on the manufacturers of utilitarian art products, thereby influencing the nature of the product.

Researchers' Attitudes toward "Primitive" and "Folk" Art

An inquiry into the violations of taste in any art tradition, despite its potential significance, has been neglected. Some investigators do not perceive infractions in the established rules of creativity, because such a possibility cannot be entertained, as the ultimate aim of many recent works on primitive art is to convince the reader that the art is of high quality. In addition, while products made after culture contact with the West owing to the impetus of tourism are disparaged as inferior to the "imposing remnants of a marvelous past," they are not critically examined even when the researcher is directly responsible for the production of such allegedly debased work (Jones 1969). And native evaluations of the objects have not been systematically recorded and analyzed to determine that which members of the group find indecorous. Even Franz Boas, in the seminal work on primitive art more than 40 years ago, sought to demonstrate that American Indians created objects of high quality satisfying artistic and aesthetic impulses. Although a defensible thesis in the main, it does not consider native standards of taste or the degree to which specific objects adhered to or deviated from the social canon of perfection. (See, for example, Crowley 1958; Boas 1955; Gerbrands 1967; Thompson 1968.)

Many, perhaps indeed most, commentators on "folk art" historically assume that such products are simple, crude, and naive, qualities that are used to define folk art or to differentiate between the superior works in an elite tradition and the mean products of the folk. Not infrequently, still lifes of young seminary ladies; the early works of Earl, West, and Copley; portraits of itinerant limners; and the decorative motifs on utilitarian objects made by Pennsylvania-German folk craftsmen are treated as phenomena of the same order owing solely to the common characteristics of (alleged) simplicity and naiveté. Folk utilitarian objects are considered inept in execution, crude in construction, and lacking meritorious qualities because the craftsmen have been only the fortuitous inheritors of formal styles emanating from urban centers, which they copied with varying lack of success. To scrutinize violations of technical and aesthetic standards in folk art is perforce a task of supererogation, for all forms of traditional, conventionalized modes of behavior, are, by definition and common consent, base.

The folklorist may view such a contention with skepticism, since it is based on an examination of a few extant objects made by unknown individuals under unspecified circumstances at a time and place that can be conjectured only; it is predicated on the assumption that the folk never invent, or create, or discover, but are merely passive agents or depreciators of the achievements of an elite stratum of society; or it is based on the false assumption that no one who communicates by means of traditional, conventionalized modes of expression can do so creatively. But owing to this conception of what has been called folk art, the few apologists find themselves in an embarrassing position: How does one justify the study of defective or debased things? Apparently, if precedent will serve as a guide, one accepts the proposition that folk art and folkloric artistic expressive modes are imperfect, but then one argues that the objects possess inherent virtues absent in the elite art from which they descend, qualities such as spontaneity, unself-consciousness, democracy, and genuineness. These attributes, therefore, render the objects worthy of a furtive glance. (See "What Is American Folk Art? A Symposium" 1950; "Country Furniture, a Symposium" 1968; Hauser 1963:277–331 and passim.; Jones 1967b.)

There is no reason to suppose, however, that all works of art are consummate, or that all utilitarian products serve as a paragon of the requirements of useful design. It is questionable also to contend that all art forms in a particular tradition are transgressions of a paradigm of excellence established external to that tradition. An approach more revelatory of folk art and its production would involve the temporary suspension of the observer's judgment and the collection of data concerning attitudes of group members toward the products created in their community. It is obligatory, then, in an

investigation of this kind, that the researcher *determine what are the standards of whom that are being violated by whom in what manner.* It is this problem that serves as the focal point of the remainder of this essay. It should be noted now, however, that the standards of excellence and preference are not limited to the artistic and aesthetic aspects of folk art production, but encompass the technological as well, for much of art is made for active use rather than passive contemplation.

Causes of Imperfection

It will be seen that violations of technical and aesthetic standards in utilitarian art production may be attributed to the craftsman on some occasions, but also they may be attributed directly or indirectly to consumer influence. These infractions of the requirement of useful design may result from an absence of technical ability or creative vision in the producer, as in the early works of a craftsman who is only beginning to learn the craft but who later masters the necessary skills, or in the works of a craftsman who seeks to create an object in a style outside his cultural tradition whether owing to personal reasons or to direct or indirect consumer influence. Standards of preference may also be transgressed by the individual amateur craftsman who has never felt compelled to learn the skills of the craft, or by a specialist who does not really have the ability to excel in his chosen line of work (see figs. 1.1, 1.2, 1.3).

Many Appalachian chairmakers, however—at least those who "make 'em to sell"—are aware of the requirements of appearance and use in manufacturing their products, perceive the technical and aesthetic properties of the raw materials which are manipulated in the production of useful objects, and take creative pleasure in the mastery of tools, techniques of construction, and raw materials.[1] How can the best, the most creative craftsmen be guilty of negligence in manufacture or of the production of indecorous objects? It is obviously impossible to appease the taste of everyone, since standards of preference are conditioned by association and personal values having little to do with technical or aesthetic excellence.[2] In addition, many violations of technical and aesthetic standards may be attributed to consumer influence, as in the case in which the customer stipulates the manufacture of an object evincing certain characteristics that do not correspond to the producer's values; or the necessity of the craftsman to take shortcuts in production, thus diminishing the quality of the product, because the price is insufficiently remunerative; or because of an inundation of orders that the craftsman cannot easily fill while maintaining his usual high standards of quality in production.

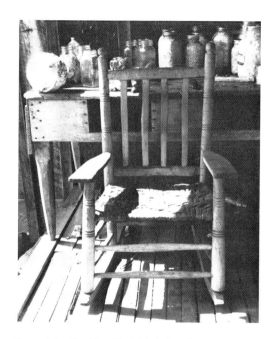

Figure 1.1. Rocking Chair Made by Chester's Brother

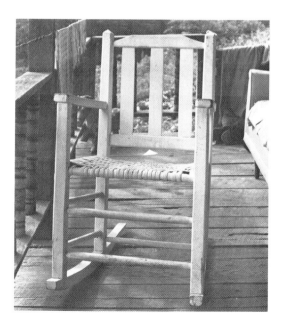

Figure 1.2. Rocking Chair Made by Nonspecialist for Personal Use

Figure 1.3 Chair Made by Nonspecialist for Personal Use

Some works seem to be of inferior quality because the craftsman did not possess the requisite skills and imagination, the objects were produced early in the maker's career, or the products were intended only for the maker's own use. All of these factors account for the rocking chair in figure 1.1—made by the brother of the chairmaking specialist Chester—and for the chairs in figures 1.2 and 1.3—made by a nonspecialist for his use only. These and similar works offended the sensibilities of traditional craftsmen in the area who spoke of the crudeness of construction and the similarity in design to "factory-made" chairs.

Whose Standards?

Before we can examine more fully each of the above ways in which standards of excellence have been breached, it is necessary to answer the question of whose technical and aesthetic standards are involved. Are the paradigms of excellence those of the craftsman, the consumer, or the researcher? In point of fact, the values of all three individuals must be taken into account, undoubtedly compounding the difficulties of analysis.

To take the category of the craftsmen first, there are some differences in the standards of those with the greatest skill and artistic vision in contrast to the values of craftsmen who are specialists but who possess less skill and talent. The former tend to examine the objects more objectively on the basis of a greater number of criteria, and their standards include criteria of both fitness for use and visual appeal. Then, of course, there are the rank amateurs, those "who jest prank around with it," whose standards of excellence tend to be lower than those of the most highly skilled specialists. From the local consumer's point of view, however, the nonspecialists are relieved of some of the responsibility of making structurally sound and visually pleasing objects, for it is recognized that—as the expression "jest prank around with it" suggests—they are not specialists with the concomitant skill and knowledge to produce works of highest quality.

For heuristic purposes, the consumers may be divided into several subgroups as well. There are the local consumers, consisting of individuals on a low socioeconomic level with a modicum of education, and those individuals of higher socioeconomic status and a greater degree of education and experience in the arts. The former tend to evaluate a product largely in terms of fitness for use, to reject ornamentation as superfluous, and to neglect attention to aesthetic standards in their evaluations. On the other hand, my experience with most of the wealthier local consumers is that there is a range of response from an occasional concern only with the technological excellence of the product to a greater emphasis on visual appeal to a general disregard for the object at all (because it reminds them of the surrounding poverty and subsistence way of life that they themselves are seeking to escape).

A second general group of customers consists of individuals who live outside the local area, all of whom are urbanites. Their preconceptions affect the standards of excellence against which they evaluate the products. Most of the urbanite consumers have an attitude toward "folk-made" things that is favorable to the point of nostalgia. Some tend to evaluate the products only on the basis of an aesthetic standard of excellence, not a technological one. In this group, also, are those individuals who think that folk-made things are inherently technically and aesthetically inferior; hence, they do not really

criticize an object for its violation of some technical or aesthetic principle, because it is assumed in advance that the object is inferior. Since these individuals expect, demand, and purchase crude things, the objects that may violate the standards of other consumers or the craftsmen themselves are really in accord with the expectations of these customers. Thus a violation of their expectations (if not standards) would be the discovery of structurally sound and aesthetically pleasing objects made by folk craftsmen, which such customers would dismiss as not "folk" at all because the products are not sufficiently debased.

Finally, there are the standards of the researcher, who may also be a customer, who approaches the materials with or without either a positive or a negative bias. The investigator also may emphasize one criterion of excellence over another, or, as has happened so often, he may have the preconceived idea that folk-made things are always aesthetically and technically inferior. Therefore there is no need to examine the problem of violations, because all works must be derelict.

We have, then, a situation of *quot homines, tot sententiae*—many men, many minds—that militates against easy generalizations and prevents complete treatment of all factors. I cannot possibly separate the responses of all groups of individuals to the products, or even present what I think are all the examples of alleged violations for each group. What is possible, however, is to survey a few of the objects in order to indicate the most obvious transgressions of the most typical standards, as revealed in critical comments by those who have judged folk art products, be they craftsmen, consumers, or museologists. Primarily, however, the remainder of my comments will be addressed to the many art historians and museologists who have assumed that folk art must necessarily be of inferior quality.

Violations and Responses:
The Interrelationship of Construction and Consumption

In the first place, one should not mistake simplicity in design, or the absence of ornamentation in utilitarian art objects, for a lack of aesthetic sensibility in the craftsman or an inability of the producer to create objects that possess more elaborate decoration and evince greater complexity of design. Chairs with much ornamentation are often designations of socioeconomic status and are made for wealthier clientele, but they are not produced for the craftsmen or local consumers because such objects are incongruous with their lifestyle and values. One commonly finds chairs of the most simplistic design; but the same craftsman who made such objects was, in many cases, capable of producing much more imaginative works if he had the consumer public to whom complicated, ornamented, and innovative works would appeal.

Financial Considerations

Related to this point are several other aspects of consumer influence on the nature of the product that may result in the transgression of someone's standards of preference. Because of an inability of most craftsmen to sell chairs that require much time and patience to make, owing to limitations in clientele and the amount of compensation that the craftsmen can expect to receive, they often produce chairs that are structurally sound, but they may not necessarily be aesthetically satisfactory from the point of view of the craftsman or the outside investigator. The rule would seem to be, in the words of the chairmaker Edgle, "If you make a simple thing, you gotta sell it at a simple price," although the reverse is also true—if a craftsman is unable to command a high price for an object, he must make it as simply as possible in accord with the requirement of economy. Thus another chairmaker named Chester was critical of the chairs made by his kin, because, while the objects were structurally sound, they were neither comfortable nor particularly attractive, in large measure because the price of the chair was too low to warrant more than minimal attention in manufacture (see figs. 1.4, 1.5).

> Them days, they made 'em awful small. They just barely made 'em big enough you could set in 'em; then you'd be settin' partly on the rounds. . . . The rockin' chairs they made in them days you couldn't rest in one hardly—they didn't space their backs in 'em, they didn't put the right bend in 'em to rest your back. . . . They couldn't get more for a rockin' chair or a settin' chair them days like they can these days. . . .

Customer Stipulation and Attitude

In addition, a chairmaker must sometimes make what he considers an ugly or inferior chair because of the consumer's stipulation, in which case the rule that "the customer is always right," even though he is wrong, would seem to apply. This is the situation that applied to Byron several years ago when a woman crippled with arthritis demanded that he make a chair with four slats instead of three, a very high seat, and only one arm so that she could use the chair easily in her crippled condition. To Byron, however, the chair was the ugliest one he had ever seen made by anyone and represented a faulty aesthetic of the customer.

A craftsman often manufactures objects according to his knowledge of the customer and how he will probably treat the product. As Byron said, quoting another chairmaker from whom he learned the craft, whenever he made a mistake or took a shortcut in manufacture, "It's not very good, but it'll do for the man I made it for." The discriminating customer, whom the craftsman knows personally and likes, will get a better product, a chair that the craftsman intentionally makes more satisfying aesthetically and structurally (see figs. 1.6, 1.7, 1.8).

Another example of this point is a chair with eight legs and four rockers that Chester was commissioned to make in emulation of a similar chair that he manufactured three years before (see figs. 1.9, 1.10). Aesthetically, as Chester realized, the copy is inferior to the original, as Chester took many shortcuts in manufacture and did not lavish the same amount of attention on the object. The reason is that the copy was made on demand in order to pay a debt to a funeral home for the use of its ambulance to transport the craftsman's injured son to Lexington for medical help. Chester did not want to make the chair, he did not have the time to create such a fancy work because he had many other orders in advance to fill, he was behind in production owing to his son's illness, and the charges for the ambulance service were far less than the expense entailed in making an exact copy of the original chair (which would require three months of work in exchange for $160 worth of ambulance service). Therefore, Chester took many shortcuts so that the finished product is not comparable to the model on which it was based. Although Chester violated his own aesthetic standards in the creation of this chair, he has complied more fully with consumers' technological standards in this particular chair than he did in the original version. Several people who commented on Chester's "two-in-one" rocking chairs, with eight legs and four rockers, objected to the middle rockers, which bark one's heels, and the tops of the front posts, which rest uncomfortably behind one's knees. As another craftsman said, "I like ever'thing about that chair 'cept it oughtta had two rockers left out of hit. Fella could hurt hisself with them posts in front." Chester admitted that he had had many people complain about the front rockers "bitin' their heels," and so "that's the reason on the last chair I drawed them posts in a lot."

Other instances of the consumer's indirect responsibility for the aesthetic or technological failure of a particular object result from the fact that, because the craftsman sells many items according to specific order, he may be unsuccessful at his first attempt to produce an object corresponding to the customer's verbal description or rough sketch. The best example of this point is Chester's first "California rocker" and a subsequent copy of it (figs. 1.11, 1.12). The craftsman had difficulties in realizing a satisfactory form incorporating elements suggested by the customer but still within his own style, and there was the additional problem of trying to work with sawed, kiln-dried red oak using nothing but an axe, drawing knife, and pocket knife.

The second chair of this design is more satisfactory technically and aesthetically than the first one, as Chester was well aware. He pointed to the latter rocking chair and said that, of the two chairs, "I like the way that one's balanced." He said that he thought the stretchers on the second chair, which are bulbous in the center, are more sound technically and look better than those on the earlier chair. On the second chair, Chester gave up entirely the notion of trying to make the posts eight-sided, although he did bevel the

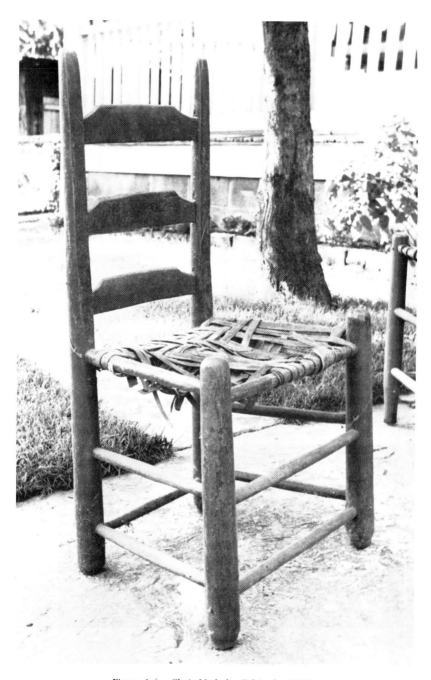

Figure 1.4. Chair Made by Cal in the 1920s

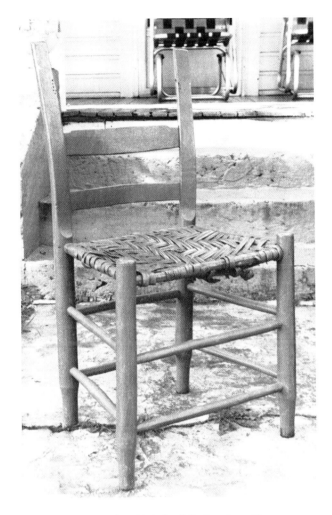

Figure 1.5. Chair Made by Cal's Grandson, Chester

The manufacturer may be capable of producing higher quality objects, but if prices are low, as they were in the 1920s when Cal made the chair in figure 1.4, there is a tendency for craftsmen to take shortcuts in production—or at least not to lavish a great deal of time on constructing the chair. Cal's grandson Chester made the chair in figure 1.5 (the top slat is now missing owing to rough treatment) in the early 1920s, having worked with Cal; other craftsmen who looked at the photographs selected it as the better (more comfortable and attractive) of the two chairs. Committed to chairmaking regardless of remuneration, Chester usually has given greater atten- tion to comfort and appearance. However, when pressed for time or disinterested in a particular job, he does violate his own standards in production.

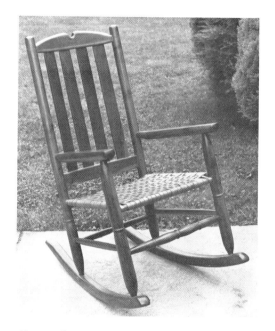

Figure 1.6. Earlier Rocking Chair Made by Byron

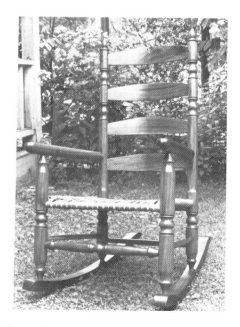

Figure 1.7. Later Rocking Chair Made by Byron

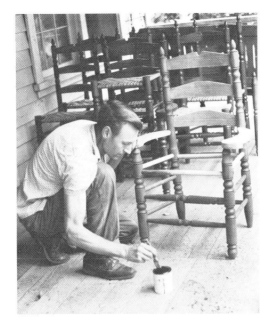

Figure 1.8. Byron Staining Armrests on Dining Chair

Like Byron, the craftsman might in retrospect find some of his works unsatisfactory. Byron dislikes the chair in figure 1.6 which he made four years earlier than the chair in figure 1.7; most disturbing are the vertical panels and the simplicity of design, characteristics which he thinks render the chair "too much like a factory-made chair." He also was not pleased with the arms on the dining chair in figure 1.8, which he had borrowed from Chester's recent works. But the customer wanted flat arms even though Byron had always made barrel arms; the customer seemed satisfied with the chair although Byron criticized the lack of integration of the arms into the overall design. Other craftsmen found Byron's work in figure 1.7 appealing, although Chester would have preferred a "spool" on the back posts below the arms (Byron objected, contending it would weaken the chair; moreover, it looks fine the way it is, he said). Standards of preference and excellence thus vary from one person to another; they depend on not only aesthetic sensibility but also opinions about usefulness and strength as well as associations and assumptions. For example, one museologist refused to buy Byron's chairs for the permanent collection on the grounds that were insufficiently crude to be "folk" (although Byron, like other chairmakers, learned the craft first-hand from others and used traditional designs, tools, and techniques of construction).

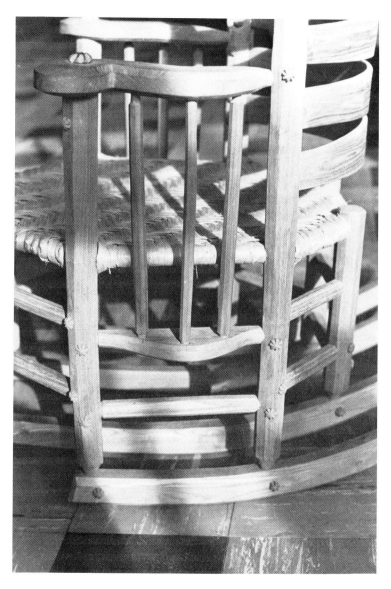

Figure 1.9. Two-in-One Rocking Chair

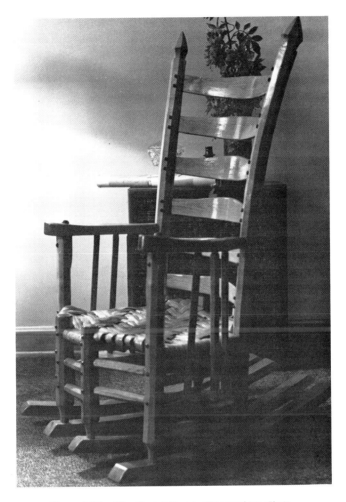

Figure 1.10. "Duplicate" Two-in-One Rocking Chair

Chester claimed to have spent 356 hours making the two-in-one rocking chair in figure 1.9. He sold it to the owner of an automobile franchise for $75. About four years later, the owner of a funeral parlor across the street insisted that Chester make one exactly like it for him as in-kind payment for transporting Chester's son (who had slipped on ice and broken his hip) to Lexington for treatment. Under pressure to make other chairs, and feeling this order was not justified, Chester simplified the design and construction of the "duplicate" chair (fig. 1.10). He did, however, make one concession to criticism of this kind of design: he drew in the middle posts in front to increase the comfort of the sitter.

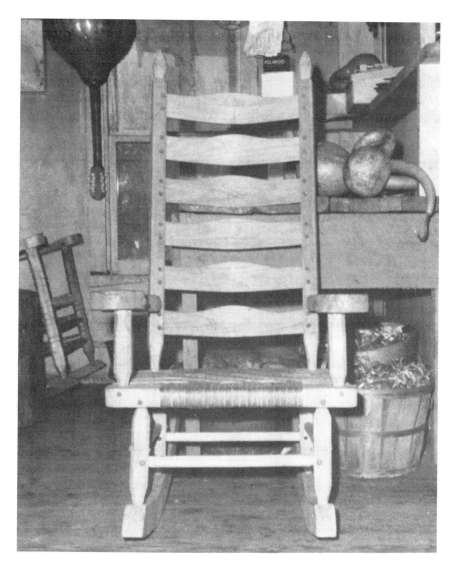

Figure 1.11. "California Rocker"

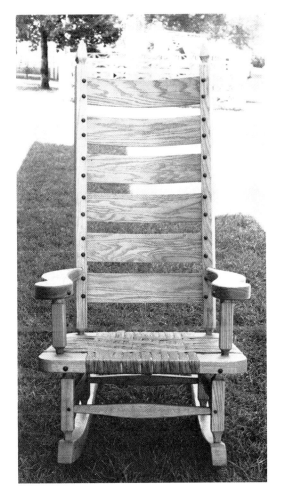

Figure 1.12. Second "California Rocker"

The "California rocker" (fig. 1.11)—named for the state in which the customer lived—owes its design in part to the customer's influence. The customer, unaware of the exact nature of chairs that Chester made, sent the craftsman a sketch of a chair with a cane seat and asked if he could make this. Although he did not have experience with caned chairs, Chester created this design using woven hickory bark. The customer claimed to be pleased with the chair. When Chester made a second version of the chair later, however, he altered the design of the slats and the stretchers in order to better integrate them in the overall design of the chair (fig. 1.12). He did this because he said he was not entirely satisfied with the first version of the chair—a matter, then, of his standards being violated because he was working with a new design (and one he did not completely understand).

edges, because "hit wouldn't look right to have eight-sided posts with this seat." Chester directed my attention to the slats of the two chairs and said that the slats in the second chair "look better" than those in the first chair. Actually, the customer of the first chair had requested slats rather more like those in the second chair; Chester, however, prefers, under ordinary circumstances, the "shaped" slats—those that are peaked in the center—so I suspect that at the time of making the earlier chair Chester was unwilling to relinquish this usual stylistic feature, and he did not perceive its aesthetic shortcomings in this context until after the chair had been constructed. The customer had requested arms on the first chair, but Chester refused to use such arms on either chair because "they wouldn't look good; only them curved arms look right." Again, then, a design element suggested by the customer offended the craftsman's aesthetic sensibilities to the extent that he refused to accept this specification. Finally, the second chair is more successful visually as an integrated whole than the earlier chair; of this quality Chester was aware, because he said that he thought the second chair generally "looks better" than the first, and specific elements in the latter chair (such as slats and stretchers) were more pleasing to him than were those in the first. Thus, the chairmaker himself was critical of the earliest example of a particular design which, he later realized, transgressed his usual standards of quality. But, as Chester said, "Like everybody else, chairmakers make mistakes."

Meeting Demands and Fulfilling Expectations

There are other obvious examples of indirect customer influence resulting in the breach of the technical and aesthetic standards of craftsmen. First, the craftsman may have attempted to imitate models external to his previous experience because the taste of the consumers has changed from traditional objects and designs to factory-produced goods which folk craftsmen sometimes emulate in order to sell their own products. A rocking chair of swamp willow, made by Chester in the early 1960s, is a copy of a factory chair and is not entirely successful in appearance. It has one disquieting technological feature as well; namely, it squeaks when the wood dries out so the owner hoses it down with water periodically. Chester is very much distressed by chairs that he or other craftsmen make that squeak, so he avoids using pine and makes certain that the joints of chairs are tight.

Another example of indirect customer influence causing violations of the craftsman's standards is a series of chairs made by Chester in the early part of 1966, when he was inundated with orders that he could not properly fill. About eight chairs made at this time were hastily created without the usual attention to structural details or aesthetic concerns. Chester did not cook and bend the chair slats, in some cases he did not bend the legs, he reduced the

number of pegs in each chair, and he created a design in which the slats, stretchers, and pegs extended completely through the chair posts, all of which reduced the amount of time and effort involved in construction.[3] Chester was embarrassed later when I talked to him about these chairs, because they were below his usual standards. In these examples, then, we have chairs that might violate the aesthetic standards of many art historians, but that also violate the technical and/or aesthetic standards of the craftsmen themselves. In each case, much of the responsibility for negligence or infractions must be placed on the direct or indirect influence of the consumer.

Use and Abuse, Service and Repair

There are other circumstances of use, rather than manufacture, that account for the allegedly debased nature of many objects preserved in museums—objects that serve as a basis for most analyses of folk art production. The museum specimen may have been badly treated by the original owner long before it was salvaged for the museum, thus appearing to be technically and aesthetically inferior. An example is two chairs that are part of a set of four identical sassafras chairs made by Chester about 1955 and sold to the owner of a local grocery store (see figs. 1.13, 1.14). The customer kept the first chair but sold the other three to a neighbor. The difference in condition of the chairs results from the different kinds of treatment that the chairs received in the dozen years after they were made. The first chair was varnished and then placed in a corner of a bedroom where it was never used, but the others were coated with blue barn paint and used continually indoors and out. It is, however, the second chair that is typical of the few products preserved in museums—products that appear rather crude to the investigators of folk art who rely on the kitchen middens and dumps of the past for their specimens. It would be typical to conclude that the craftsman who made the second chair lacked adequate technical skill and artistic vision, as the chair is rickety and rough in appearance, but a comparison of this chair with its well-preserved and unused mate suggests a different interpretation. Interestingly, I was unable to buy the better preserved of the two chairs and had to settle for the second chair, which is now a permanent acquisition of a museum.

An additional point is that repairs of objects are often not done by the original craftsman, but by another individual who may well be of lesser talent or conceptualize the work differently. This is particularly true in instances in which folk-made chairs have had new "bottoms" or seats put in. Often the owner of a chair will replace the original seats of hickory bark splints with strips of rubber inner tube which are less satisfactory technically or aesthetically. Or an individual might use bark splints that are of a different,

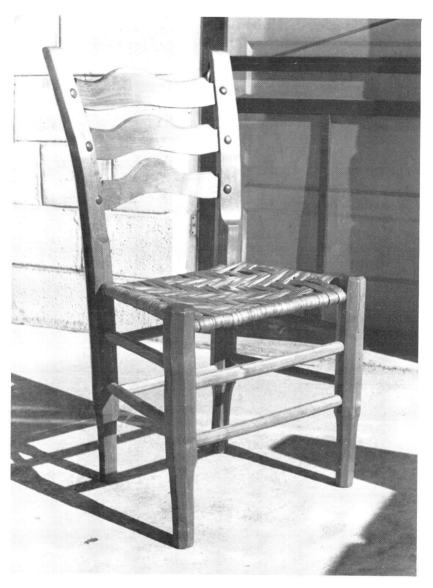

Figure 1.13. Chair Made by Chester, Varnished by the Owner

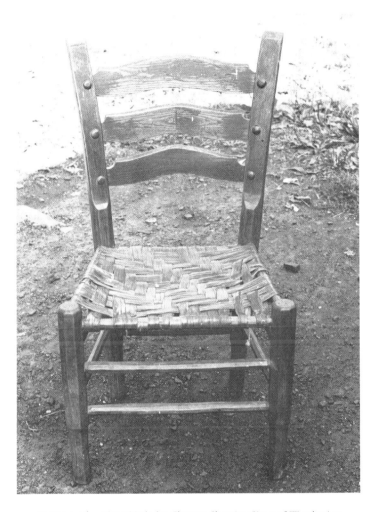

Figure 1.14. Chair Made by Chester, Showing Signs of Weathering

Sometimes the works of traditional manufacture found in museums have been salvaged after much abuse; it is on the basis of these objects that inferences might be made about a craftsman's skill (or lack of it). Chester made the chairs in figures 1.13 and 1.14 in the mid-1950s as part of a set of four. The chair in figure 1.13 was lightly sanded by the owner, then varnished (suggesting it was not quite up to his standards in its earlier condition), and virtually never sat in. The owner of the chair in figure 1.14 used it every day—indoors and outdoors—subjecting it to the disintegrating effects of weather and continuous use. I was able to purchase the second chair for a museum, but not the first; thus, the superior artistry of the producer will remain unknown to museum-goers who will see only the weathered chair. (Many of the other chairs I was able to purchase as museum specimens were in a similar state of disrepair: paint-splattered from having been used as a ladder, missing slats, and so on.)

and incomparable, width, as Chester did when he repaired the seat of a rocking chair made by his uncle Grant half a century earlier. Other chairmakers who looked at a photograph of the chair thought the chair was satisfactory, but "the bark's too wide for the chair"; that is to say, only a seat of narrow hickory bark splints would be properly integrated aesthetically into the total design of the chair. Probably many other chairs have been altered in this fashion, because, as the chairmaker Vince said about those who specialize in reweaving seats, "most don't know how to do it. They don't weave the bark underneath—just let it hang—so the seat sags."

A third point in this connection is that the object may have been for the craftsman's own use, not for sale, in which case it is probably makeshift, for the craftsman did not want to spend the time or use the proper materials and construction methods on objects for his own use when he could get money for the product. All of the full-time chairmakers admitted to this practice, as did Byron who explained about a rather crude stool that "it ain't no account; I just made that to take fishin' with me." The proverbial expression that "a chairmaker never has a chair to sit on" may sum up the attitude of the traditional craftsman toward his own furniture.

Conclusions

These examples are not intended to gainsay the importance of the craftsman himself as a factor responsible for the violation of somebody's standards of excellence in folk art production. Obviously, many such failures do occur owing to the craftsman's lack of requisite skill and aesthetic sensibility, as in the case of a chairmaker who has not yet learned the essentials of his craft or is a rank amateur. In every case that the specialist who has the physical dexterity and mental skills to produce great works is offended by these objects and criticizes them because they are shabby in construction or imperfect in appearance, and, in some cases, because they were made without imagination but simply in emulation of commercially produced objects.

By way of conclusion, I would repeat that the craftsman's artistic ability, creative vision, and sensitivity to aesthetic principles are not always apparent in a given work. Usually it is the craftsman whom commentators on folk art blame for the manufacture of what they take to be inferior products, but in most instances the violations of standards involve the customer as well, and these violations of the craftsmen's and researchers' standards may be attributed directly or indirectly to the consumer's influence. Traditional craftsmen do, in fact, have technical and aesthetic standards themselves in the production of utilitarian art objects which they may transgress for a dozen reasons, only one of which is really an absence of skill or talent. Finally, it should be apparent that the conceptions, values, and attitudes of various

individuals, networks, and groups are revealed by means of an examination not only of successes in art, but of failures as well. An emphasis on violations of standards dramatizes the interrelationships between taste and the creation of utilitarian art products, and serves as a way of ascertaining why so many commentators on American folk art have treated the material as inferior or debased works.

Notes

1. It is not possible to present all illustrative material demonstrating this and other points in this essay, but the reader is referred to Jones (1970a), especially pages 594–667.

2. See the discussion of "taste" and "aesthetics" in Jones (1970a: 230–352). The present essay is derived in part from my dissertation, pp. 230–35, Jones (1970a: 230–35 and 337–52), and it is a longer version of an illustrated paper given at the American Folklore Society meeting in Bloomington, Indiana, 17–19 November 1968.

3. For two illustrations of these chairs and a complete history of their manufacture, see Jones (1970a), illustrations cliii and cliv, pp. 751–56. All of the data in the present essay were taken from Jones (1970a), which in turn was based on three summers of field work in 1965, 1966, and 1967; during the field research, special attention was given to a dozen chairmakers in southeastern Kentucky. Biographical data about Chester, Byron, Edgle, and other craftsmen mentioned in this essay are given in Jones (1970a: 433–80, 481–532, and 538–93); other violations of technical and aesthetic standards in this utilitarian art form are described in the data on the production and consumption of 125 objects in Jones (1970a: 684–856).

A Strange Rocking Chair . . .
The Need to Express, the Urge to Create

The article below was printed in *Folklore & Mythology* (1982b), a newsletter published by Patrick K. Ford when he was Director of the UCLA Center for the Study of Comparative Folklore and Mythology. Appearing three times a year, issues carried major articles as well as notes and news items. Although I had not written about Kentucky chairmakers for several years, I agreed to prepare this article because it gave me an opportunity to comment on why I had asked certain questions in research, looked for answers in various realms, and emphasized the individual craftsman in much of my work.

Moreover, I was considering rewriting my earlier book. *The Hand Made Object and Its Maker* (1975) had been out of print for some time. Despite the book's wide readership, the press did not reissue it in soft cover—a decision I agreed with. The handwritten script that the publisher had chosen was difficult to read. I had written the book at a time when folkloristic research on material culture was just getting under way. Some of the issues and concepts I dealt with had not been treated by other folklorists yet; they needed to be refined. In addition, I wanted to restore the original title of the book—"Craftsmen of the Cumberlands"—which the publisher had changed because of its regional focus.

The upshot was that in the summer of 1981 I began revising the volume. After a few weeks, however, I abandoned the project because of other responsibilities and commitments. The introduction to this article, intended to be a preface to a revised version of the craftsmen book, is what survives of those efforts. The rest of the essay explains why I had highlighted Chester Cornett's "strange rocking chair" and considers such matters as the materials, tools and techniques of construction, tradition, consumer influence, and the individual artist and his experiences and self-concept in answer to questions about the origins of this chair and other utilitarian art objects.

What I do not mention in this article is that several unpublished papers figured significantly in my writing of *The Hand Made Object and Its Maker*. Much of the first chapter called "A Strange Rocking Chair" incorporates a paper I gave at the

This article originally appeared in *Folklore & Mythology* 2, no. 1 (November 1982): 1, 4–7.

American Folklore Society meeting in 1972. Entitled "The Well Wrought Pot: Folk Art and Folklore as Art," it was solicited later for publication in *Conceptual Problems in Contemporary Folklore Study,* ed. Gerald Cashion (1974). In chapters 3, 4, and 5, called "It All Ended Up the Wrong Way," "Make It Look Older, More Antique," and "Like Somebody Hugging You," I drew from "Personality, Style, and the Origins of the Two-in-One Bookcase Rocker, Masterpiece of Furniture," a paper I gave at the annual meeting of the Southern California Academy of Sciences (1971). The second chapter of the book, "The Bookcase Masterpiece and the New Design," incorporates another SCAS paper (1972) called "Folk Art: Planful or Impulsive?"

I also do not mention in "A Strange Rocking Chair. . .The Need to Express, the Urge to Create" or elsewhere some of the early influences on my work. Thomas C. Munro's *The Arts and Their Interrelations* (1967) and *Toward Science in Aesthetics* (1956) gave me an excellent grounding in the history and philosophy of art; his work helped me understand some of what I was reacting to in art history and trying to overcome in my own studies of the aesthetic impulse in everyday life. D. W. Gotshalk's book *Art and the Social Order* (1962) directed my attention to how the artist manipulates and exploits raw materials. David Pye's *The Nature of Design* (1964), which concerns "fitness for use," gave me a valuable concept as well as appreciation of how the useful or practical aspects of craft and the decorative element are combined and interrelated in an object.

C. G. Jung's *Psychological Types, or the Psychology of Individuation* (1964), to which I was introduced by Carlos C. Drake (a fellow graduate student in folklore at Indiana University), provided me with an understanding of the psychology of each craftsman I studied. I have often quoted the statement by Franz Boas in *Primitive Art* (1955:9) that "all human activities may assume forms that give them esthetic values." For a long time I was infatuated with Ruth Bunzel's *The Pueblo Potter* (1972) yet also disturbed by it. Eventually I realized that her otherwise promising and oft-cited chapter, "The Personal Element in Design," which had helped direct some of my queries in fieldwork, had the goal of dispelling the idea of individuality in folk art. In her preoccupation with trying to establish (like her mentor Boas) general cultural laws, she virtually championed cultural determinism by refusing to accept Indian potters and white traders' statements that they could identify the works of particular artists or distinguish individual styles.

One of the most influential works had nothing to do with material culture. Robert A. Georges's "Toward an Understanding of Storytelling Events" (1969) directs attention away from narrative texts to the process of narrating, treating storytelling events as communicative processes and social experiences. His landmark essay was a direct challenge to longstanding assumptions within the historic-geographic method regarding tales as diffusible entities, in literary analyses of folktales, and in much of anthropological research that sought to explicate story "texts" in terms of a broad cultural perspective without regard for the specific circumstances of narrating. Much of what Georges wrote about narrating seemed true of constructing and using objects. Both the telling of stories and the making of things by hand are done within networks of interaction in which participants assume or ascribe certain social identities and act in accord with mutual expectations. The object that

is produced, like the "text" of a story that is transcribed from a tape recording, is but one output of the interaction. One needs to know the particulars of the circumstances of interaction to understand what was generated. In other words, contrary to what Robert Plant Armstrong (1971) wrote, the "significance" of a work of art is *not* "incarnated within its own existence" (see my 1973b review).

In the mid- to late-1970s following publication of *The Hand Made Object and Its Maker,* some anthropologically- and sociologically-oriented researchers questioned whether a focus on individuals was "generalizeable." Preoccupied with broad constructs of "culture" and "society," and inclined to make general statements regarding whole groups of people, they were understandably uneasy about studying situational contexts and specific individuals. This approach may be changing, as suggested by Benita J. Howell (1984), who compares my book with Bill Holm's *Smoky-Top: The Art and Times of Willie Seaweed* (1983).

Also in the mid-1970s, some museum personnel complained that their historical research was limited to surviving specimens and archive documents; they could not follow the methods I had set forth in my study of contemporary chairmakers in southeastern Kentucky. Although they were scarcely in a position to interview craftsmen and their customers, these students of past traditions nevertheless had a set of guidelines directing attention not to the object alone but to social, economic, psychological, aesthetic, and ritualistic aspects of craft production and the uses of material culture. All they needed to do was look in the historical record with certain questions in mind. A recent example of this is Robert F. Trent's "Legacy of a Provincial Elite: New London County Joined Chairs 1720–1790" (1986).

The essay that follows is an attempt to explain why I wrote what I did in *The Hand Made Object and Its Maker,* and why I raised certain questions and sought answers in particular areas of concern. As such, it should help clarify what some of the methods of folk art study are and why these methods may be useful. (In the first version of this article, as well as in the book, I have identified Chester Cornett as Charley Garrells. To avoid confusion here, the craftsman's real name is used.)

<center>* * *</center>

Research into human behavior must begin as well as end with human beings and should focus on the individual, for an object cannot be fully understood or appreciated without knowledge of the person who made it.

Much of my research in the late 60s concerned craftsmen living in or near the Cumberland Mountains in southeastern Kentucky. Known simply as "chairmakers," many of them made baskets, musical instruments, and other furniture such as tables and cabinets as well as chairs. Who are or were these individuals? What were their experiences, their beliefs and values, their aspirations, and their conceptions of themselves? How do these matters relate to the making of such ordinary and unpretentious objects as chairs?

How were designs conceived, and why those features rather than other ones? What were the reactions to the chairs by family, friends, and customers? How have the attitudes and expectations of others affected the craftsmen and the things they made?

Answering these questions leads to the posing of others. Why do people strive to perfect form in some aspects of their daily lives, even in the making of utilitarian objects? What is the aesthetic experience, and how is it expressed? What is folk art, are art and craft really different phenomena, and what constitutes creative behavior? How do we study folk art—what assumptions and concepts may we make and use, what questions can we ask, and what solutions should we seek?

These are some of the issues I addressed in my Ph.D. dissertation at Indiana University (1970), several articles and a book entitled *The Hand Made Object and Its Maker* (1975). The book is an extended study of particular individuals engaged in craft work, and it focuses on one chairmaker, Chester Cornett. The few biographies of "folk artists" before it dealt with painters, while the bulk of studies of folk craft did not consider individuals at all; instead they utilized a cultural or historical framework, postulating types and the diffusion of subtypes of objects or describing changes through time resulting from culture contact. The book also analyzes and assesses such concepts as art, folk, creativity, and aesthetics; and it sets forth a method to account in specific ways for the features of objects that people make.

The thesis of *The Hand Made Object and Its Maker* is that the things made by the chairmakers discussed owe their traits and features to tools, materials, and techniques used in construction; to designs learned from other craftsmen; to preferences and expectations of customers as stated by them or inferred by the craftsmen; and especially to each maker's beliefs, values, and aspirations. Moreover, it illustrates that many of the forms human beings find pleasing or satisfying are useful in some way. Whether called art or craft or simply chairs or pots, most objects of everyday life are means to help us achieve some practical goal as well as ends in themselves to be admired for their form. Technological and creative processes are entwined, and evaluations of products admit considerations of both fitness for use and appearance. To stress one dimension and to exclude consideration of the other would be to distort the nature of chairmaking and similar activities and to do a disservice to the objects and their makers.

To illustrate some of these points now, as I did earlier in the book on Kentucky chairmakers, I would refer to one of Chester's more unusual chairs, the "two-in-one bookcase rocker, masterpiece of furniture." Discovering how this "strange chair" (as Chester called it) came into existence inspired much of my research on chairmaking, so it seemed fitting to use the solving of

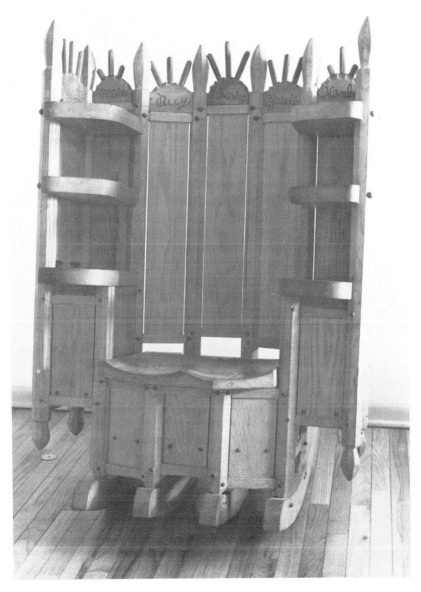

Figure 2.1. Chester's "Masterpiece"
 Chester's seventh two-in-one rocker, second bookcase rocker, and first and
 only "bookcase masterpiece" (December 1965) is made of red oak with white
 oak rockers and black walnut trim and pegs. There is storage space below the
 seat and lower shelves. "There ain't nothin' in the world like hit. That's why I
 call it my 'masterpiece.'"

this mystery as an organizational principle of the book. Why was the chair built? What did Chester think of it? In what way is this chair expressive of who Chester was or of what he wanted, of his relationships with others, and of the need to create?

"I have Bin this month Workin day and nite on a Big Rocker," Chester wrote to my wife and me in late December, 1965, only a few months after we met him and photographed him at work. Big chairs, although not typical in southeastern Kentucky, were scarcely remarkable for this craftsman, for he had been known for several years as the maker of rocking chairs at least five feet in height with seven or more slats, thick posts, and plenty of room in the seats. "This one is Made so different that hit don't look like iney chire that I Ever made," he insisted. "They are sometim strange about this Rocking chire . . . I don't Reley no what hapin . . . I just startied work on hit . . . Seems to Be sometin Kidin me . . . so Strang."

We were mildly curious but not really perplexed about this piece of furniture, because we knew that while Chester had made some unconventional chairs they were—well—*chairs;* and a chair is a chair, so to speak. More puzzling was Chester's own bewilderment about the process of manufacture, for our impression had been that he fully conceived of the object before he began construction; the requirements of useful design usually preclude spontaneity in making the object.

The chair disturbed Chester, though, because he wrote to my wife's sister about the piece shortly after he had sent a letter to us. "This one is a strang [chair]," he repeated to her. "I Reley dinton in tin to Make hit this tipe." There was no description of the chair, only the same reference to an unsettling feeling in Chester because "This Rocker is Reley strang . . . Neve sen inney thing like hit in my hole life . . . hit Reley Looks like my Master Pece of furniture."

We heard nothing further about this chair during the ensuing months, nor, strangely, did the craftsman mention the rocking chair that we had ordered in November of 1965. Our chair was to have seven slats, a set of woven hickory bark splints, and pegs that contrasted in color with the wood of the chair. It was supposed to be similar to one we had purchased from him for a museum, and had greatly admired.

We did not see Chester again until the end of August, 1966. We wandered into his workshop to find our piece of furniture crowding a corner of the room. It was not what we had requested but the "masterpiece" that Chester had mentioned in his letters. This "strange" chair, which Chester presented to us as ours, is made of solid oak with black walnut decorative trim at the top. The heads of its walnut pegs are carved in a pattern of ridges and grooves. It has eight legs and four rockers. Five panels forming the back and sides create a strong feeling of enclosure. Shelves on each side of the chair are

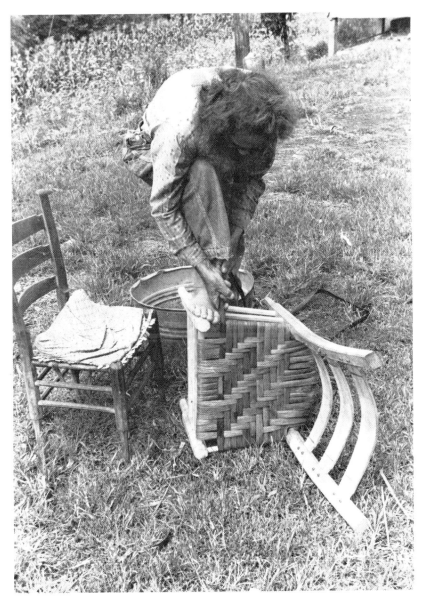

Figure 2.2.　"Barkin'" or "Bottomin'" a Chair
Chester recalled: "My uncle Oaklie taught me to do the barkin' but I had a long time alearnin' it." Chester used "notch lockin'" to hold the strips of hickory bark together, but most chairmakers tied the ends of the bark together instead.

supposed to hold books. Beneath the lowest shelves are storage units, and the seat lifts up to reveal storage space below it. The shelves and the storage space partly account for Chester's calling the chair a "bookcase rocker," and because it has twice as many legs and rockers as usual it is a "two-in-one rocker." Although standing only 50 inches high, the chair seems massive and imposing because of its 35-inch width and 29-inch depth in combination with its weight of about 75 pounds and the large pieces of solid wood used in construction ("posts" or legs are about two inches in diameter and shelves and seat are two inches thick).

"Now what's it s'posed to be?" asked a visitor to Chester's workshop shortly after we arrived. Chester informed him that it is a rocking chair that holds books—hence, a bookcase rocker. "That's nice, real nice," said the man, without much conviction.

All of us were uneasy, Chester because this was not the chair we had ordered, my wife and I because it was not what we wanted or could really afford or perhaps even fully appreciate, and the visitor, who was as surprised as we were at the nature of the chair. After asking about some minor detail of construction, and hardly listening to the answer, the man hurried out of the room.

Most people who have seen the chair said nothing at first sight, perhaps because of shock, and little afterward owing to mixed emotions. To some it is a throne, to others a puzzlement, and to several an aberration. But two craftsmen who worked in a chair shop in the area declared the chair a work of art because of the elaborate construction and the extensive ornamentation.

"I think it's pretty," said one of the chairmakers. "If I had that chair I'd set it up in my living room and set things in it. Put ivy vines on it, you know, to make it look kinda like a cliff."

"I think the people that bought that chair bought it for the looks," replied the other chairmaker after a moment's reflection. "Now if I had that chair I wouldn't let nobody set in it. I'd fasten that to the wall and put whatnots in it." He also noted that the four rockers seemed to "fit the design of it" and looked "all right on the chair," although he had complained earlier that the extra rockers and legs on some of Chester's other two-in-one chairs are "kinda dangerous" and that "a man could hurt hisself on them things."

What was Chester's attitude toward his "masterpiece"? "When I first saw it, I liked it pretty good," he said, but after having lived with it for eight months and having endured the puzzled stares and inane questions of neighbors and customers, he was less sanguine.

"I'm kinda like other people," he said; "hit don't look right someway." He suggested adding a leg rest in front, as he had done to a couple of other chairs, and black leather upholstery to the seat, back, and sides. Even so, "It don't look like it b'longs here yet; I b'lieve it come here too early or too late, one."

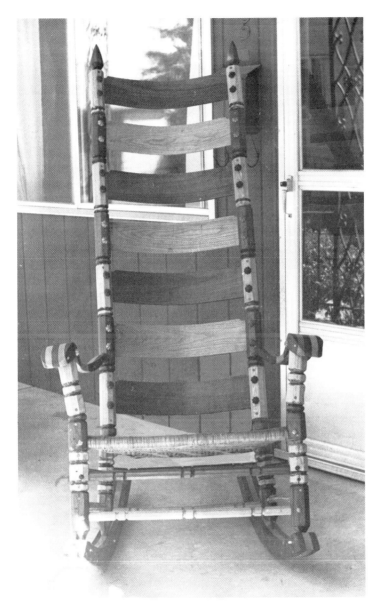

Figure 2.3. Chester's "New Design" Rocker
The idea for this chair came to him in a dream; the fin-
al product is not quite the same as the original vision.
The basic procedure was the same as that used to
make a seven-slat rocker out of a six-slat rocker.

"If you don't like it," I asked Chester, "why do you call it your 'masterpiece'?" "Cause, uh, it is," he said. "I never made nothin' like it in my life. There ain't nothing in the world like hit. That's why I call it my 'masterpiece.'"

Actually, Chester's remark is a bit misleading, for there were in fact many design antecedents for the chair in his 40-year career as a chairmaker, although I did not know that at the time. But the earlier works themselves are not an adequate explanation of the masterpiece's unusual qualities.

How this chair was made, why it is of this form with these particular features, and what this has to do with understanding human behavior are questions that required a couple hundred pages to answer and illustrate. Rather than try to give the answers now, I would mention areas in which I sought solutions to these problems.

An immediate consideration was the materials, tools, and techniques that Chester used in making chairs. A distinctive trait of his work since the mid-50s had been stretchers or "rounds" and legs or "posts" that were eight-sided. He achieved this effect by shaping them with a drawing knife, a time-consuming and laborious process. Reasons he gave for doing it this way are that his handmade foot-powered turning lathe had broken and he could not get it repaired, it was too difficult for one person to use this kind of lathe anyway, and he had become accustomed to shaping the pieces with a knife. Sometimes he referred to both the effect and the process as "old-fashioned," a remark that baffled me. The chairs made by his grandfather and uncle, with whom he worked as a youth and from whom he learned much about chair making, consisted of pieces turned on a lathe. Only later did I learn that before putting the posts and rounds on the lathe they roughly shaped them eight-sided with an axe. Chester had refined as an element of design what to others was merely a part of the construction process; and he seemed to relish the old-timeyness of it.

I considered "tradition" as well. That is, what were the techniques and tools as well as designs used by Chester's predecessors whose direct influence I could establish, and by other craftsmen in the area who were his contemporaries? One notable trait of most of the chairs is that they are made without glue or nails or even pegs. By warming the rounds on top of the stove for several days, but leaving the posts green, craftsmen take advantage of the natural propensity of the unseasoned wood to shrink around the seasoned pieces. Sometimes pegs or "pins" are inserted unobtrusively in the back of the post at the top to secure the top slat. Although a master of the art of working with "wet" wood, Chester made more and more chairs in the 1960s with an increasing number of pegs prominently displayed on the front. This, too, he referred to as "old fashioned," but it was unique.

On learning that customers seemed to prefer this decorative touch and that Chester emphasized the pegs ostensibly because it helped sell the chairs,

I turned my attention to the matter of customer influence on the craftsman and the designs he made. Many of the chairs owed features to Chester's attempt to please customers directly or to attract them indirectly. A settin' chair with cross-hatching on the front posts, several dining and rocking chairs made of expensive woods such as walnut and cherry, and a couple of chairs with pegs the heads of which were carved in a series of ridges and grooves resulted from a combination of personal desire and the attempt to gain attention. I began to suspect, too, making me feel ill at ease, that the more than 90 pegs in the bookcase rocker—several of whose heads were carved in the ridges-and-grooves pattern—were there because of me (and that perhaps the book shelves—which will not hold books, although Chester might not have realized this because he does not have any—were inspired by my identity as "scholar").

I gathered from innuendo and a few comments by his wife that Chester had wanted to make something special for us, as he had done a couple of times before for people who had befriended him and praised his work. Several times during our visits in August and November of 1965 I had remarked on another rocking chair he had made a few years before that had nearly a hundred pegs, some of which had specially carved heads. The feature was certainly noteworthy, lending a regal quality to the chair. Little did I anticipate the effects my remarks would have.

That Chester used some of the techniques learned from others in the area, that the overall design of the masterpiece has precedent in his own career, that my comments inspired him to add special details—these facts are only part of the story of how this chair came to be. They do not account for the chair's alleged "old-fashioned" qualities or for his calling some of his chairs "old timers" and dwelling on their old-timey traits. Nor do they explain why the chair is so massive, so solid, so seemingly protective. "Hit's just like somebody huggin' you," said Chester in regard to the deeply curved back of other two-in-one rocking chairs that he made in the early 60s.

As I tracked down and scrutinized several score of his chairs made from the 1920s to the mid-60s, I became aware of certain trends in Chester's work. Consistent from the beginning was superior skill and a propensity to experiment with materials, techniques of construction, and design. In the mid-50s Chester made side chairs with six, seven, and eight legs. This was followed by several years during which he made simple and ordinary chairs. In the early 60s he began constructing rocking chairs with eight legs and four rockers. A period of making ordinary chairs followed, but in the mid-60s the qualities of old-fashionedness and enclosure prevailed. Why?

Other behavior puzzled me. Chester had long hair and a beard, he wore overalls, and he was barefooted. In these ways he was unique among the men I saw, but in keeping with the appearance of those in Al Capp's "Li'l Abner" comic strip, which Chester recalled having seen in the mid-50s; the

Figure 2.4. The "Mayor's Chair"

Chester's third two-in-one rocker and first "bookcase rocker" was made of black walnut with hickory bark splints. This chair has a leg rest that extends in front; the lids of the basket arms lift up.

haphazardly constructed furniture in the strip inspired Chester in the spring of 1965 to build a chair with similar visual qualities, the slats and rounds extending through the posts. Shortly after we first met him in August of 1965 Chester sang a song of his own composition called "Old Kentucky Mountain Home." The tune reminiscent of "Man of Constant Sorrow" (a song that two years later Chester was to tell me is his favorite, especially as he remembered its being sung decades before when he lived on Pine Mountain), this song tells of a man a "long, a long ways from my old Kentucky mountain home" who is fighting a war, praying that he will survive to return to his old Kentucky mountain home, the "place where I was born and raised." Knowing he had been drafted in World War II and stationed on the Aleutian Islands, I assumed Chester had composed the song 20 years before as an expression of his feelings at that time. I did not realize until much later that he had created the song in the spring of 1965, only a few months before he sang it to me. There was a marked tension between his wife and him. The family struggled with poverty, the health of the male children seemed to deteriorate rapidly when they reached their teens, and Chester often complained of various ailments as well as frequently objected to living near the highway and insisted on returning to Pine Mountain where he was born and raised. Whether I wanted to or not, I had to consider Chester's relationships with others, those experiences that were common topics of conversation, his expression of needs, and his statements of aspirations. For it was becoming increasingly obvious that Chester's chairs were not constructed in a vacuum and that many forms of behavior were both expressive and interrelated.

Inexorably I was drawn into the complex web of Chester's life, fascinated yet repulsed and unable to extricate myself: his treatment in the VA hospital for emotional problems, his rejection by a young woman when he returned to the Cumberlands after the war, his marriage to his present wife whose husband had deserted her and her daughter and for whom Chester felt pity but not love, his failure at several jobs urged upon him by his wife who was embarrassed by his chairmaking, his years of hardship and deprivation because Chester could command little money for his chairs, his frustration over his plight and his inability to understand the illness to which his sons succumbed, his extreme introversion and his irrascibility when his work was interrupted by curious passersby and familial responsibilities and the complaints of his wife that he was trying to live in a world of his own making, his gradual identification with the past and dreams of residing where he had grown up and of living as he had decades earlier when free of the problems that beset him now, and his wife's having left him in the mid-50s and the early 60s because she found intolerable his way of life of eking out a bare existence in some isolated hollow.

I was forced to examine immediate circumstances in which the strange rocking chair was constructed: Chester's growing obsession with old-timeyness as evidenced by his comments and appearance and chair designs, his expression in song of doing battle with unknown enemies and fear of failure, his desire to isolate himself both from the curious who spotted him from the highway nearby and the eager patrons writing him daily because of recent publicity in national newspapers, his feelings of obligation to those few who befriended him and desire to reciprocate by making things especially for them, his urge to create something testifying to his capabilities and mastery and as symbolic of the ability to solve some of the problems heaped upon him, and his need to isolate as well as insulate himself in this time of turmoil and assault.

I had to explore ways in which the making of things relates to psychological states as well as to cognitive and interactional processes: how, for example, grief may precipitate certain acts of creation both as an expression of and a solution to the losses that one suffers, how the grieving process compels us to behave in particular ways, and how intensely felt emotions may guide and direct and give shape and substance to many of the things we make and do.

Whatever the attitudes of others toward the strange rocking chair, and whether I wanted the chair or could afford it or ever would appreciate it, I had to accept it when Chester offered it to us as ours. And I had to keep it. For I came to realize that in Chester's life and work it was indeed a "masterpiece." Viewed as an utilitarian object—a chair to rock in with ease and comfort—the two-in-one bookcase rocker, masterpiece of furniture seems to have come too early or too late. Certainly it is not of this world of practical objects serving their useful purposes well, and therefore, "Hit don't look right someway." But this is a "strange rocking chair," one whose meaning and existence cannot be explained in ordinary terms, or at least within the frameworks common to folkloristic scholarship when I commenced my research.

In June of 1981 the chairmaker Chester Cornett died in the VA hospital in Cincinnati, Ohio. He had been ill for two years and had made no chairs during this time. Fortunately, however, the last chair he built was documented in detail. Filmed by Herbie Smith and his wife Elizabeth Barret, a 90-minute study of the work of Chester Cornett called "Hand Carved" is available through Appalshop Films, Box 743, Whitesburg, Kentucky 41858.

It has been 17 years since I began research on craftsmen of the Cumberlands. In the early 70s I published a series of articles on folk art, using chairmaking as the data. By the mid-70s I was preoccupied with trying to articulate concepts and perspectives. The late 70s saw me investigating ways

in which people in urban areas personalize space and otherwise try to make their everyday existence both pleasurable and meaningful. My concern in recent years has been the work place: how to use folklore as a diagnostic tool to ascertain what is wrong as well as what is fitting and satisfying, what elements of our expressive behavior might serve as models for improving our working environment, and why studies of occupational and organizational folklore are a vital part of understanding human behavior and of attending to various ills that our society faces.

During this time many of the students in the Folklore and Mythology Program have done research on art and aesthetics, contributing in ways and to an extent that I could not have imagined when I began my own work. Among the current Ph.D. candidates, for example, Patricia Wells is probing deeply into basket making, maple sugaring, and other activities in a rural area of Massachusetts in order to understand both creativity and community. Examining in depth motivations of several individuals, the process of conceptualization and the nature of aesthetic responses, Verni Greenfield (individual Ph.D. in folk art and museum studies) is the first to really understand a fundamental compulsion in many of us—the desire to recycle objects by creating an entirely new and different form from discarded items. Roberta Krell, who has taken gerontology as an allied field, is about to set forth new conceptions of both aging and creativity by researching the expressive behavior of the elderly.

These and many other studies past and present recognize that human beings have a need to express themselves. Moreover, they explore the urge to create as a condition fundamental to being human. Increasingly apparent from such research is that building a strange rocking chair is but an example, albeit an extreme one, of behavior common to us all: mastering skills, expressing ourselves, and creating forms whose existence is to be understood in terms of identity and experience, needs and aspirations, self and others. Like his bookcase masterpiece, Chester Cornett was unique. But in essence, and in the ways that count the most, he was just like the rest of us. Although no longer among us, he has left behind physical testaments to his achievements, enriching our lives and reminding us of what makes us all human and thus members of a common species: the need to express, the urge to create.

Part Two

Sensory Experiences

3

L. A. Re-dos and Add-ons: Private Space vs. Public Policy

In the mid-1970s after the publication of my book on chairmakers in southeastern Kentucky, I returned to the study of folk medicine (begun in 1968 with field research in northeastern Canada). And I began writing about fieldwork methods, pedagogical techniques, and architectural design. My interest was largely action-oriented and applied. In the previous decade I had read widely in art history, sociology, anthropology, and psychology. I had written many papers and articles about various concepts, theories, and perspectives. But the study of folklore also relates to fields that apply hypotheses and inferences to bring about social action and change. Practitioners in medicine and nursing, social work, gerontology, architecture,and urban design were only beginning to be aware of the value of studying traditional behavior (if they even knew that the field of folklore studies existed).

I found myself interested in architecture for personal reasons, having lived in several "styles" of houses and also having begun to learn the skills of remodeling through "on-the-job training." That my wife changed professions from nurse and nursing educator to real estate salesperson might have influenced me as well.

In 1977 I was invited to give a paper at The Winterthur Conference on American Folk Art. A revision of that paper appeared as "L. A. Add-ons and Re-dos: Renovation in Folk Art and Architectural Design," in *Perspectives on American Folk Art* (1980c).

Before the conference began it was rumored that this would be the "shootout at Winterthur." Controversy was expected, for many of the folklorists had a very different point of view from that of most folk art collectors and dealers and from some museum personnel. In his catalogue entitled *Beyond Necessity: Art in the Folk Tradition* (1977), accompanying an exhibit by the same name and appearing just before the conference, Kenneth L. Ames spoke of "moldy figs." He objected to several assumptions found in many writings on folk art and to a propensity of folk art enthusiasts not only to ignore the situations in which objects were made and used but also to create for themselves a fanciful and falsified context. The term "moldy

A longer version of this article originally appeared in *Perspectives on American Folk Art,* edited by Ian M.G. Quimby and Scott T. Swank (New York: W.W. Norton, 1980), pp. 325–63.

fig," noted Ames, has been used by some jazzmen in recent years to refer to someone interested only in early jazz (that which was written before World War I). It is appropriate to folk art study, as well, contended Ames. For a common notion is that the only true folk art is painting, sculpture, and handicrafts produced in an earlier age of agrarian simplicity, or sometimes found today among the old and obscure but presumably happy folk in remote pockets as a survival from the past.

Louis C. Jones, another participant in the conference, objected to what he took to be the "acerbic tone" of Ames's catalogue. He expressed resentment that for some people there seemed to be only one way of looking at American folk art. He criticized the exclusion of American paintings from consideration in many of the presentations at the conference. Setting forth his ideas in "The Winterthur Folk Art Conference: Some Afterthoughts" (1977), Jones referred to "material culture specialists" at the conference as "the Pink Plastic Flamingos." These people, complained Jones, "recognized no limits to their inclusions, lumping together, in their generalizations, architecture, kitch (hence the Flamingos), furniture, tools, and voodoo ritual items as well as many of the objects claimed by the Moldy Figs." For Jones, "The real crux of the difference between the two groups lies in the area of aesthetics, for," he writes, "the Moldy Figs insist on there being an element of the beautiful or satisfying, if an object is to be inside their definition of otherwise dissimilar objects." The Pink Plastic Flamingos, on the other hand, who "want to bring a scientific orderliness to the field," emphasize "tradition" and "context" and "artifact" rather than "art" that is personally appealing (1977:5).

A way of resolving the apparent conflict between the two orientations of folk art appreciation and its scientific study lies in recognizing similar concerns, rather than stressing the differences, between them. The area of aesthetics, Louis C. Jones insists, might well be the crux of the matter. For aesthetics clearly relates to the attraction of folk art for many people who want to isolate it for contemplation. But aesthetic concerns also embrace, as Ames contends, the attitudes and responses of those who made and used the objects originally. Although certain forms have been singled out for appreciation and study as American folk art, particularly painting and sculpture, there are other forms that are less perceptible and more ephemeral that are also examples of tradition and the aesthetic impulse in every-day life. Study and contemplation of a few objects that one finds personally pleasing, then, is but one aspect of a more encompassing respect for human beings and what they are capable of making and doing.

Especially in the last half dozen years or so, traditional architecture has been recognized by many as an art form and examined in regard to matters of symbolic expression and social function as well as ramifications for improving urban planning and developing a user-oriented, behaviorally based system of architectural design. I have in mind, for example, works by Michael Ann Williams (1985), Charles Martin (1983), Sara Selene Faulds (1981), Christopher Musello (1986), and Simon J. Bronner (1983), as well as numerous articles reprinted or cited by Dell Upton and John Michael Vlach (1986) and the many essays in *Perspectives in Vernacular Architecture, II,* ed. Camille Wells (1986).

This is not to gainsay the earlier work of Henry Glassie. From the mid-1960s through the mid-1970s he published many articles on the geographical distribution

of barn and house types as well as building techniques. He also authored works taking a semiotics approach to architectural design. A few of his many publications are mentioned in the references. These and other works inspired subsequent generations of folklorists who based their own research on them, exploring similar as well as different kinds of issues.

One of these topics is that of both historical and contemporary remodeling and modifications. Alluded to by Henry Glassie in "The Wedderspoon Farm" (1966), this subject was treated more recently and extensively by Thomas Carter, Gerald Pocius, Robert Blair St. George, Bernard L. Herman, and Michael Ann Williams at the American Folklore Society meeting in 1982 (see also Milspaw 1983; Cromley 1982).

I gave the paper below in October 1977, at a symposium of the Popular Culture Association/West on the topic of Manufacturing Urban Realities. This was a month before I presented a paper at the Winterthur Conference on the same subject of remodeled houses in Los Angeles. The essay below is shorter and less formal than the one that was published, and it contains somewhat different information and treatment of the subject. Both essays, however, consider aesthetic matters, sensory experiences, and the ramifications of studies of traditional architecture for behaviorally oriented design and public policy.

<div align="center">* * *</div>

In this presentation I focus on a particular form of behavior and its outputs, that of the renovation of homes by owners (or under the control of owners). I also examine some of the consequences of this kind of study for folkloristics and related fields; I am concerned particularly with ramifications for the designing of houses by architects, for improving the relations between the building department and the public, and for understanding the so-called housing boom.

The remodeling of houses seems to epitomize the theme of this symposium: Manufacturing Urban Realities. Information is certainly readily available. We are deluged with books and articles in popular magazines offering advice to the would-be remodeler. Many homeowners have participated in this activity and are anxious to share their experiences, whether pleasant or unpleasant.

That the creation of personal space *should* be examined becomes apparent when we consider a few statistics. In their book *The Owner-Builder and the Code* (1976), Kern, Kogon, and Thallon report that owner-built houses account for minimally 40% of all new housing in rural areas and 20% of all new single-family dwellings in the United States. These estimates, based on government statistics, do not include the many instances of adding to, repairing, or refurbishing homes. Even if not everyone physically modifies a home, most of us decorate or redecorate. There is, therefore, an enormous data base to be examined for its implications and ramifications.

This data base consists of varied activities and forms. In the local parlance, a "re-do" has been (or soon will be) renovated. It might or might not have been a "fixer upper" in need of repairs (and if so, it might also be a "re-hab," particularly if it is a part of the city being rehabilitated). Or, rarely, the structure is "restored," that is, someone has gutted the place of accumulated renovations and remodeling attempts in order to return the building (or at least some parts of it) to its original appearance or "character." Making repairs to reverse the trend of "deferred maintenance" is expected. Where there is little hope of "re-doing a place" because of its alleged economic or functional obsolescence or its run-down condition, the property may be sold "for lot value" and its building dismissed as a "tear-down." A "move-on" is a building constructed on one site but later moved to another location; it might also have been "re-done" or have an "add-on."

Re-dos and add-ons are similar in some respects to "conversions," whether making a home of a former mill, barn, school, bank, factory, winery, or warehouse, or, commercially, converting a building from one use to another (e.g., in Santa Monica a natural food store called "Nature's Power Station" occupies what once was a service station, while two historical homes have been moved from a residential area to a commercial section and turned into a restaurant and a museum, respectively). They are also similar—in process, attitude, and aesthetic concerns—to many "owner-built" or "handmade" houses. Some researchers have combined several of these phenomena into one category of so-called spontaneous, indigenous, nonformal, nonpedigreed, nonclassified, vernacular, anonymous, exotic, or communal architecture (also called "architecture without architects"). Then these structures are contrasted to "official" or "commercial" architecture produced by contractors, professional builders, designers, and architects.

Re-dos and add-ons relate to other architectural forms studied by folklorists in the past (log cabins, for example) in that they involve "tradition." Through the imitation or repetition of forms, design elements, materials, construction techniques—which people become aware of largely through oral communication and face-to-face interaction among friends, colleagues, or acquaintances—fixer uppers exhibit continuities and consistencies in human behavior. The same kinds of questions may be asked about re-dos and add-ons as are raised regarding the making of quilts, chairs, and other objects studied by folklorists. What motivates people to remodel houses, renovate their homes, or decorate and personalize their space. How and why are certain forms, design elements, or construction techniques generated; why are they perpetuated; how are they modified? How do people conceptualize and use space? What meanings do the activities and forms have for people, or what psychological or social purposes or functions are served? And, of course, what are some of the implications and ramifications of answers to

these questions for both understanding human behavior and improving the quality of life? In what follows, I address only a few of these questions in order to suggest that this aspect of contemporary behavior offers much to consider regarding the topic of "manufacturing urban realities."

Why Remodel?

One area of research is that of motivations and rewards for individuals' constructing, redesigning, or readjusting personal space. There are half a dozen principal reasons for even contemplating remodeling or adding onto a structure, and for doing some or most or all of the work oneself. An obvious one is attending to (changing) physical needs (for more space, different kinds of space and space utilization, or particular amenities). This motive was rarely stated or implied by homeowners I talked to, although it is one of the most frequently cited justifications in articles that attempt to stimulate the homeowner to action.

A second principle, frequently mentioned in how-two articles and books, is that of taking advantage of financial matters (to make or to save money). On the one hand, some people "fix up" properties as a long-term investment, renting the houses at a price commensurate with the amenities or putting them up for immediate re-sale. On the other hand, some individuals do much of the work themselves not only to capitalize on their own labor but also because they claim not to be able to afford the labor of others. Yet other individuals say they are motivated by the fact that they can obtain more space for less money, because the house needs work. Others point out that often they cannot duplicate the quality of workmanship or the features found in older houses. Write Stanforth and Stamm (1976:3): "Many couples are finding that they can buy more space than they can afford to rent, discovering they can even live rent-free in houses that were built with twelve foot ceilings, wood paneling, and half a dozen marble-manteled fireplaces instead of boxy little plasterboard rooms. Some are enchanted to own homes with elaborate old parquet floors and intricate brass hardware. Others who prefer a contemporary setting buy 'shells,' and gut them. Dramatic new spatial environments are created by stripping to the bare walls and redesigning the interiors." Fahy (1975:xviii, xx) notes that "many of today's builders never learned to do things the old ways," that "there is a mellow quality about old places that you just can't duplicate," and that there is often "the problem of getting someone to do small jobs." He concludes, "Chances are you will do as good or even a better job than the professionals. The reason? It's your place you're working on, and you care about it. . . . Fixing an old place makes you a more competent person. It gives you more control over your life. The more you do, the more you are willing to tackle. . . . It's a good feeling to have that

᾽ confidence and that independence.. . .And finally, when you do the work yourself, the house becomes truly yours. You'll enjoy living in it far more than you would if you had it all done by somebody else." Admits my sister-in-law: "It's just us; we don't like new houses. They don't have warmth, they don't have storage space: they're just boxes." She added, "I think the basic reason we have restored houses is that we could get a lot more house, and an older house, for the money."

It is apparent from these statements that economic incentives are not in themselves the only, or often even the major, motivation for adding to and altering the nature of houses. Newspaper headlines often scream "speculation" as an explanation of the inflated prices of houses in Los Angeles, the topic of financial rewards often crops up in conversation, and many people claim to be inspired initially and partially by dreams of wealth; yet financial rewards is usually given as an explanation of behavior when the commentator does not wish to reveal other motives. The first four males I talked to when I began my research became involved in remodeling houses when they were having problems with their jobs, which had been an important part of their lives and identities. While they considered home remodeling as an occupational alternative, none in fact has pursued this as a career. The houses they worked on for a few months now serve as a small source of income and large source of future gain, but the actual activity of remodeling the houses seems to have been precipitated by a need to occupy one's attention with other matters and to reestablish a sense of self-worth, both of which were accomplished by undertaking a task with perceptible outputs and a task that was very much unlike their jobs: in essence, one reconstructs oneself through the act, which becomes symbolic, of reconstructing an object outside oneself. Grief is like that—it can and often does spur creativity. But as an impetus, it is subsumed by a broader principle, that of self-expression.

The discussion thus far suggests several other, interrelated principles. A third reason for redesigning personal space, especially when one does much of the work oneself, in addition to the motives or rewards of increasing spatial needs and amenities and of making or saving money, is that of maintaining a sense of authority and degree of control over oneself, one's life, one's possessions. Here I have in mind such remarks as those by John Yount (1976:97, 146):

> One does not become a heroin addict, an alcoholic, or a hardware freak overnight. Doubtless, a flawed character plays a part, also frustration, the influence of a certain milieu, peer pressure. I isolate ownership as a huge contributing factor in my case. Ownership of anything. . . . Why not call painters, carpenters, whoever might be needed, you ask? I do, I do, I answer. But often they don't come when I need them. Sometimes they do perfunctory work when they finally arrive. Always their bills shock me. One illusion of addicts, alcoholics, and hardware freaks is that they were driven to their fates, and so it is with me.

He continues, "I've already isolated ownership as the terrain in which my condition takes place and hinted at some of its elements: the urge to be free of repairmen; their timetables, which never seem to fit my need; their sometimes perfunctory work; their bills. But there are other sides to a hardware freak that are neither paranoid nor defensive. The wish to make something work, to build, devise, to construct."

This same desire motivated others to remodel homes. "At one time," a remodeler told me, "I worked on an assembly line for GM, creating aberrations. There was no consciousness attached to the product, no wholeness and integrity. But if you built an entire car, then you would have a projection of self into the whole project. The same with houses." One reason for launching his first major remodeling project in 1971 was that he courted the challenge. He had had experience as a construction estimator in the 1950s. "I got to the point where I wanted to do it all," he said, "because I recognized what the problems were and how they should be solved. I wanted control of the whole project."

Some other homeowners have contended that only they, having lived in the house and thus sensed its many peculiarities, are capable of understanding, appreciating, and maintaining the uniqueness and integrity of the home. One family went to two architects and two contractors for help in designing alterations, only to be frustrated by receiving plans that were too expensive to implement, or simply unmanageable (moving a several ton fireplace 60 degrees), or inappropriate to the present character of the structure; their solution was to design the space themselves.

A fourth principle is that of attaining intellectual and sensory goals. These include, for example, exercising control over the product, learning new skills and about oneself, constructing unique and highly personalized spaces, taking pleasures in the associations engendered with respect to past owners or builders and eras as well as in regard to the materials, deriving pleasure from solving tangible problems, or simply enjoying the sensuousness of different smells, textures, colors, and even kinesics (as in working with certain tools). It is this principle that is especially apparent in the published literature on so-called "handmade" houses and on renovations, and it was prominent in my interviews as well. Write Stanforth and Stamm (1976:4), the Stamms "had no idea of the frustrations that lay ahead of them, and they did not care. To them the house was beautiful, even with its half-dozen sinks and stoves, decrepit furniture, and old plumbing that sprang a new leak every day or two. They explored every inch, discovering beautiful door knobs hidden under layers of paint, and stamped brass hinges on every door." According to Cobb (1977:440), Fred Schurecht, who turned a horse barn into a house, remarked, "It's really just a question of maintaining the character of the original building. . . . You start with a shell. Old barns are great fun projects—they don't have the problems normally associated with

remodeling an old house. On this project there was no major problem other than cleaning out the manure." And "River" (1974:84, 127) quotes several people, including Douglas Patrick who said, "Building is like yoga. You can't do it any other way than one nail at a time. It's the meditation of it. It's a constant surrender. 'Look at that hammer hit that nail!' As within, so without." Phil Lewitt told her, "I really like the satisfaction of seeing a building go up. It's really tangible. And I like cutting, making things fit. . . . I'm a redwood house builder. Redwood feels wonderful to work with, it's soft and giving. Elastic. And the splinters always fester. Basically, I have built and like to build wooden structures because I like the feel of wood." And Kent said, "Well, y'know, building a house isn't nearly so hard as living in it. . . . A house is a continuous trip. The easy part is building the structure. It's the finishing that takes all the time; door jambs, hinges, stuff like that. It's like meditation, really. It gets you down to a reasonable pace. You can't think about what's going on tomorrow, or you'll smash your thumb."

The comments above also suggest a fifth principle, that of actualizing self through symbolic statements. One builds an environment and also objects expressive of what one thinks one is or wishes one were or hopes others think one is. Or one generates a sense of self-worth by accomplishing a task with perceptible outputs, engaging in a rite of trial in which one tests oneself. Or one produces a sense of identity with respect to place and to others. In regard to the use of salvaged materials (which many homeowners and remodelers like to utilize), Phil Lewitt said in "River" (1974:65) "The buildings are like people—generations—the same seed running through it." Said Wayne, "I seemed to be trying to prove something to myself while I was building the house. It was a lesson to me in perseverence. I wasn't sure if I could do it or not, 'cause I'd never done it before." Charlie Ramsburg, who restored an adobe house, told Gray et al. (1976:61), "The first house you build you find out about yourself—the kind of space you need. Some people blow it because they design a house that seems idyllic to a certain fantasy, but has little to do with the reality of their life. . . . It can be an addiction, this adobe building. A lot of people building houses are always looking for the perfect space, trying to find peace of mind through building." Said Hal Migel, "When you live in a house while you're building it, each time you add a detail, paint a stripe around a doorway, you become part of its growth." Adrienne said, "This is a pushing out house, on many levels. The whole thing is very symbolic. It records our changes." And as Kathy Strain observed, "When you relate to the house every day, your focus really narrows. Since we built it ourselves, there's a real attachment. This has become our commitment, our roots."

However, people do sell the houses, or rent them to others after renovation. "As long as they are involved in the place," contends Cobb

(1977) as long as they are working on it, you probably couldn't buy it for love or money. Once the job is finished, however, and they should be enjoying the fruits of their labor, they grow restless and want to tackle another project." Fahy (1975:xiv) warns, "Fixing a house is an intimate proposition. You get to know its every inch, and when you leave it, it's like leaving a friend." Said one person when I asked him his feelings about selling houses he had remodeled, "The house on Tennessee Street is still part of me—it's my house even though I sold it after fixing it up. It is probably how an artist feels: even though he no longer owns a particular work, it is still a part of him." And in regard to his present home that he is renovating, he said, "There is a real danger in not wanting to leave. To sell is to defeat the instinct to hold on to something. I feel that way now, here, with this house: I feel like I don't really want to sell, that maybe I should rent it, hoping to return in two or three years. On the other hand, I may sell because I might need the money."

One other principle I would comment on now is that which concerns the socially symbolic, rather than the strictly personally significant, nature of remodeling attempts by some people. Alterations and additions to homes can be and sometimes are a social experience and the basis for interaction and communication. Consider the remarks of Stanforth and Stamm (1976:170).

> As a renovator, one becomes part of a fraternity whose members anywhere have instant rapport. For example, one day in the midst of construction their doorbell rang, and Merle Gross introduced herself. It was obvious that the Stanforths were renovating a house, and so was she, on Seventy-Seventh Street. So she came in and talked, comparing experiences. A short time later, the Grosses invited the Stanforths to a party. They must have had about a dozen couples—all of them brownstoners, all indulging in the game of oneupsmanship over who had suffered the worst experience, whose house had looked the grimmest (rather like people comparing their operations). Everybody was having a delightful time. It was there that the Stanforths met the Stamms and began the friendship that led to this book.

Remodeling a house may be a family affair, and often friends have an urge to help. But sometimes it is also a strain. One person said she has "lived in sawdust for 20 years." Other people complained that they never have had a house to "show off" because it is always under (re) construction. Divorce is not infrequent. How does a family avoid disaster? Generating rituals helps. When one family was working on their house this summer, there were seven people living in the midst of the rubble. "At dinner, we had a five-minute gripe session to air all the problems that day," said the husband. "And we also had grace. We thanked God that the dirt was moved that day, or that we managed to get something else done."

To recapitulate, the motives and rewards for undertaking the alteration of a home, especially when one relies in large measure on one's own labor, embrace more than attending to changing spatial needs or to financial

matters. They also include gaining a degree of control over oneself and one's possessions, attaining intellectual and sensory goals, actualizing self through symbolic forms, and achieving at least to some extent a basis for interacting and communicating with others. For some people, renovating an older house is a moral imperative, and it redounds to the advantage of the community as a whole. (See figs. 3.1, 3.2, 3.3, 3.4.)

But there is another side to the coin. Many people do not want to remodel; if it must be done, they turn the task over to others. Chuck Scarborough (1977) takes a stance contrary to what one usually finds in magazine articles about remodeling. He concludes his survey of personal disaster by admitting that he finally realized that he had overestimated his ability to do the work himself. "It was at this moment that, like a flash of Kansas heat lightning, a soundless, startling moment of brilliance, the two great myths of 'Do-It-Yourself' were revealed to me." In regard to Myth No. 1: Doing It Yourself Is Enjoyable and Rewarding, he writes, "For people like me, it is not. Doing it myself was thumb-smashing, muscle-straining, temper-wrecking, and miserable. Only having it finished was rewarding. Even boasting to your friends about having done it yourself isn't what it's cracked up to be." And with respect to Myth No. 2: You'll Save Money, he contends, "If you try to save, you'll end up owning a lot of cheap things. If you don't try to save, you'll end up owning a few expensive things. But either way, you'll spend more than is prudent. Any money you save by doing it yourself you'll only blow on dinners out or radial tires."

Conceptualizing and Creating Spaces

A second element in a study of the ways that people construct, redesign, and readjust personal space is the reactions to and conceptions of space and its utilization as well as the meanings attributed to spatial arrangements. It is generally assumed that major elements in designing and using space are texture, cavity, openness, light, color, proportion and scale, geometry or morphology, flow, and acoustics as well as the principles of harmony, rhythm, and balance. Personal opinion varies in regard to the type and amount of each element, however; all that is standard is the elements themselves, not their combinations. It is obvious, for example, that some additions look "added on," while others are integrated more completely with the original structure; the building itself may not visually accept an addition without major and expensive restructuring, the homeowner may be trying intentionally to alter the appearance or "character" of the structure, and so on. There are also different notions of formality and informality inside and out, and of public, private, and utility space (to some people front yards are public and formal, yet two or three years ago the *Los Angeles Times* featured a

photo and an article on Eddie Albert who had converted his front yard to a—rather private, and somewhat informal—vegetable garden). An otherwise public and formal room may at times be cluttered with paraphernalia of several activities because there is no other space available, or because of the other meanings and uses of this space.

When the remodeling or construction of a house is under the control of the owner who intends to live there, other elements not usually considered by architects or contractors are also of great importance. These features include *territoriality* (that is, which space is for whom and for what), *symbolism and self-expression, associations,* and *identification.* It is the possibility of achieving these features, but the difficulty of communicating them to others in the designing stage, that inspires many homeowners to undertake some or much of the task of remodeling themselves. It is the achievement of these features that truly "personalizes" a house, custom-tailoring it and rendering it a "home."

Another consideration is that of behavioral similarities, and in particular the use of models on which to base one's behavior. That which is done to the "fixed up" structure includes a "face lift" inside or outside (repainting, repapering, adding a facade of shingles or brick or boards), an addition, enhancement of the inherent qualities of the structure as conceived of by the owner, alteration of the structure to change its character completely, and/or remodeling inside especially by installing a new kitchen or bath in accordance with current trends (presently, the use of wood, ceramic tile, used brick, and stained glass is gaining in popularity). That which is done depends on the owner's skills, finances, motives, and personal taste as well as self-concept. Often there is a difference between what owners do for themselves if they intend to live in the house for a long time and what they do in anticipation of the desires of others if they intend to sell the house soon. For most alterations there tends to be a reliance on models, which is of course tempered by particular circumstances. These models include conceptions of what the building ought to look like (e.g., what are the characteristic features of a "true" Spanish, Mediterranean, California Bungalow, etc.?), what one thinks others desire in a home, and so on.

A second set of models concerns the sources of designs, techniques of construction, uses of tools, choices of materials—otherwise sometimes known as "tradition." These models include books, magazines, friends and acquaintances with some experience relevant to a particular problem, suppliers (especially knowledgeable people in hardware stores, lumber yards, and plumbing and electrical stores), contractors and designers who are hired to assist or who are asked for estimates and then pumped for information, other houses, and tradesmen (observed at work and questioned). That is to say, people's behavior is influenced by print, by the oral communication of

Figure 3.1. Kitchen "Before"

Figure 3.2. Kitchen Remodeler

Figure 3.3. Kitchen "During"

Figure 3.4. Kitchen "After"

The kitchen of a small house was being remodeled. The remodeling carried many symbolic meanings, brought a great deal of pleasure in successfully meeting challenges, and epitomized the "salvage aesthetic" typical of some people in the area at the time (i.e., refurbishing the entire house cost less than $1,000 for materials, few of which were new). (The person in the doorway in fig. 3.4 is a visitor to the house and was not involved in the remodeling.)

information and advice (which is the principal external influence), and by objects that they observe (e.g., "I've finally figured out how to do the door and doorway; remember that house we saw on Oceano. . .?"). Typically many homeowners alter plans during construction and remodeling and make further adjustments during use as they come to realize more fully the kinds of space they want and the meanings they are giving to the space. Often they depend on serendipity—the fortuitous discovery of salvaged or inexpensive materials, the help of friends or "handymen," sudden inspiration from a supplier or publication, and so on.

Other models refer to outlook, assumptive framework, or accent. That is to say, many people distinguish in the behavior of others and sometimes themselves, at least implicitly, between two processes, attitudes, and approaches. On the one hand, there is the "systems approach," though not always named (or called that), commonly associated with a contractor or architect unfamiliar with the specific uses to be made of the space. It consists of advance planning (often based on standardized procedures and designs employed a priori), the use of the ideal sequence of "layering materials" in construction, and the relegation of specific tasks to different specialists. Such an approach is considered "cost-efficient" by some individuals—those who are not trying to personalize the space—but it is objected to by others, including homeowners employing some contractors and designers, because of the expense to them and because of what seems to be a lack of concern for their specific values and personal needs. On the other hand, there is the "person-specific approach," or "customizing," commonly associated with the homeowner or owner-builder, concerned more with personal-space utilization than with the most efficient ways to operate a business.

A curious dilemma is generated for some homeowners who find themselves caught between the extremes of wanting to mythologize the space to conform to and express their fantasies and to fulfill their particular symbolic and ritualistic needs, on the one hand, and on the other, to make the remodeled house appeal to others for resale purposes. (One family, for example, covered a wall of the dining room with old moss-covered, weathered shingles, though acknowledging that to other people trying to eat dinner in such an environment might be a nauseating experience. Another family, when remodeling and adding to their home, actually diminished the living room area to practically nothing and enlarged several bedrooms to a grand scale for they, unlike many people, tend to "live" in the bedrooms as if they were private "islands." Another person was overheard to remark, "For myself, I would like to have a free-standing restaurant stove in my kitchen, but since few other people are really gourmet cooks maybe we ought to just install a simple built-in; on the other hand, maybe we can put in the built-in,

but also have a space for a commercial range and just take the range with us if we move; but then again, maybe I could. . ., or. . ., or maybe. . . .").

The point is, there do seem to be two intuitive models by which homeowners and researchers alike distinguish attitude, approach, and principal concern (my wife insists that now she can walk into an open house, take a quick look around, and know immediately whether it was remodeled for the owner's particular use or specifically for resale). In essence, many homeowners who do much of the work for themselves—and for many of whom the guiding principles seem to be reparation, piecemeal learning and working, and salvaging—feel that their approach is that of "organic growth" developing from a "living experience" and leading to "wholeness" through "self discovery." C. G. Jung (1957:225), who was an owner-builder, writes, "I built this house in sections, always following the concrete needs of the moment. It might also be said that I built it in a kind of dream. Only afterward did I see how all the parts fitted together and that a meaningful form had resulted: a symbol of psychic wholeness." Such sentiments probably originate partly in the nature of the process of construction and remodeling that often attends the work of the homeowners: they build or remodel while living in the structure, design while building, collect information and learn skills as they are needed, and tend to work with and within the existing structure instead of superimposing another geometry.

Toward a Behaviorally-Based Architecture and Public Policy

Among the ramifications of construction and redesign and readjustment of personal space are, first, the consequences for folkloristics and related fields of study. Contends Frank Lloyd Wright in *The Sovereignty of the Individual* (quoted in "River" 1974:19):

> The true basis for any serious study of the art of Architecture still lies in those indigenous, more human buildings everywhere that are to architecture what folklore is to literature or folk song to music and with which academic architects were seldom concerned. . . . These many folk structures are of the soil, natural. Though often slight, their virtue is intimately related to environment and to the heart-life of the people. Functions are usually truthfully conceived and rendered invariably with natural feeling. Results are often beautiful and always instructive.

What Wright calls "folk" is that which is more person-oriented, customized or tailored, subjective rather than objective, and mythologized and ritualized (i.e., "more human buildings," "of the people," "functions truthfully conceived," "rendered with natural feeling"). It is not the outputs of a category or class of people, or a particular output readily distinguishable

from other objects, but an *attitude, approach, and principal concern;* and such an attitude is a *function of a particular individual and of a specific circumstance.*

Architectural research in recent years has witnessed a growing sense of alarm at what is taken to be the abuse of the systems approach. Especially well known and articulate are the calls to action by Clovis Heimsath (1977) and John Friedmann (1973), both of whom are concerned primarily with the planning of institutions, office buildings, multiple-unit dwellings, and cities rather than single family residences, and both of whom point out some of the dilemmas in current design approaches. Also increasing is the publication of verbal descriptions and visual documentation of so-called exotic or spontaneous architecture, such as the books by Christopher and Charlotte Williams (1974) and Bernard Rudofsky (1964), neither of which includes examples of modifications in prefab houses, tract homes, and mobile homes, or of owner-built houses in the United States, and neither of which provides analysis.

What is needed is a combination and integration of the two interests, that of developing a new approach to architecture and that of recording examples of architecture without architects. "Users are not principal members of the design team," writes Heimsath (1977:31). After a building is constructed, "there is no feedback to check that the assumptions used in designing the building were indeed valid." He lists "rules of thumb" customarily followed by architects in designing a structure, at least half of which are relied on for designing single-family residences, and he observes: "None of these twenty-three rules of thumb *directly* involve behavioral considerations, yet each will affect some aspect of the behavior of people using the buildings designed by means of these rules." Although there are, he is quick to point out, behavioral assumptions implicit in the current design process, they are not usually tested, made explicit, or added to with new data and insights. There is, of course, one form of feedback readily available—that of users' personalization of space. But not many researchers have recorded and analyzed this information for its relevance to architectural design and public policy.

Speaking of public policy, some mention should be made of the relationship between homeowners and the building department, and between the behavior of do-it-yourself remodelers and "the code." As Kern et al. (1976) point out, regulations, which often reflect the desires (and power) of special-interest bodies, and which have many desirable attributes, sometimes unduly restrict the owner-builder, impose expensive and otherwise unnecessary solutions to problems, militate against innovation, ignore the behavioral processes inherent in owner-built and homeowner-redesigned houses, and create an atmosphere in which violating the codes is sometimes encouraged.

Some years ago the PTA in Topanga Canyon performed a skit in which a real estate salesman shows some "flatlanders" a house that, to everyone's surprise, even has wall-to-wall flooring. And someone in the skit later says, "Show me where it says in the code that the drain field has to be outside." There is an actual case, too, in which an owner-builder, testifying to a grand jury when he was an "outlaw" builder, explained, "I never bought a permit, because there weren't any for sale for what I wanted to do!" The only way to make these regulations more realistic and reasonable is to examine the actual behavior of people who construct shelters and readjust personal space, and, on the basis of such studies, to propose alternatives to the present code and its manner of enforcement. But other behavior needs to be examined as well, namely, that of the people in the building department. Homeowners (and sometimes architects and contractors) have complained about the problems of trying to get information, advice, and approval from people behind the counter at the building department, many of whom seem either uninformed or uncaring, and one of whom, it is well known and often remarked, is downright nasty. Perhaps circumstances have something to do with this. Rarely have I heard complaints about the building inspectors who are "in the field" and on the actual site where they become aware of the problems faced by the home-owner as well as the possible solutions (some of which might not be accept-able to the letter of the code).

Yet another ramification of the study of homeowner-redesigned space concerns housing and its availability. On the one hand, abandoned houses constitute a rich resource through rehabilitation (rather than destruction and costly replacement) that could provide housing—and housing that many people find acceptable (because of associations and symbolism and identification). On the other hand, it would appear that remodeling and adding to houses, or otherwise refurbishing them, plays a part in the current housing boom with its spiraling prices. Many people, unable in the current market to afford a larger house or a "better" home, add to and remodel their present one. Yet others derive part of their income from fixing up houses for immediate rental or resale, thus contributing to rising prices (but also saving structures from demise and improving neighborhoods). And yet other people, by fixing up one house as their home and then selling it to buy another fixer upper, and so on, are enabled to improve their housing situation over the years.

There are other aspects of the housing boom that could be understood and appreciated more fully were one to examine the actual behavior of people. Explanations of spiraling prices are usually broadly based, e.g., speculation, inflation, and supply and demand, but fail to answer specifically a question that is so often asked: "If I cannot now afford to buy the house I am living in which I bought several years ago before the boom, then how can so

Figure 3.5. Notebook for the "Ideal Home"

Figure 3.6. Exterior Plan for the "Ideal Home"

Figure 3.7. Plan for the Bedroom

Figure 3.8. Plan for the Dining Room

These pages were taken from a booklet on home planning created by an eleven-year-old girl in Iowa. The booklet included floor plans, rooms, examples of different architectural styles and styles of furnishings, and illustrations of the kind of ambience, social relations, and technological amenities that were thought to constitute "the ideal home."

many other people afford to buy this house today?" There have been few attempts to profile buyers, and those tend to dwell upon the broad socioeconomic categories of age, ethnicity, present income, marital status, and so on. To my knowledge there have been no studies of actual sources of money used for both down payment and monthly payments (such factors as the increase in number of moonlighting and working spouses, or of people living together and thus contributing several incomes to rent or purchase, refinancing one property to buy another, receiving windfalls, upgrading one property and then selling it to buy another in need of rehabilitation and so on). Other behavioral considerations are involved in a study of spiraling property values, including the recent practice of holding lotteries for the sale of development homes, which seems simply to have spurred "panic buying," the practice of many homeowners known as "stretching" their family finances in order to meet payments, and even perhaps "redlining" by some lending institutions.

Conclusions

To return for a moment to the fundamental matter of personal space and its meaning, I want to conclude this presentation by emphasizing the importance that a dwelling may have in the lives of people. In 1936 an 11-year-old girl in Iowa was required to prepare for class a booklet expressing her conceptions of "home planning." A few of the pages from that booklet are in figures 3.5, 3.6, 3.7, and 3.8. Twenty-one years later she and her husband bought a house in the Los Angeles area; the only feature in common between the house dreamed of in 1936 and the one purchased in 1956 is that both of them are green. The house is well constructed, built by the Meyer Brothers in 1947, and, as a simple stucco box, is in many ways an ideal "tract" house if cost-efficiency is the primary consideration. Some drawbacks of the house, however, are that the spaces are rigidly defined, not lending themselves to the generation of other meanings and uses (no ambiguity here, except, unfortunately, in one of the three small bedrooms which also serves as a traffic way to the backyard, thus forcing what might otherwise be private space to become semipublic space). There is no entryway and there is no central hall plan to separate spaces and their uses. There are no nooks and crannies, no bay window, no attic to excite the imagination and generate associations or encourage symbolic behavior. Even radical attempts at adding on to the house are likely to produce anomalous designs. I am not suggesting that this owner and other owners of the house have not *tried* to personalize, mythologize, and ritualize space, for indeed they *have* tried. This woman, for example, put a wallpaper mural of colonial Williamsburg on the living room wall; a subsequent owner covered it with white carpeting (to produce a variety in texture) and installed a very large mirror (to suggest greater room

size and to create a fantasy in the interplay of spaces). I am contending, however, that sometimes an approach to architectural design that stresses the systematization of labor and standardization of materials, that requires the replication of models and techniques on an a priori basis, and that is generated and perpetuated solely or primarily for the benefit of the builder of the house ignores the behavior and the needs of the people who will dwell in these structures.

A study of owner-built and homeowner-redesigned houses suggests that it is this behavior of adding on to, remodeling, decorating, redecorating, and designing shelters, which is so prolific in contemporary American society, that would provide the necessary information and the conditions for testing assumptions that Heimsath and others demand in order to make urban planning and architectural designing more amenable to people's needs and space uses. "In mutual learning," writes Friedmann (1973:xix), which he is advocating, "the processed, scientific knowledge of the planning expert is joined with the deeply personal, experiential knowledge of the client." Homeowners and owner-builders have been telling architects a great deal for some time now, if only they would listen.

4

Modern Arts and Arcane Concepts: Expanding Folk Art Study

I was invited to give a paper in March, 1980, at "A Midwestern Conference on Folk Arts and Museums," which was sponsored by the University Gallery of the University of Minnesota. For several years I had been documenting everyday examples in contemporary American life that illustrated Franz Boas's statement (1955:9): "All human activities may assume forms that give them esthetic values." I had taken photos of landscaped yards, ways in which people decorate rooms of their homes, the organization of images in family photo albums, and even arrangements of utensils in kitchen drawers, boxed and canned goods on cabinet shelves, and foodstuffs inside refrigerators.

Although to many commentators "art" was painting and sculpture by a few individuals, it seemed to me that the aesthetic impulse is pervasive in the lives of all of us. The structure and order of arrangements, the economy and efficiency of motion, the perfection of form that results from the skillful manipulation of raw materials in the making of pleasing and useful objects contribute to our physical survival by helping us function. We also derive intellectual pleasure, and sometimes a sense of self-worth and self-esteem, from our ability to perfect form. And contemplating a well-made object or beautifully executed performance (whether a meal, a party, a fair or celebration, an interaction or verbal exchange at work) can be spiritually elevating and enriching to our lives no matter how fleeting the moment or seemingly "ordinary" the object or activity. It seemed to me that while easel paintings, duck decoys, and quilts might indeed be art, the aesthetic impulse—a feeling for form and a desire to perfect form—is apparent in dozens of subtle ways in the things we make and do during the course of daily interaction, problem solving, and the accomplishing of tasks.

In addition, I had long been dissatisfied with conceptions of "folk" and the use of the word "folk" as noun or adjective. I had expressed my uneasiness several years earlier when I put "folk" in quotes in titles to articles about chairmakers and chairmaking in southeastern Kentucky. I finally confronted some of the issues in a

This article is a revision of a paper originally delivered at the Midwestern Conference on Folk Arts and Museums, held at the University Gallery of the University of Minnesota, March 21–23, 1980.

paper at the American Folklore Society meeting in 1972 called "The Well Wrought Pot: Folk Art and Folklore as Art," which was published later (Jones 1974) and also incorporated into the first chapter of *The Hand Made Object and Its Maker* (1975).

To some museum personnel, "folk" as an adjective denoted naive, often anonymous painting and sculpture. To many anthropologists, "the folk" were peasants in Latin America or Europe. To some folklorists, "the folk" were culturally or geographically isolated populations who preserved the old ways of doing things that had survived from earlier periods. To yet other folklorists, "a folk" was any like-minded group defined ethnically, regionally, or occupationally who had some traditions peculiar to them. I had contended in the "Well Wrought Pot" (1974:86) that *"folk* does not mean backward, poor, or illiterate people" nor "'group' either, 'like-minded' or otherwise." For while "a 'group' has at least one factor in common . . ., not everyone who interacts with other people conceives of himself as thus belonging to a 'group.'"

The conceptual problems generated by definitions and the use of the terms "the folk" (as an isolated, homogeneous and integrated group of peasants) and "a folk" (as any isolated, homogeneous and integrated group) are numerous and complex. Some alternative ways of conceptualizing traditions have been proposed by Beth Blumenreich and Bari Lynn Polonsky (1974) and by Robert A. Georges (1983).

Suffice it to say that when I was invited to give a paper at the conference on folk arts and museums I was doing research on contemporary, urban examples of the aesthetic impulse which called into question some of the prevailing assumptions about both art and folk. Hence, I titled the paper "Modern Arts and Arcane Concepts." The subtitle, "Expanding Folk Art Study," suggested my hope and desire.

And, indeed, recent years have witnessed an expansion of what folklorists consider examples of traditional, aesthetic behavior. Among the postcards printed and sold by the American Folklife Center, for example, is one of a photo taken by Sue Samuelson of jars of home-canned vegetables and fruits arranged by color and item. Elaine Eff completed a dissertation (1984) called "The Painted Screens of Baltimore, Maryland: Decorative, Folk Art, Past and Present." Leslie Prosterman's dissertation (1982) is on "The Aspect of the Fair: Aesthetics and Festival in Illinois County Fairs." Another recent dissertation is Theodore Daniels's "The Grammar of Kindness: The Exchange of Homemade Gifts in Folklife" (1985). At UCLA, Verni Greenfield wrote a dissertation on recycled objects which was revised and published as *Making Do or Making Art: A Study of American Recycling* (1985). Recently Jack Santino authored "The Folk *Assemblage* of Autumn: Tradition and Creativity in Halloween Folk Art" (1986). Deirdre Evans-Pritchard (1985) discusses in detail Ernie Steingold's "brass car" and Tony Faria's "junk car" as sources of information about life styles, the social dynamics of urbanites' environment, and individual interests, values, and concerns. At the American Folklore Society meeting in 1986, Gerald Pocius gave a paper on "Parlors, Pump Houses and Pickups: The Art of Privacy in a Newfoundland Community." Even at the Minnesota conference in 1980, Roger Welsch gave a paper on fence posts on the Great Plains that had been topped with worn-out cowboy boots.

In my own presentation at the folk arts and museums conference, I chose as examples of tradition and the aesthetic impulse the arrangement of trash cans in my neighborhood in Los Angeles. More recently I have included slides of trash-can arrangements in several lectures and classes on folk art to demonstrate that even (or perhaps especially) in regard to the chaotic and displeasing aspects of our daily functioning the desire to perfect form might be evident, and to illustrate how a tradition may develop.

I have photographed many more trash-can arrangements since the late 1970s, and have given two conference presentations on them—one called "Untitled No. 1" at the UCLA conference on Aesthetic Expressions in the City: Art, Folk Art, and Popular Culture (1982), and the other called "Suburban Lore" at the annual meeting of the California Folklore Society (1985). In both presentations I went beyond remarking on these behaviors as examples of tradition and the aesthetic impulse to consider creativity, processes of conceptualizing form, psychological functions, and ramifications for understanding suburbia.

<p style="text-align:center">* * *</p>

In light of recent research, some assumptions and conceptions from the past, although still popular, appear to be of limited use. I have in mind most conceptions of art as an isolable phenomenon consisting of a particular class of objects and activities. I am thinking also of the word "folk" as a noun referring to a particular population. On the other hand, some ideas have withstood the test of time, and perhaps are even more appropriate and useful today than when they were first expressed. Among these are the phrase "perfection of form," articulated by Franz Boas in his book on primitive art in 1927, and the word "folk" as an adjective as it was begun to be used by Joseph Jacobs in 1893.

Arcane Concepts

Many conceptions of art have been set forth, some of them serving to guide studies of the so-called folk and primitive arts. Whether a notion of art stresses the expression of emotion, the intent to create something aesthetic, the production of things that are in no way of practical use, the addition of a quality to craft products transcending their utilitarian nature, or the creation of major monuments scarcely matters.[1] For the basic assumption is the same. The element that most conceptions of art have in common is that art is restricted to a limited sphere of activity, and therefore art is the domain of only a few individuals. A venerable history lends this assumption support, from the coining of the expression "les beaux arts" in the eighteenth century to the insistence on "art for art's sake" in the twentieth.

This is not to gainsay the right of human beings to make and do things for aesthetic satisfaction alone, or to diminish the monumental beauty of some

objects and activities generally recognized as being great achievements. I do intend to suggest, however, that conceptions of art based on the assumption of "limited domain" do a grave disservice to humanity. For these conceptions exclude from consideration—and thus from appreciation—most of the activities most people engage in most of the time.

The "Arts" and a "Feeling for Form"

Telling in this respect are remarks by James West in his study of a small town in Missouri that he calls "Plainville." West had to abandon most notions of art as they excluded the behavior of these residents. And yet West felt intuitively and correctly that the word "art" should be used in reference to many of their activities. "Gossiping amounts really to an art," for example, he writes, "an art practiced as vigorously as it is condemned by most Plainville adults. The art of gossiping," explains West, "is to retail gossip in such a way as to entertain listeners and condemn victims without risk of getting into trouble as a scatterer of gossip." To do this requires skill in phrasing and innuendo. It also demands full knowledge of social relations of the listeners "so that nothing said can be carried in definite form to the subject of the gossip or the subject's family." West also observes, "People admire a well-kept house, freshly painted, neat indoors, and well-maintained without." Men, he writes, "admire a straight furrow better than anything else in the world." Women "like pretty dresses, are interested in hairdos, and sometimes take an aesthetic pleasure in the labeling and arrangement of glass jars of canned fruit"; they "dress up" on Sunday, and they concern themselves with "make up." Finally, West observes that the people of Plainville pay considerable attention to the forms of behavior of fellow residents (their "manners"), basing social distinctions on how—and how well—people dress, cook, talk, and act (West 1946:270, 298, 302 and passim).

It was not West's intent to reassess conceptions of art on the basis of these and other observations. Nor does he explain quite why he felt that residents' behavior should be spoken of as art. But two decades before West published his study in the mid-1940s, Franz Boas had coined a phrase that West might have found especially fitting to his needs. That phrase is "the perfection of form."

Early in his book *Primitive Art* (first published in 1927), Boas states, "All human activities may assume forms that give them esthetic values" (1955:9). He does not contend that all human activities are in fact examples of forms perfected, nor does he suggest that only a few activities may be perfected by a limited number of people. Any human activity can have aesthetic value if an individual is aware of and manipulates qualities that appeal to the senses in a rhythmical and structured way so as to create a form ultimately serving as a

standard by which its perfection (or beauty) is measured. Sometimes these forms elevate the mind above the indifferent emotional states of daily life because of meanings conveyed or past experiences associated with them, but they need not do so to be appreciated. Perfection of form is enough to satisfy; if the forms convey meanings, that adds to their enjoyment but it is not essential (Boas 1955:9–12).

One ramification of this notion is that tools and other practical things, which are not made or done principally or at all for aesthetic reasons, may have aesthetic value, and they may be appreciated for their formal excellence. Another is that any action, not just an object, may be given form and found satisfying. This includes the technique of making something as much as it includes the objects constructed; the way someone constructs a fence, for instance, may be as pleasurable in its form as is the completed structure.

Boas observes further that many of the formal qualities contributing to our enjoyment of objects or activities are correlated with the physiological condition of the human body, sensations experienced physically, and techniques of production. Such features as symmetry, surface evenness and smoothness, and rhythmical regularity seem to result from the way the body functions physiologically as people make and do things (Boas 1955:15–63). But this is insufficient, he implies, to explain why people strive to perfect form, and why formal excellence is so often appreciated.

To account for these two aspects of the perfection of form—success in achieving perfected forms and satisfaction with forms that have been perfected—Boas makes two additional statements. The first is that "we cannot reduce this world-wide tendency to any other ultimate cause than to a feeling for form. . . . " People have an aesthetic impulse prompting them to emphasize the form of objects they make. Second, art is "based upon our reactions to forms that develop through mastery of technique" (Boas 1955:58, 62). Boas did not elaborate on these two pronouncements. But he seems to be suggesting that fundamental to all human beings, as a condition of their being human, is a feeling for form compelling them to give a degree of order and structure to some of their activities at least part of the time. He seems to suggest, too, that all living, functioning human beings have the capacity, again as a condition of their being human, to master and control their actions, to develop skills with which to order materials into something having both shape and substance.

These assumptions that fundamental to being human is a feeling for form and a capacity to master technique have far-reaching ramifications. For Boas's pronouncements open up, rather than restrict, areas of inquiry, making it possible for researchers such as James West to investigate heretofore neglected aspects of everyday life with a view toward understanding human

behavior more fully. Whereas many other commentators have restricted art to a limited domain involving a few individuals engaged in a particular type of activity, Boas stresses and the observations of West demonstrate that art in the sense of striving to perfect form—with the attendant appreciation of formal excellence—is universal among human beings and is an essential element within the continuum of human experience. It is not a readily isolable phenomenon. It is not a quality to be added to or deleted from products of human manufacture. And it most certainly is not the sole pursuit of a few individuals, having little to do with everyday existence. Quite the contrary, for many forms and the process of perfecting form satisfy us for what they help accomplish in our daily struggles, often in a practical way (ordering phenomena, facilitating the completion of tasks, and otherwise aiding in day-to-day survival), and they please us for what they represent, including our ability to master techniques.

"Folk"

Although Boas was speaking mainly of what he called "primitive art," and at times he seemed on the verge of assuming that somehow primitive or folk peoples constitute a distinctive class of humanity, his pronouncements about art call into question various notions of "folk." The number of researchers challenging the use of the noun "folk" has not been great, although concepts of "a folk," and especially of "the folk," occasionally have been criticized. Among the few critics is Joseph Jacobs (1893), who implies that the word "folk" might not distinguish a group of people at all. If the word must be employed, one infers, perhaps it would be put to better use as an adjective rather than as a noun. And at a time when others were commenting on peasant customs and savage myths, Jacobs spoke of "our" folklore, suggesting that the continuities and consistencies in the behavior of other human beings, even the cultured British of his day, might be appropriate subject matter for investigation.

As in Jacobs's era, most notions today of *the* folk assume the existence of a particular class of people with traits distinguishing them from us. A principal trait often cited is their alleged conservatism. This quality presumably accounts for why they are sources of lore, which in turn is a survival inherited as part of the cultural legacy bequeathed by virtue of group membership. Even more recent notions of *a* folk assume that selected populations constitute distinctive groups of people whose behavior is similar by virtue of their being bound together by some unifying factor(s). A common identity allegedly explains why they have lore, and their lore in turn provides unification.

Jacobs was rather harsh in his comments, writing that "the folk" are "a fraud" and "a myth." Contrary to the opinion of many folklorists, contends Jacobs, the folk are not sources of lore in a collective sense at all; only individuals create and express themselves. In addition, notes Jacobs, the assumption that only the folk as an isolated conservative group possess lore is in error. Finally, while according to this assumption folklore should disappear in time as geographical isolation and cultural distinctiveness diminish, it does not; at most it is different. In regard to the notion of *a* folk, one could repeat some of Jacobs's remarks about *the* folk. People who are lumped together in the same category do not behave quite the same way or for the same reason(s), despite some similarities in the behavior of some of them. They could not simply be the fortuitous inheritors of a culturally distinctive body of lore. It is always specific individuals, Jacobs reminds us, who are express-ing themselves and creating forms as they interact and communicate with other individuals.

The use of the word "folk" as a noun to refer to people collectively does seem to point to some of the factors involved in the generation of folklore, at least implicitly. For it directs attention to human beings who make and do things in the course of their day-to-day existence. It suggests that these human beings have shared some experiences by being together in one place at one time. It implies further that these common experiences involve interaction and communication. It suggests therefore that these interactions include behavior, both verbal and nonverbal, which often results in some output, whether the making of an object, narrating, joking, or playing a game. Finally, it implies that there might be similarities in behavior or outputs of behavior; interaction and communication require, just as shared experiences often result in, continuities and consistencies behaviorally. If the word "lore" directs attention to forms that appear to be continuous through time and consistent at a particular place in time, then the word "folk" could serve to emphasize the interactional and experiential basis of these similarities.[2]

Modern Arts

A new conceptual framework, then, would emphasize the study of con-tinuities and consistencies in behavior or the outputs of behavior having an experiential and interactional basis. This would make it possible at last to defend conceptually the inclusion in our research of many activities we feel intuitively ought to be included but which we cannot justify on the basis of most currently employed concepts developed in the past. Examples of some of these activities are building sand castles, decorating a tree and stringing lights around the grounds at Christmas, customizing an automobile, land-

scaping a yard, remodeling a house, decorating the interior of a home, embroidering designs on denim clothes, narrating about personal experiences, having block parties, giving house-warming gifts, and so on. These are not cultural survivals, nor do those who engage in them constitute the folk or a folk comprising a particular group whose unification accounts for the existence of these behaviors. But there are similarities in space and through time. This can be attributed in part to the fact that people tend to some degree to model their behavior after the behavior of other human beings with whom they interact. The existence of behavioral similarities also stems partly from the fact that when experiencing an event together, individuals to some extent generate forms of behavior embodying and reflecting this sharing of experiences.

To give one modest example illustrating attempts to perfect form in day-to-day existence in which there are continuities and consistencies in behavior, I would cite the arrangement of trash cans in the area of Los Angeles in which I live. Before moving here three years ago, my family and I had not made the selecting and arranging of refuse containers a priority in our lives. Perhaps this was so in part because the cans were kept in the alley; hence, out of sight out of mind. In the area where we now live, however, there are no alleys; refuse collection takes place on the street in front of the houses. Many of our neighbors sometimes devote time and energy to arranging their refuse in pleasing ways. Aware of various visual and tactile qualities of both containers and the trash contained therein, they manipulate these materials in rhythmical ways to produce structures constituting forms that serve as standards by which their perfection (or beauty) is measured.

My neighbor to the north, for instance (fig. 4.1), has a matched set of plastic containers. He places them in a perfect line along the edge of the curb, lids in place to contain the trash neatly, and the handles exactly aligned. Even when on one occasion this fall, after having raked fallen pine needles from his yard, he had too much trash for his set of containers (fig. 4.2), he lined up the cans as usual and behind them—using a single type of container of the same size and shape and color, just like his plastic cans—arranged paper bags filled with needles. A neighbor across the street usually lines his cans with plastic leaf bags, and arranges the four cans in the shape of a square. Another homeowner whose driveway is bordered by a low wall, and whose mailbox is near the entrance to the drive (fig. 4.3), places his trash cans to either side of the mailbox in a visually balanced arrangement. One day he solved the problem of what to do with nonconforming items like a stack of newspapers by placing them between the cans and under the mailbox, which filled a gap visually in the arrangement of containers. Even empty cans are sometimes neatly arranged after refuse collection (fig. 4.4), awaiting their return to the backyard.

This is not to say that everyone including me attempts to achieve perfection in the arrangement of trash or its containers. But some people do. Thus some of the behavior of several individuals at a particular place in time exhibits consistencies. There are also continuities. My family and I, having moved to this area, now find ourselves tending to model our behavior after that of some of our neighbors, to the extent that we have gotten rid of our dilapidated and mismatched containers and replaced them with a matched set of cans that we often arrange with the lids on rather than off, in a square or other form (figs. 4.5, 4.6, 4.7).[3]

This single example of similarities in behavior involving a striving to perfect form among people who interact and who experience an event in common demonstrates that some notions from the past are not very useful today, while other ideas propounded long ago can be developed as assumptions and concepts of greater service now than when proposed. Combining some of the ideas of, say, Boas and Jacobs, or following through on their implications, is not as difficult as it might at first appear. The consequences justify the effort, for if only part of a conceptual foundation can thus be laid, using some of the materials from the past, future research will benefit. While some people soon tire of reviews of conceptual matters and attempts to develop methods corresponding more closely to contemporary knowledge and interests, it must be as apparent to them as to others that some assumptions and concepts relied upon now are inappropriate and inadequate. Hence, further discussion is mandatory, which is the purpose of this conference.

An issue for consideration, as I have suggested throughout this essay, is that what we as folklorists document, describe, and try to explain the origins of is folk art and the folk arts not only as objects but also as activities. Though seemingly we delineate a subject matter by giving it a name, the behavior or behavioral outputs so designated are not in reality isolated from the continuum of human experience. When studying the folk arts, we focus attention on the striving to perfect form in day-to-day existence, primarily in situations in which people interact and communicate face-to-face. And further, we examine the appreciation of formal excellence in types of behavior exhibiting similarities through time and in space as they relate to the shared experiences of human beings in the course of their daily affairs.

By emphasizing that as folklorists studying the folk arts we do research on similarities in the ways in which individuals attempt to perfect form in everyday life, I am making several assumptions about human nature. These suppositions grow out of and lend support to the conception of the folk arts posited here. And they extend ideas set forth long ago which subsequent research demonstrates to have been feasible then and applicable now. On the one hand, following the lead of Boas, I am assuming that fundamental to

Figure 4.1. The Trash Can "Handle" Arrangement

Figure 4.2. The "Overflow" Arrangement

Figure 4.3. The "Gap-Filling" Arrangement

Figure 4.4. The "Empty Can" Arrangement

The first two views are of the trash cans belonging to my neighbor to the north. All four depict carefully planned arrangements of cans. Figure 4.1 illustrates the precise alignment of the handles on the curb side. Figure 4.2 illustrates how, even when my neighbor had nonconforming trash, and too much for the cans, he maintained consistency in the choice and arrangement of containers, which suggests (in Boas's words) that "all human activities may assume forms that give them esthetic values." In figure 4.3 another neighbor has effectively used the stack of newspapers to fill the gap underneath the mailbox. Figure 4.4 shows an orderly arrangement of even empty cans.

Figure 4.5. Lack of Attention to "Displaying" Trash

Figure 4.6. The "Matched Set"

Figure 4.7. "Proper Balance"

Containers we had brought with us from another area when we purchased this house did not seem in keeping with many (but certainly by no means most) containers in the neighborhood to which we had moved. In the old neighborhood, trash cans were left at the back of the lot on an alley. There was no alley in the area where we moved; rather, containers were placed in front of houses. Perhaps it is not surprising, then, that what once had been "out of sight, out of mind" became more of a conscious presence, leading to the purchase of a set of matched containers and, often, their arrangenment in a pattern rather than haphazardly. Such is the way some traditions—repeated acts evincing continuities and consistencies in behavior—develop.

human beings, as a condition of their being human, is a feeling for form; further, human beings have the innate capacity to control techniques in order to perfect certain forms generated in their interactions with one another. I am supposing, too, on the basis of a suggestion by Jacobs, that all human beings exhibit continuities and consistencies, as well as uniqueness, in their behavior; the similarities are interactionally and experientially based rather than determined by the imposition of a common label on an aggregate of people.

Conclusion

Given the conception of the folk arts and the assumptions about human nature discussed here, the study of folk art can be expanded in regard to subject matter and analysis. Forms already documented can be examined from a new perspective addressing different questions. No longer is it necessary in publication or museum exhibit to leave readers or viewers of objects on their own to ponder how and why certain forms have developed or how they were responded to; to restrict publication and display to objects; or to dwell on alleged survivals in the culture of a bygone era. Other kinds of behavior heretofore neglected or newly generated can be included in our research and exhibits. I have in mind, for instance, not only some of the forms mentioned earlier but also the topic of working as art and of the arts of work. While we are familiar with the expression "works of art," and appreciate the effort required to produce them, we are less knowledgeable about the art and play involved in working, especially in today's factories and offices. Examining this matter, however, has the potential of adding the human element to current attempts to reconceptualize the principles and practice of management, and thus to apply inferences from folkloristic research to the solving of contemporary social issues. Whether this area of inquiry is explored or not, my point remains [see chapter 7]. Such a topic *can* be examined, and can *only* be studied, through a broadening in the conceptual underpinnings of research of the folk arts. In turn, attention to the continuities and consistencies in the behavior of all human beings, and to any activity by people which can assume a form having aesthetic value, provides a basis for refining concepts and methods that we employ in our research. Presumably others at this conference will pursue questions of methods or will describe phenomena leading to the development of new methods, or both.

Notes

1. I have prepared a handout which I use sometimes in the course Folklore 118: Folk Art and Technology. It contains 37 statements suggesting conceptions of folk and primitive art specifically and art generally. Some of these statements are taken from Haselberger (1971), and include her remarks as well as those by other people appended to her article. Some of the statements are from the comments in "What Is American Folk Art? A Symposium" (1950). Others concerning "art" are taken from Munro (1967). Yet others are from books and articles by folklorists and museum personnel. I mention these sources only as a guide; it seems that the specific sources scarcely matter, for conceptions tend to be similar.

2. The experiential and interactional basis of folklore is discussed in Blumenreich and Polansky (1975). I have remarked upon conceptions of folklore and folk art in several publications, among which are *The Hand Made Object and Its Maker* (1975), "In Progress: 'Fieldwork—Theory and Self'" (1977), and "L. A. Add-ons and Re-dos: Renovation in Folk Art and Architectural Design" (1980c).

3. Approximately 135 slides and about 30 pages of narrative regarding trash-can arrangements (along with 5,000 other items) are available on a laser videodisc called "Varieties of Expression," which was produced by the UCLA Office of Instructional Development and the Folklore and Mythology Center.

The Proof Is in the Pudding: The Role of Sensation in Food Choice as Revealed by Sensory Deprivation

"Some habits never change," remarked a student in a paper for one of my classes on foodways in America: "a hot dog on a stick and lemonade at the beach, hot chocolate at the ice skating rink, and chocolate-covered raisins at the movies." While free to choose from among many foods and methods of preparation and situations in which to eat, we tend to develop patterns of behavior. Moreover, many people today still produce some of their own foods, whether livestock on a farm or alfalfa sprouts in the cupboard and herbs in a pot on the patio. Some make a ritual of food shopping. Most of us prepare, serve, and eat in customary or habitual ways at birthdays, holidays, weddings, soirees, and on other occasions. We participate in picnics, ice cream socials, clam bakes, pancake suppers, and backyard barbeques. We go on pizza runs, make a special event of dining out, and assemble at a fast-food restaurant as something to do and someplace to do it.

From 1973 through 1975, I gave several classes on foodways and eating habits in America. But then I quit. There was a large body of literature on primitive subsistence patterns and peasant customs in Africa and Latin America, ethnic and rural traditions in the United States documented during the 1940s and 1950s, and nutritional curiosities, needs, and recommendations. But there was little about the customs and traditions of nonethnic, contemporary dwellers in suburbia like me and most of the students in my classes.

Even the special issue of *Keystone Folklore Quarterly* (1971) on contemporary foodways in American folklife tends to emphasize the traditions of ethnic and rural groups, although essays do advance inquiry by raising questions about the symbolic, expressive, and communicative aspects of food selection and consumption. But in general, the methods prevailing at the time were not able to handle the complexity and heterogeneity of foodways and eating habits in America.

"In the present state of eclectic variety," asked one researcher, "how do we

This article is also set to appear in an upcoming issue of *Southwest Folklore.*

study American folk cookery?" Don Yoder's answer to his own question was that "we can approach American cookery (1) ethnographically, and (2) historically" (1972:336). Don Yoder has authored many excellent essays on dishes and recipes prepared by the Pennsylvania Germans, especially in the past. Such studies conform to his conception of folklife as the entirety of a "folk-culture" in a pre-industrial era (1963). He offers many examples of historical and ethnic traditions in the remainder of his article on folk cookery, but he does not illustrate or analyze the kinds of behavior of modern urbanites except to point out the disbandment of older traditions.

Why do people eat what they eat? It has been contended often that food choice depends on what is accessible in the environment or attainable because of historical and technological developments or economic conditions; or it depends on what the culture permits and what the society insists is appropriate. Such views long served the need for broad generalizations, prevailing during earlier years of research on people who were thought to compose homogeneous populations with fixed behavior patterns and unchanging attitudes. But they are challenged often when applied to specific instances of foodways and eating behavior in contemporary America.

Eventually I changed the problem for consideration. To answer the question of why we eat what we do, I asked, What is the fundamental nature of eating that makes this activity unique? It seemed to me that understanding what is distinctive about eating helps us appreciate why preparing, serving, and consuming food often provide bases for interaction, serve as vehicles of communication, and constitute sources of associations and symbolic meanings. I explored these ideas in a paper for the centenary meeting of the (English) Folklore Society in 1978; the essay was later published (1980d).

But I still did not offer a course again on foodways in America, for there was no collection of essays that seemed appropriate as a textbook. At the American Folklore Society meeting in Los Angeles in 1979, however, Elizabeth Mosby Adler gave a paper called "Creative Eating: The Oreo Syndrome," Tim Lloyd spoke on "The Cincinnati Chili Culinary Complex," Thomas A. Adler remarked on "Making Pancakes on Sunday: The Male Cook in Family Tradition," and several other people explored yet other aspects of contemporary customs. During the summer and fall of 1980, I edited papers with Bruce Giuliano and Roberta Krell, and prepared a prologue, epilogue, and introductions to three sections of essays incorporating my earlier paper on perspectives in the study of eating behavior (1981).

The foodways volume focuses on the sensory and social dimensions of food consumption. At the time that it appeared in print, I gave the paper below at the Southern California Academy of Sciences meeting. My intent was to elaborate on the role of sensation in food choice. To do so, I reviewed taped interviews with my mother a few years before when I asked her a number of questions about the effects of a loss of smell, suffered in an auto accident, on her eating behavior.

It was not the first time I had based research on a family member. I was one of my own subjects in the study of home-owner remodelers. In 1980 I gave a paper at the California Folklore Society meeting called "G. I. Joe and the Germs: Conceptualizing Form" (1980b), which focuses on the play of my son and a friend of his.

Folklorists have long studied expressive forms that they themselves engage in, although they have not always admitted doing so. In "'. . . And You Put the Load Right on Me': Alternative Informants in Folklore," Lee Haring even suggests that "the folklorist's best and only subject is himself" (1974:66). One of the most extensive studies in which the researcher uses herself and her experiences as the data base is Cathy A. Brooks's Ph.D. dissertation, "The Meaning of Childhood Experiences: A Dialectical Hermeneutic" (1980). In it, she describes her "getting of taste" through the kinds of furnishings purchased by her parents, the attitudes of peers, and the art projects required of her by teachers.

What follows is a brief study of how my mother's loss of smell affected some aspects of her food preparation and food choice as well as her associations and memories. The paper is to be included in a special issue of *Southwest Folklore* on eating behavior in America, edited by Keith and Kathy Cunningham at Northern Arizona University. Another recent anthology is *Ethnic and Regional Foodways in the United States: The Performance of Group Identity,* edited by Linda Keller Brown and Kay Mussell (1984), whose papers do indeed, as the book's title suggests, concern ways that group identity is thought to be expressed through foodways. An article examining the complexity of this issue is Robert A. Georges's "You Often Eat What Others Think You Are: Food as an Index of Others' Conceptions of Who One Is" (1984). It is based on the author's personal experiences of being a guest and a host and having such other social identities as nephew, chef, and Greek.

<div align="center">* * *</div>

"So there are ways in which your food preferences have changed as a result of your having lost your sense of smell?" I asked my mother. The question was rhetorical, for I knew that she had lost her ability to smell in 1953, the result of head injuries suffered in an automobile accident, and I was aware that this condition had affected food choice. What I did not know, but wanted to find out, was what changes in particular had occurred in her eating behavior as a consequence of sensory deprivation.

"Yes, I suppose so," she replied in answer to the question about whether food preferences had changed. "But chicken and dumplings I still like," she continued, smiling while reflecting on the taste sensation of a food she had enjoyed many times in her youth. "I think maybe I like that because I remember."

"You mean, remember how it used to be?"

"Yeah; it was *soooo* good," she said. "I would just sit there and eat dish after dish."

We were sitting in the dining area of the kitchen; my wife was preparing something to eat, although I do not recall what it was. The date was 30 December 1972. The place was our house in Los Angeles. Present with me were my wife, Jane, and our five-year-old son, David; my mother, Anne Jones; and my wife's mother and father, Alice and Ralph Dicker—the latter three

visiting from Kansas. My father had died a few months before, shortly after an earlier visit by my parents. My mother and my wife's parents had been at our house for several days, together, during the Christmas holidays. Often food was a topic of conversation, as it is for other people in similar circumstances. Having long been curious about the effects of the loss of a sense of smell on my mother's eating habits, I took the opportunity to inquire.

Sensory Deprivation

"Did you ever get a feeling that you could actually smell it," I asked, referring to the chicken and dumplings, "even though you cannot, because of this association?"

"Sometimes," she said. "Sometimes I wonder if my smelling ability isn't coming back. I'm just so sure I smelled something," she contended. "Then I try again, but I can't smell a thing."

"Is that the case with food other than chicken—chicken and dumplings?"

"Yes, I have occasionally thought I could smell something, but I've gone back to it and tried to smell it, and pretty soon I can't do it at all." She continued: "I know I still can't smell, because I eat green peppers, raw, for my lunch many times and the other teachers will say, 'Oh, I know Anne's got green peppers again because I can smell them,' but I don't smell a thing." She concluded: "I like them because they're crunchy."

I was tape recording our conversation, considering some of the exchange an "interview," for in a week or so I would begin teaching a course on foodways and eating habits. While there was a substantial amount of literature on food preference and avoidance with which I was familiar, none of it focused on sensory deprivation; the greatest lack, however, seemed to be that of recognizing the fundamental significance of sensation in food choice. Other factors instead were emphasized: what is available, what one has been taught to eat in childhood, what the culture insists or the society demands, and so on. "Food attitude scales"—based on questionnaires used to determine food preferences—referred to preferences for or aversions to items like "steak" or "liver," "spinach" or "carrots" but did not consider how food was prepared or served, or how well. Anyway, having read and thought about the topic of food choice, I was anxious to explore the matter in greater detail. My mother seemed a suitable subject, the circumstances were propitious, and my interest was keen.

At first my mother was unable to recall, 19 years after the accident, how food preferences had changed. "I still think the problem is that I've been so long without a sense of smell. But I love lemon pie because I can taste that," she said, noting current preferences. "It's got the sour, see, that is delicious."

I asked her for other preferences now.

"Oh, ice cream; I much prefer a sherbert," she added.

"Why?"

"Because of the sourness, I guess—like pineapple, lemon. With real ice cream—it's chocolate I prefer. I think it must be the texture."

"Does chocolate ice cream have a different texture from vanilla?"

"It does to me, um hmmm. Thick, thicker. Raspberry Revel is delicious. We got that at the Hillsborough [store] and I love that, because there's all that sweetness. I can get the sweetness."

"So there are some preferences as a result of losing your sense of smell?"

"Yes," she said, "and on my salads, I have some preferences there," she continued, observing a change in food choice. "I used to like French dressing best, but now I like the blue cheese."

"What's the difference, now, without a sense of smell?"

"I think the French dressing's got too much sour. See, that's got more vinegar taste than blue cheese. I didn't like the blue cheese for quite a while and that was your father's favorite, and all of a sudden I began to like it. I like the thousand island," she added; "it's got a lot of pickle in it. Oh, and I like pickles; you can taste them—sweet pickles."

"Not dill?"

"Oh, I like dill, but not like the sweet pickles."

"Anything else that you prefer now?"

"Strawberry, strawberry preserves or cherry preserves are the best kind of preserves. I don't care for blueberries. Your father liked blueberries, but I can't get anything from a blueberry. . . . Too bland," she added.

"What's a strawberry? Sweet, or sour, or both?"

"I like the fresh strawberry because it's got a texture to it, which you can get. And the marmalades, the lemon and orange marmalades; there you got a texture. A lot better than—like grape jelly or apple jelly. I'm not much for that. Your father liked apple jelly but I never could see why, because there's not enough to it to get anything out of it."

"Did you like it before you lost your sense of smell?"

"I don't remember that far back, but I imagine I did."

"What about pies now?"

"Apple pie, cherry pie, lemon or cream pie doesn't do much for me."

"Pumpkin?"

"Yeah, I like pumpkin but it's the spice in the pumpkin. Some people put a lot of anise in it; I don't like that," said my mother, for it makes the pie taste bitter.

"Mincemeat?"

"Yes, mincemeat is good. It's got lots of flavor," she said, remarking on the sweetness of the raisin and the sourness of the apple as well as on the different textures.

I then asked her about some Italian sausage we had had recently. "I got some spiciness, but not very much," she said; "mostly texture." The sausage was very rich, she said, too rich to eat more than once a week. I next asked her about pizza, which she denied having eaten much of, largely because it seems so "doughy" and she did not want much bread—or not as much as she once ate. "So there are some ways in which your food preferences have changed as a result of a loss of smell?" I asked, by way of summary. It was to this question that she responded, "Yes, I suppose so. But chicken and dumplings I still like. I think maybe I like that because I can remember."

"You mean, remember how it used to be?"

"Yeah; it was *soooo* good," she said. "I would just sit there and eat dish after dish."

These few remarks by my mother suggest that after losing the sense of smell she became preoccupied with taste—sweet and sour—and texture—crunchy, lumpy, crispy, velvety. As if in reinforcement of this point, she added a few minutes later that while she does not like cake, she does enjoy the nut breads my wife, Jane, makes, as well as fruit cakes. Why? "Because they're full of nuts and fruits; I guess I get that texture, or whatever I get—the sour and the sweet." As a consequence of her condition, then, the focus on a food's distinguishing features shifted from olfactory concern to tactile and taste considerations; there was no mention of the visual sense, perhaps because she took it for granted, nor any remarks about the aural, although the crispy and crunchy sensations are as much auditory as they are tactile. In addition, only half of the taste sensations were pleasant—sweet, and also sour if not too pronounced or if balanced by sweetness—whereas the other half—bitter, and salty—were unpleasant. Indeed, she ceased to drink coffee and to eat licorice because of their bitterness and she objected to heavily salted foods.

Something else striking about my mother's comments is the materialistic, acquisitive, and active quality of her phraseology. Repeatedly, she employed such phrases as "[The food] doesn't do anything *for* me"; "I get something *out of it*"; "It does not do anything *to* me"; "I *get* the texture and the sweet and sour." She did not say, "It *has* this or that texture or taste"; rather, she phrased the matter in far more dramatic, subjective, and personal terms, observing whether the food had qualities that *affected* her or that could be *given up* to her for sensual enjoyment. This stress on the affective qualities of food was apparent throughout the conversation, even, or especially, when she talked about her search for new and interesting dishes.

"I read a recipe about curried chicken and I thought maybe that would have a special flavor to me," she said, "but I didn't get a thing, so I just didn't do it again."

On several other occasions trying a new food or drink was disappointing.

"I read a lot about hot, spiced cider, but it isn't as good as the story reads," she told me.

"You didn't like it?" I asked in surprise.

"No, I didn't like it. They had something—the PTA had something for Christmas. It was hot and everybody was going on about how wonderful it was. I thought it was very *un*delicious. . . . I think probably it was full of spices, but to me it was just a hot, sour drink."

Some things she had enjoyed in the past, such as coffee and licorice, she could not even tolerate after the accident. "Coffee is bitter; that's why I don't like it any more," she said. "I've tried it with cream and it still isn't good."

"What did you say earlier about liver and onions," I asked; "why don't you fix them any longer?"

"Because I don't get anything from the onions. It's just like having fried liver; so if you're going to have liver, just have fried liver."

Only occasionally did she eat liver at all after losing her sense of smell. "Food is food," she said. "You eat it just to be eating, I think. Not because there's any wonderful flavor about it or odor to it. You just eat it." She elaborated, noting that she had once enjoyed preparing dinners and going to dinner in the homes of others. Some of the food, such as chicken and roasts, she continued to eat, "but not for the same reason," she said. "Just because it's food." Once it was delicious, but more recently, she said, "it's just food."

There were, however, some pleasant gustatory experiences after the accident, which surprised my mother. From my wife a year before the interview she had learned to prepare ratatouille, and often she made it for herself at home. And she recalled vividly a few months before when Jane had served beef and broccoli stir-fried in a wok. "Those were not cooked very long and they're really good and I was surprised how good they were," she said. "It was unexpected. I didn't think they'd taste that way. . . . I love broccoli, but I never ate it that way. I've eaten it raw and well done, but never just kind of cooked briefly two or three minutes. It's delicious," she said. "Your father put up with it when he was here this summer, but I could see he was just putting up with it."

In addition to both disappointment and satisfaction with new dishes that my mother sought or happened to be served, there is apparent in her remarks a disaffection with certain foods she once liked, such as cream pies, fried chicken (unless moist inside and crispy outside), liver and onions, coffee, nuts and peanut butter (in regard to which aroma predominates), and green olives (which, she said, had become bitter to her). Moreover, there were foods she liked later that she had not enjoyed before losing her sense of smell or that she could not imagine having enjoyed: the stir-fried broccoli, for example, and hamburgers with condiments like mustard, tomato, and pickles (before the accident she invariably ordered a hamburger plain). In addition,

some things that she never ate before, or that she did not enjoy eating, she neither ate nor enjoyed after losing her ability to smell food. A case in point is fish and seafood, the fish because she could still recall the unpleasant odor of it in canned form, and seafood such as oysters and shrimp because she thought they were ugly creatures. Finally, she continued to eat some foods that she had enjoyed before the accident, not because they were especially interesting and not necessarily getting much from them with respect to sensation; rather, the eating of chicken and dumplings, other chicken dishes, and beef roast brought to mind memories of earlier, pleasant experiences with these foods both socially and sensorially.

The Role of Sensation

An interview is not the best source of information about a person's eating behavior, especially when the interviewer wants the subject to reconstruct events occuring over a 20-year period. Nevertheless, my mother said enough to demonstrate that sensation played an important role in her choice of foods, to suggest that particular circumstances rather than general conditions must be considered when attempting to ascertain why people eat what they do (or do not eat), and to indicate ways in which, and the extent to which, food habits might be generated and continued, modified, or extinguished.

In regard to my mother, principal among the factors affecting food preferences and food choice were notable sensory events and major social experiences. Some of the social experiences that she described in the course of the taped interview were growing up on a farm in Kansas in the 1920s and 1930s, marriage, working, and increased interaction with others (including my wife) following the death of her spouse. But even in her reminiscences about these major social experiences, the focus seemed to be on sensation: in regard to childhood, the memory of freshly dug "new potatoes," of the succulent fried chicken and other foods her grandmother prepared, and of fresh greens in the spring, including wild plants like lamb's quarter and sour dock and poke, which followed several weeks or months during the winter when the only vegetables available were home-canned ones or shriveled potatoes; with respect to marriage, the recall of my father's food preferences, whether they corresponded to my mother's or not; in regard to working, the dependence on convenience and fast food; and with respect to my father's death, the increased interaction with neighbors, fellow teachers, and my wife, from all of whom my mother obtained recipes for new dishes or different ways to prepare familiar foods.

What appears to be of greatest importance, then, and what I have therefore emphasized in this report, is the matter of sensation, which later in her life seemed to dominate my mother's concerns about food. For it was

during the last 25 years of her life (she died in 1976) that she was deprived of one of her senses—that of smell. While there were disappointments—"food is food," she said; "it's just food now"—the very disappointments themselves, the search for new and interesting dishes or methods of preparation, and the recollections of earlier, pleasant sensations leave no doubt that the sensory quality of food continued to be important even though she had lost one source of sensation, and thus her ability to appreciate food was substantially reduced.

It might be argued that sensory deprivation of this sort is not typical of the human population. Yet every one of us at some time—often several times in our lives, and for periods of varying length—is deprived of a sense of smell when we have a cold. And many other people are born without, or later lose, the sense of sight or hearing. In addition, one researcher—Dr. Robert I. Henkin, director of the Center for Molecular Nutrition and Sensory Disorders at the Georgetown University Medical Center—estimates that perhaps a million or more Americans suffer a loss of taste acuity—the ability to distinguish tastes—or a distortion of taste and smell. Causes are unknown, but aberrations of taste and smell are symptoms of the common cold and of hepatitis, often accompany pregnancy or follow an attack of the flu, or result from head injury.[1] Some instances, though not necessarily all, seem to be linked to an imbalance in the amount of zinc in the saliva. Whatever the cause or causes of distortion of taste and smell, the point is that taste or smell dysfunction is not that rare in the species, and further, such an extreme instance of condition and consequence as found in my mother and her behavior serves to emphasize the role of sensation in food choice that in less exaggerated form is common to us all.

Conclusions

"The pleasures of the table are for every man of every land, and no matter what place in history or society," begins one of the aphorisms of Brillat-Savarin, writing in 1825 about the physiology of taste; "they can be a part of all his other pleasures, and they last the longest, to console him when he has outlived the rest" (Brillat-Savarin 1978:3). Although often taking food for granted, especially once we have satisfied our hunger, we sometimes reflect on the uniqueness of eating. We might not be inspired to author a treatise called "Meditations on Transcendental Gastronomy," as was Brillat-Savarin, but probably we would make some similar observations, realizing that one of the distinguishing features of eating is that it involves so many senses and sensations. Having these sense impressions, and remembering them, it is no wonder that sometimes we crave something moist and tart, crisp and salty, chewy and sweet, warm and doughy, or thick and filling; that

we cherish some earlier experiences with food; or that we long to reproduce an event that was memorable.

Above all else, eating is a physiological and an intellectual experience, unique in the range and intensity of effect; it is ongoing, at once familiar and yet also novel, with past experiences becoming part of the meaning of food as each subsequent meal is eaten. In providing pleasures and satisfactions personally and immediately, food can enliven social relations, enrich spiritual affairs, and enhance an individual's sense of well-being; it can be used to threaten, reward, cajole, or punish and in other ways manipulate behavior. Fasting might be uplifting and the denial of food by others devastating. Eating as a recurrent experience in the lives of human beings results in the generation of preferences and dislikes, and even of disgust and aversion. Because food affects so many senses and produces such a broad spectrum of states, the timing and the manner of preparation, service, and consumption of food assume special importance, resulting in the development of skills, values, and criteria for evaluating these activities and the foods connected with them. Any study of why people eat what they do, then, must begin with the uniqueness of eating, including as it does the sensory domain.[2] That this injunction is defensible should be obvious to us when we reflect on what eating is, and on what eating means to us. "The proof is in the pudding," as it were.

Notes

1. See Berton Roueché (1977), which was called to my attention by Susan Gordon, a student in the Folklore and Mythology Program at UCLA and one of my research assistants [employed as Program Officer of the California Council for the Humanities, beginning September 1986].

2. Much of this paragraph is a condensation of what I wrote for the introduction to "The Sensory Domain" (1981).

Part Three

Art at Work

6

Creating and Using Argot at the Jayhawk Cafe: Communication, Ambience, and Identity

"Cherry pie, that was *c-pie*. Of course, if there was ice cream on it, it would be *I-a*," said Paul Sinclair. "And if it had two dips on it, which a lot of boys wanted, it was *mode-mode*. If you wanted two dips on there, it would be *c-pie mode-mode*."

For eighteen-and-a-half years Sinclair had owned the Jayhawk Cafe in Lawrence, Kansas. It was located just below the top of Mt. Oread, the site of the University of Kansas.

"What about a glass of ice?" I asked.

"Yeah, yeah. *Bucket of hail*. And *bucket of hail in the air* was a tall glass of ice."

"What if you wanted three glasses of ice?"

"If they were short glasses it'd be *hail a crowd*.

"What if they were tall?"

"It'd be *hail a crowd in the air*."

"What about a refill?"

"We'd call that *riffle*—shorten it down to *riffle*."

Having been a frequent customer at the Jayhawk Cafe much of the four years I was an undergraduate student at KU, I already know most of the terms. Also I had worked at the Jayhawk part time as a waiter. But I did not know the origins of some of the expressions or the rationale for their use.

"If you wanted five limeades . . . ?"

"That'd be *squeeze a handful*. And, uh, it could be *to the right* [i.e., the flavoring located to the right of the Coke dispenser]. A lot of them used cherry limeade, see, so if you had five limeades, two of them cherry, you'd call, *Squeeze a handful, a pair to the right*. That'd give you five limeades, two of them cherry. *Squeeze a handful*: that gives the bartender the designation of how many is his full order. Then if there's any deviations or additions to them, that comes later. You wouldn't want to say, *Squeeze a crowd*, and then, *Squeeze a pair right*. That's repeating yourself. So the first call would be *Squeeze a handful*. Then he knows that's five limeades and you go from there—pair of them *to the right*."

"I see. Pretty complicated, isn't it?" I asked after we had discussed some other calls, such as *Stretch a bridge in the air all through Georgia*.

This article originally appeared as "Soda-Fountain, Restaurant, and Tavern Calls," in *American Speech* (1967): 58–64.

"Actually, it's complicated 'til you put this sort of thing together and [then] it's actually easier than trying to remember *'four tall chocolate Cokes.'"*

"Is that the reason you used these calls?"

"No, really, actually, no, the reason actually, of course was for the atmosphere—the college lingo, slang, or whatever you want to call it. But actually, as we went into it, over a period of years, all the boys readily agreed it made their ordering a lot easier to remember. Actually, it was a help, a big help."

He said that he had never experienced such extensive use of argot as found at the Jayhawk. "It was unique."

"How would you say, *Two strawberry sundaes?"*

"Drop a pair a patch," said Sinclair, laughing. "It's all coming back to me. Ain't hardly thought about it for three years."

He had sold the Jayhawk Cafe in early 1964, partly for health reasons. A year later, however, he bought a small cafe, The Call, on the other side of campus. I was interviewing him the evening of 16 June 1966 at the American Legion Club in Lawrence, where he was tending bar. It was early; only two people came in during the hour-long interview, one to buy a drink and the other to use the telephone.

"What did you say was the origin of the term *86?"*

"Well, that of course didn't originate at the Jayhawk but was taken over from the railroads years ago. When they were first getting their start, they had to send all their messages by code—wireless tap—and they'd shorten it to anything to save time. Say, somebody wanted five boxcars at Baltimore tomorrow morning at eight o'clock. If there's no boxcars there or you couldn't complete the order, then to make an easy explanation you'd tap out *86.* That's 'out.' And, uh, the help [a waiter or bartender at the Jayhawk Cafe], if he was out of anything, instead of stopping and telling somebody, 'Oh, I'm sorry, we're out of that,' your 'echo' [reply] would be *86."*

Many of the terms already existed at the Jayhawk Cafe when Sinclair worked there for three-and-a-half years as a college student. After buying the cafe in 1946, and continuing the custom of employing students, he left it to employees to use and originate other terms.

Virtually all of the clientele in the early 1960s, and probably before, were students at the university. Customers used the argot almost as much as the employees did. Evenings were raucous. Through the din, only the argot could be understood clearly—"hood a High a handful" or "burn a crowd a van" cutting through the shouting of football scores, the laughter, the arguing over some political or philosophical issue.

Perhaps this is another reason the argot was perpetuated. It actually facilitated communication through the uniqueness of the terms and the structure in which they were ordered. But the existence and use of the argot also corresponded—and contributed—to the ambience of the Jayhawk Cafe. And it defined the cafe, the business establishment, the organization—and even became part of the identity of many of the customers and employees as well as the owner.

When I talked with Sinclair on that June evening in 1966, he sometimes waxed nostalgic about the Jayhawk Cafe that had been so much a part of his life, first as student-waiter and then as owner. He seemed to regret having sold the cafe. That

its character immediately and drastically altered after the sale saddened him, too. When I mentioned the change in ambience, he said,

> Well, actually,not everybody likes to feel that their—their place in the university is to do a little, help the students, but I still contend that . . . I don't believe you'll ever find another place in the world like it, actually, really. Cause I've talked to kids that's been to many many other universities. . . . We've always went on the assumption of trying to make it as, as personal contact as you could to the students. Make 'em feel at home because they are away from home. If they've got some place where they can feel at home, I personally feel I've done something besides make money.

I wrote the article below in 1966 while in my second year as a graduate student in folklore at Indiana University. It appeared in *American Speech* (1967a). Although I had published two short pieces previously, this was my first analytical article. A few years later, Gerald E. Warshaver (1971) noted that my article, like others he examined, had a lexical focus: "However, more important than this linguistic aspect is the fact that it provides us with a *context* by means of which the phenomenon of dialect vocabulary can be studied, not atomistically as a series of isolated linguistic fragments, but as part of a total work situation." He continues: "Even though Jones was primarily interested in a long attachment to a single place, he could not help but collect other genres of occupational folklore as well as valuable data regarding the sociology and psychology of this type of occupation." Warshaver based his remarks on the published article but also on the interview transcript and introductory and concluding observations which were housed in the archive at IU.

In the last page of my notes I had written, "When asked why he did not continue the calls in his restaurant, The Call [already named that when he bought it], Sinclair said that they belonged to the Jayhawk and to his memory of eighteen-and-a-half years, and that's the way he wanted to remember it." I added that "the Jayhawk changed hands several times after Sinclair sold it [I counted five owners in two years, each of whom altered the decor and tried to generate a different ambience], but apparently none of the new owners has continued the calls."

I went on to suggest several factors that might account for this extinction of the argot. "First, the charismatic personality of Paul 'Buffie' Sinclair is gone. The subsequent owners, at least the ones I have met, have no outstanding personality traits and apparently no interest in creating a 'college atmosphere'. Secondly, under the management of the first two owners there were no student waiters; as Sinclair indicated in an earlier interview, the older people [residents of Lawrence who sometimes worked the kitchen] would have little or nothing to do with the calls. Third, to some extent, at least, the clientele changed right after Sinclair sold the Jayhawk." Few students frequented the cafe; most of the customers were local residents, a group who never seemed in evidence when Sinclair owned the Jayhawk. "Hence, the people who originated and continued the calls—the students—were no longer part of the clientele." That the argot was not prevalent at the business that Sinclair bought two years later may be in part because "there are no student waiters. Also, it is a restaurant rather than a tavern or combination of the two. As a result, the atmosphere is completely different from the Jayhawk."

The title of the article as it appears in *American Speech* is "Soda-Fountain, Restaurant, and Tavern Calls." On rereading it and the tape transcript and my notes, I realize that the essay concerns more specifically creating and using argot at the Jayhawk Cafe. The argot—or "calls"—pervaded the speech of student employees and customers as well as originated and persisted because of their value in communicating orders, generating a particular ambience, and establishing an identity for people, a business enterprise, an organization, and a place. Hence, I have retitled the article for this book.

<p style="text-align:center">* * *</p>

The traditional calls reported in this article are now moribund, but once they were part and parcel of the Jayhawk Cafe in Lawrence, Kansas, an eating establishment that served its college clientele not only food but also soda-fountain drinks and beer. By selecting for the principal informant Paul Sinclair, who worked at the Hawk as a waiter during his student days at the University of Kansas before the Second World War and owned the cafe from 1946 until 1964, it is possible to establish the approximate date when each item was introduced, to indicate the structure of calls, and to discuss the origin and process of creating some of the expressions.

A typology of calls would embody seven different categories of terms: 1) food, such as *bowl of red* (chili), *c-pie* (cherry pie), or *filet* (fudge cake); 2) beer, such as *Blue* (Pabst) or *High* (Miller); 3) soda-fountain orders, like *burn* (a malted milk shake), *drop* (a sundae), *jerk* (an ice-cream soda), or *suds* (root beer); 4) the number of identical items desired in each order, as in *a crowd* (three) or *a handful* (five); 5) the relative sizes of beverages, such as *bullet* (a one-quart bottle), *hock* (a 16-ounce can), *hood* (a 12-ounce bottle), or *in the air* (a 10-ounce tumbler); 6) special instructions or particular flavorings, like *hold the hail* (put no ice in the fountain drink) or *patch* (strawberry ice cream); and 7) a miscellaneous group comprising such items as *echo* (repeat the order), *eighty-one* (a customer desires service), *eighty-six* (we don't have the item ordered), and *riffle* (refill the order).

The structure of a call consists first of the basic item of food, beer, or soda-fountain order, then of the modifications of number and size, and last of the special instructions. For example, an order for three tall (10-ounce) glasses of Dr. Pepper, two of which have a cherry flavoring added, would be *M.D.'s a crowd, in the air, a pair to the right.* Considerations of brevity and clarity determine the way in which separate items are united into a complete call; thus, a small glass of Coca-Cola is *shoot one* and lemon flavor is *to the left,* but the actual call is *shoot a left* rather than *shoot one to the left.* In addition, unless otherwise indicated, it is always assumed that *shakes* and *malts* (malted milks) are chocolate flavored, *Cokes* are plain, coffee is with cream, and all orders of beer refer to Budweiser.

Another aspect of traditional calls that should be treated is their genesis. Most of the items are the result of a kind of wordplay based on association, such as *patch* for strawberry ice cream or *echo* to indicate that the order should be repeated. Almost as numerous are expressions that are descriptive of some physical characteristics of the food or drink or its container, as in *white one* (milk) or *bucket of mud* (a dish of chocolate ice cream). The location at the fountain accounts for the origin of *to the right* and *to the left,* that is, on either side of the Coke dispenser. The method of preparation gives rise to *shake, drop,* and *squeeze one* (a limeade); according to Sinclair *jerk* belongs in this group also, as it probably derives from observing the operator jerk the soda-fountain lever forward to make the carbonated water fizz for a soda. Abbreviations of words and phrases, such as *van* (vanilla) or *c-pie l-a* *(cherry pie à la mode),* account for other calls. A few terms are derivatives of longer brand names, such as *Blue,* which is a contraction for Pabst Blue Ribbon Beer. Finally, there are contractions or blend words like *riffle* and *filet.*

In specific instances it is possible to demonstrate the actual method of creating calls, including the process of selecting from various alternatives to comply with the basic pattern or other criteria, and the role of waiters, customers, and the owner in the entire process. In the first place, Sinclair attributes to the imagination of student waiters most of the calls that were introduced; the origin of *one of the best* (a bottle of Coca-Cola), dating from the time when Sinclair was a waiter at the Hawk, will serve as an example. About 1937, a football player nicknamed *Lobo* was working at the fountain. He was seldom consistent about making a Coke conform to the formula of an ounce of syrup in a 6-ounce glass: "He'd have about 4 ounces of syrup or he'd have about an ounce of syrup. So in a joking manner someone told him the best Coke he could make is a bottled Coke. So from then on, why, a bottled Coke was 'one of the best.'" Under Sinclair's management, too, waiters were the major source of the expressions: "I kinda left it up to them because they had to work with it. If we'd get a new item in, why that was the first thing we'd do—immediately try to determine some kind of a catcall for it that would fit in our pattern."

But Sinclair also played a role in the creative process, first by permitting and encouraging the use of expressive language, and second by establishing injunctions against calls that might involve *double-entendres;* hence the use of *shoot a right* rather than *virgin Coke* (cherry Coke), and the fact that peach pie, unlike cherry or apple, did not have an expressive equivalent: "I think that being's how you mention pie, that was one reason why we didn't call peach pie *p-pie.* " The same prohibition operated in creating the terms for cold and hot tea. A cup of hot cocoa was called *hot cup,* "so we couldn't figure out what else to call hot tea. You wouldn't wanna say *hot bag.* So the nearest

we could come to it was calling it *spot,* so we designated it *cold spot* and *hot spot."* No doubt the British expression *a spot of tea* was a contributing factor also.

The customers, too, exerted an influence on the development of certain calls. First, the code was intended for use by the waiters, but any customers acclimatized to the cafe's environment quickly adopted the calls, thus helping to perpetuate them. The use of some calls by the clientele, however, created a dichotomy between reality and what the owner (Sinclair) considered the ideal, which in turn suggests the way in which customers may attempt to refine or clarify certain expressions. According to Sinclair, the term *eighty-one* means 'a glass of water', and by extension it grew to include the customer himself. The owner meant it to be used among waiters to indicate that a customer in a certain area of the cafe had not been waited on, as in *Eighty-one in the first section!* Although Sinclair discouraged it, customers themselves shouted *eighty-one!* thus altering the original term to mean 'Service, please.' The expression then had three possible meanings. Among the customers, at least, the term *clear one* (a glass of water) developed to reduce some of the confusion. Although this term was rejected by Sinclair, who preferred the more widely used *eighty-one,* it is conceivable that had the calls continued at the Jayhawk, the customers might have successfully effected a complete change.

Why were these calls used at the Jayhawk Cafe for perhaps 30 years or more, and why were additions made to the code? Sinclair gives his own twofold reason for using the calls: "The reason, actually, of course, was for the atmosphere—the college lingo, slang, or whatever you wanna call it. But actually, as we went into it, over a period of years, all the boys readily agreed it made their ordering a lot easier to remember. Actually, it was a help, a big help." The clarity, brevity, and distinctiveness of each call, then, facilitated ordering, while the exclusive language—not shared by other cafes or taverns in Lawrence—provided the habitués with a sense of identity and group solidarity, at the same time that it established the uniqueness of the Jayhawk Cafe. In Sinclair's words, "I don't believe you'll ever find another place in the world like it."

Yet, when Sinclair sold the Jayhawk in 1964, these calls immediately died. Probably the moribund state of the calls can be attributed to a destruction of the interwoven relationship between the cafe, the owner, the waiters, and the customers. Drastic changes in décor, the absence of student waiters, and a different clientele may be partially responsible for the death of the calls. Certainly, when Sinclair left, the cafe lost the person who helped perpetuate this expressive language. Nor has it been transferred to another cafe which Sinclair bought in 1965. As he explained, the Jayhawk and its calls were one, and—as part of the past—they are to be remembered together. In addition,

there are no student waiters at the cafe to keep the terms alive, nor are most of the customers the active tradition-bearers who frequented the Jayhawk.

In compiling the glossary that follows, I have indicated the approximate date on which each term was introduced at the Jayhawk, given the circumstances surrounding the creation of a few calls, suggested their probable genesis, and supplied examples of usage when desirable. I used five sources in annotating the collection: the *ATS;* the *DAS;* the *DSUE;* H. L. Mencken, *The American Language, Supplement II* (1948—referred to hereafter as *AL*); and John Lancaster Riordan, "Soda Fountain Lingo," *California Folklore Quarterly,* (1945)—referred to hereafter as *CFQ.*

ALL THE WAY, *adv. phr.* (1940) Used when ordering fudge cake with chocolate ice cream. Compare this call with *one in all the way* "a chocolate soda with chocolate ice cream" in the *ATS,* 822.7.

A-PIE, *n.* (1940) Apple pie.

BLUE, *n.* (1945) Abbreviation for "Pabst Blue Ribbon beer": *Blue in the armor* is one can of Pabst.

BOWL OF RED, *n. phr.* (1939) A bowl of chili.

A BRIDGE, *adj. phr.* (before 1946) Four. Cf. *CFQ,* 53,54; *a bridge party.*

BUCKET (OF MUD, PATCH, etc.), *n. phr.* (1939) One large scoop of (chocolate, strawberry, etc.) ice cream.

BUCKET OF HAIL, *n. phr.* (1940) One small glass (6 ounces) of ice. A large glass (10 ounces) of ice is a *bucket of hail in the air;* however, three large glasses of ice are *hail a crowd in the air.*

BULLET, *n.* (1945) A one-quart bottle of beer—Budweiser, unless otherwise designated, as in bullet of Blue. Term probably derives from the shape of the bottle.

BURN, *n.* (1940 or earlier) A malted milk shake—always chocolate, unless otherwise specified, as in *burn a crowd of van* 'three vanilla malts'. Both the *DAS* and the *ATS,* 823.1 contain the expression *burn one,* but do not indicate the flavor. Cf. *shake one and burn it* in *CFQ,* 56.

CHOC PIE, *n. phr.* (1940) Chocolate pie.

CLEAR ONE, *n. phr.* One glass of water. Used by some customers and waiters, but the owner preferred EIGHTY-ONE.

COKE PIE, *n. phr.* (1940) Coconut pie.

COLD SPOT, *n. phr.* (after 1946) One glass of iced tea. Probably derives ultimately from *a spot of tea.* Call created during informant's ownership and chosen in preference to *cold [or hot] bag* because of the latter's sexual connotation. *See also* HOT SPOT.

A CROWD, *adj. phr.* (before 1946) (*CFQ,* 53, 54) Three. Derives from the saying, "Two's company and three's a crowd."

C-PIE, *n. phr.* (1940) Cherry pie.

DROP, *n.* (before 1940) A sundae. Term may come from the method of preparation (i.e., dropping scoops of ice cream into a dish).

ECHO, *n.* (1939) (*ATS,* 817.1; *DAS; AL,* 752) Repeat the order. Also used in a department store in Bloomington, Indiana, when a sales clerk asks the office secretary to call the manager over the public address system.

EIGHTY-ONE, *n.* (1939 or earlier) (*ATS; AL,* 772; *CFQ,* 53,54) One glass of water. Term may also be yelled by a customer to indicate that he wants service or by one waiter to another to indicate that a certain customer has not been served. *See also* CLEAR ONE.

EIGHTY-SIX, *n.* (1939) (*ATS,* 817.2, 823.2; *DAS; CFQ,* 53,55) We don't have the item ordered. In the *DAS* and the *CFQ* it is also given the alternative meaning of "a glass of water." According to

the informant, the term was borrowed from railroad jargon, where it was used in telegraphy to indicate that a yard was unable to fill an order for a specified number of cars.

FILET, *n.* (1940) Fudge cake à la mode. Sample calls include *filet one* ALL THE WAY "fudge cake with a scoop of chocolate ice cream" and *filet one* MODE MODE "fudge cake with two scoops of vanilla ice cream."

GLAMOTTLE, *n.* (about 1948) A 13-ounce glass of Budweiser draught beer. Contraction of *glass that holds more than a bottle*. The informant explained: "Sticks in the back of my mind that was an advertising promotion by Budweiser. It was right about 1948. I won't say for sure on that, but it sticks in my mind 'cause I remember a sign, and we never had any signs painted."

HAIL, *n.* (1940) Ice. See also HOLD THE HAIL.

HANDFUL, *adj.* (before 1946) Five. The *DAS* gives its meaning as "a five-year prison sentence," and the *DSUE* says that it comes from racing slang.

HANDFUL PLUS (ONE, A PAIR, A CROWD, etc.), *adj. phr.* (before 1946) Six, seven, eight, and so forth. Cf. *CFQ,* 56, where the expression is *on six,* and so forth.

HIGH, *n.* (about 1945) An abbreviation of Miller High Life beer, as in HOOD *a High* "one 12-ounce bottle of Miller beer."

HOCK, *v.* (1945) One 16-ounce can of beer—understood to be Budweiser, unless otherwise stated, as in *hock a pair of* ROCKY "two 16-ounce cans of Coors." The *DSUE* gives the meaning of *old hock* as "stale beer."

HOLD THE HAIL, *v. phr.* (1940) (*ATS,* 823.1; *CFQ,* 51, 55) To put no ice in the fountain drink. *See also* HAIL.

HOOD, *v.* (about 1945) One 12-ounce bottle of beer—Budweiser (e.g., *hood one*), unless stated differently, as in *hood a pair* of HIGH.

HOT CUP, *n. phr.* (before 1940) One cup of hot cocoa.

HOT SPOT, *n. phr.* (after 1946) One cup of hot tea. See also COLD SPOT.

IN THE AIR, *prep. phr.* (about 1940) A large glass (10 ounces) of milk or a fountain drink, with the exception of Coca-Cola, which is STRETCH ONE. *See also* WHITE ONE; WHITE ONE THROUGH GEORGIA.

IN THE ARMOR, *prep. phr.* (1945) A 12-ounce can of beer—Budweiser, unless otherwise indicated. One can of Budweiser is simply *in the armor* or *one in the armor,* while a can of Coors is ROCKY *in the armor.*

JERK, *n.* (1940 or earlier) An ice cream soda. An order for four chocolate sodas is *jerk a bridge* THROUGH GEORGIA. Term derives from the method of preparation (i.e., jerking the soda-fountain lever forward to make the carbonated water spray).

L-A, *adj.* (1945) A la Mode, as in *C-pie l-a.*

L-PIE, *n.* (1940) Lemon pie.

M.D., *n.* (1945) Dr. Pepper, as in *M.D.'s a crowd in the air* "three glasses of Dr. Pepper." A form of wordplay involving association of *M.D.* and *doctor.*

MODE MODE, *adj. phr.* (1945) Two scoops of vanilla ice cream on a piece of pie or cake.

MUD, *n.* (1939 or earlier) Chocolate ice cream, as in BUCKET OF MUD.

NATURAL, *n.* (1940) 7-Up. Derives from the combination of 5 and *2, a natural* in the game of craps.

O.J., *n.* (1948) (*ATS,* 816.59; *DAS; CFQ,* 55) One small glass of orange juice. *O.J., a pair in the air, hold the hail* means "two large glasses of orange juice without ice."

ONE, *adj.* (1940 or earlier) (*CFQ,* 53) One, as in *jerk one.*

ONE OF THE BEST, *n. phr.* (1937) A bottle of Coca-Cola. A football player working as the fountain operator was unable to make a good fountain Coke. Someone told him that the best Coke he could make was a bottled Coke; hence, a bottled Coke was referred to as *one of the best.*

ON WHEELS, *prep. phr.* (after 1946) (*CFQ*, 53, 56) An order to be taken out. Informant states that the term became popular after the cafe initiated a delivery service to the residence halls of the University of Kansas; although the service terminated after a brief period, the expression continued.

A PAIR, *adj. phr.* (1937 or earlier) (*DAS; CFQ*, 53, 56) Two.

PATCH, *n.* (1940) Strawberry ice cream.

POUR BLACK, *n. phr.* (1937 or earlier) One cup of black coffee.

POUR ONE, *n. phr.* (1937 or earlier) One cup of coffee with cream. Cf. *ATS*, 817.2 *draw one black.*

RIFFLE, *v.* (1939) Refill the order, as in *riffle black, riffle* POUR ONE, or simply *riffle* "refill a beer glass with draught beer."

ROCKY, *n.* (1945) Coors beer ("Brewed from pure Rocky Mountain spring water").

SHAKE, *n.* (1937 or earlier) (*ATS*, 823.1) A milk shake—chocolate flavored, unless otherwise designated; *shake a crowd of patch* "three strawberry shakes."

SHOT, *n.* (1937 or earlier) (*AL*, 772) A small (6-ounce) fountain Coca-Cola, as in *shoot one.* For analogues to the complete call, see the following: *ATS*, 823.1; *DAS;* and *CFQ*, 50, 56. At the Jayhawk Cafe, *shoot a van* meant "one small vanilla Coke," but the same order in the *ATS*, 823.1 is *shoot one van.*

SQUEEZE ONE., *n. phr.* (1939) One small limeade. Term derives from the method of preparation.

STRETCH ONE, *n. phr.* (1939 or earlier) (*ATS*, 823.1 *DAS*) One large (10-ounce) glass of fountain Coca-Cola, Cf. *CFQ*, 56; *shoot one and stretch it.* Compare *stretch a van* "one large vanilla Coke" with *shoot a sissy and stretch it* in the *CFQ*, 52. *See also* IN THE AIR.

SUDS, *n.* (1937 or earlier) Root beer.

THROUGH GEORGIA, *prep. phr.* (about 1946) (*ATS*, 823.1) Chocolate flavor added to milk or Coca-Cola. Compare *shoot one through Georgia* 'one small chocolate Coke' at the Jayhawk with *drag one through Georgia* in the *ATS*, 823.1. *See also* WHITE ONE THROUGH GEORGIA.

TO THE LEFT, *prep. phr.* (before 1937) Lemon flavor, which was dispensed from the left of the Coke dispenser.

TO THE RIGHT, *prep. phr.* (before 1937) Cherry flavor, which was dispensed from the right of the Coke dispenser.

VAN., *n.* (1937) (*ATS*, 91.23, 91.32,and 822.9) Vanilla ice cream or vanilla flavoring for malts, shakes, and Coca-Cola.

WHITE ONE THROUGH GEORGIA, *n. phr.* (about 1946) A small (6-ounce) glass of chocolate milk—hence, *white one* THROUGH GEORGIA, IN THE AIR "a large glass of chocolate milk." Note, however, the following: *white* A CROWD, IN THE AIR, *all* THROUGH GEORGIA "three large glasses of chocolate milk."

Notes

1. This and subsequent quotations are from my taped interview with Paul Sinclair in June 1966. The tape has been deposited in the Archives of Traditional Music at Indiana University.

A Feeling for Form, as Illustrated by People at Work

Long before I completed my dissertation on one kind of work, chairmaking in southeastern Kentucky, I conducted field research in the Maritimes under contract with the Museum of Man in Canada on another occupation, that of faithhealing. Four years after I began the study (and two years after I completed my dissertation), I published a monograph entitled *Why Faithhealing?* (1972c).

One of the issues was why patients availed themselves of the services of traditional therapists. To answer the question, I asked many former patients as well as recorded stories told me by healers about who had come to them and why [on a related matter, see my article "Doing What, with Which, and to Whom? The Relationship of Case History Accounts to Curing" (1976b)]. In a moment of scientific inspiration or personal desperation, I presented myself to "Uncle" Joe Gallagher as a patient. I had been plagued by eczema on my hands for several years, and treating eczema was one of his specialities.

Another question for research was what motivated someone to become a healer. I had data about several traditional therapists. I also read widely in the psychology and sociology of work, particularly the literature concerning occupational role and identity. I returned to the subject in 1976, giving a paper at the Southern California Academy of Sciences meeting on another occupational identity. In the essay called "In the Switching Yard, with Railroad Men" (coauthored with Paul Deason, a longtime friend and the source of much of the data analyzed), I considered the matter of occupational identity.

In 1979 I examined virtually every book, article, and dissertation on occupational folklore that I could find. I read studies in the anthropology and sociology of work. Having had an article solicited for a *festschrift* for Linda Dégh (1980a), I began writing the essay that is printed below. And I designed a course on occupational folklore which I taught in winter quarter, 1980.

This article originally appeared in *Folklore on Two Continents,* edited by Nikolai Burlakoff and Carl Lindahl (Bloomington, Ind.: Trickster Press, 1980), pp. 260-69. Reprinted by permission of the publisher.

As valuable as previous research on occupational folklore was, something seemed to be missing. Some of the research was informed by the earlier notion of folklore as a survival and "the folk" or "a folk" as an isolated group. Much of the literature before the 1970s concerned the tales, songs, and beliefs of miners, seafarers, loggers, and oilfield workers.

In the 1970s the range of expressive forms, occupational identities, and research questions was greatly expanded. Robert S. McCarl (1974) wrote about the art of contemporary production welders. Alan Dundes and Carl Pagter published *Work Hard and You Shall Be Rewarded: Urban Folklore from the Paperwork Empire* (1978), which concerned "Xeroxlore." At the Smithsonian Institution's "Working Americans" Festival in 1975 and 1976, 600 hours of stories and reminiscences were recorded from visitors representing varied industries and occupations. Michael J. Bell published "Tending Bar at Brown's: Occupational Role as Artistic Performance" (1976), Bruce Nickerson completed "Industrial Lore: A Study of an Urban Factory" (1976), and McCarl published "Smokejumper Initiation: Ritualized Communication in a Modern Occupation" (1976). In 1978 *Western Folklore* published a special issue on "Working Americans: Contemporary Approaches to Occupational Folklife," edited by Robert H. Byington, and Camilla Collins completed a dissertation about "Twenty-Four to the Dozen: Occupational Folklore in a Hosiery Mill" while Jack Santino finished one on "The Outlaw Emotions: Workers' Narratives from Three Contemporary Occupations." The next year Catherine Swanson and Philip Nusbaum edited a special issue of *Folklore Forum* on "Occupational Folklore and the Folklore of Working"; Patrick B. Mullen published *'I Heard the Old Fisherman Say': Folklore of the Texas Gulf Coast* (1979), and Beverly J. Stoeltje completed her dissertation, "Rodeo as Symbolic Performance" (1979).

The 1980s witnessed the publication of yet other books and articles on occupational folklore and folklife. Most of the research by folklorists, however, was carried out in isolation from an enormous body of literature in the fields of administration, management, and behavioral and organizational science. Folklorists' research on occupational folklife and workers' culture dwelt on lower-level employees, following an historical dichotomy between "workers" and "management," and tended to ignore the lore of managers or of the organization as a whole. More importantly, the concept "organization" escaped attention. Numerous studies by folklorists contained implications for developing the concept of organization and for understanding organizations, and they had ramifications for improving organizations. But these implications and ramifications were rarely made explicit. On the other hand, even as late as the end of the 1970s researchers in behavioral and organizational science who had begun writing about "myth," "symbols," and "ceremony" were unaware of folklorists' extensive research on occupational folklore since the turn of the century.

When I wrote the article below in 1979, I was just beginning to examine some of the management and organizational literature. I was struck by the increasing interest in the humanities and concern about a more humanistic orientation in the theory of organizations and administration. And I thought the concept

"organization" relevant to folklore studies. Therefore, it seemed to me that the fields of folklore studies and organizational and behavioral science possessed interests and concepts that could be mutually beneficial, achieving a greater understanding than heretofore of the organizational aspects of folklore and of the folklore in organizational settings. "A Feeling for Form, as Illustrated by People at Work" is an early statement of a theme I was to continue developing for several years.

* * *

"A well-turned investigation is something like a well-turned piece of furniture," remarked Sandra Sutherland, a private investigator in San Francisco. "There are cases where everything fits together beautifully," she said, continuing to use the analogy of art; "facts and procedures flow into logical conclusions." The result is "the elegant solution," as her husband, also a detective phrases it, "meaning a solution that cuts through chaos to utter simplicity." Such a case he calls the "perfect job," she added. For, she explained, "We're after ... not so much the truth but coherence." When asked what the perfect job would be from her point of view, Sutherland replied, "The chance to do a case where the only limitations would be the reach of your own creative abilities—no time or money considerations." Under such conditions, she implied, the ideal form of investigation—culminating in an elegant solution—might be attained more often. "The reality," however, she explained, "is you do the best you can with what you're allowed" (Lewis 1979:34).

Words and concepts essential to a study of art appear in the few statements above by Sandra Sutherland, a detective: beauty, elegance, perfection, and so on. Rarely, however are contemporary workers treated as artists or their activities examined as art by occupational researchers, including many folklorists. On the other hand, classic studies of folk and primitive art by Boas (1955), Grosse (1897),[1] Haddon (1895), and others do in fact concern labor, or rather the physical outputs of early industry and primitive technology. While focusing on the artistic quality and aesthetic-arousing effects of these objects, however, the authors do not develop some of their inferences about the nature of human beings *qua* workers or the relationship of art and aesthetics to work per se; certainly few readers today make the connections.

An essay on form and its perfection and appreciation in the context of working seems appropriate in a volume honoring the endeavors of Linda Dégh. She is well known for her insightful and influential study of the art of storytelling and storytellers. She has gained prominence for her efforts to discern and characterize the form of narratives, particularly the legend. She is noted for her research on the expressive behavior of immigrant workers in the New World. And she has been outspoken in her concern for the applica-

tion of inferences from folkloristic research to practical problems in contemporary society. Workers' dissatisfaction with their jobs looms large among these social issues. While several experts on labor relations have been making a plea for "job enrichment" and a "humanization of the workplace" (see, e.g., Fairchild 1974), Linda Dégh, as a folklorist committed to the study of expressive behavior, has recognized implicitly what many others have not: that through their folklore all workers express their humanity, and many attempt to maintain a sense of personal dignity in circumstances that often appear demeaning. What, then, is this "feeling for form" which is characteristic of human beings that Linda Dégh has been dealing with in her research, in what ways and for what reasons is it manifested in work, and what are some implications of this "art of work," especially in regard to notions about "management" and the designing of jobs?

The Aesthetic Impulse

"All human activities may assume forms that give them aesthetic values," writes Franz Boas. While a word or a cry or unrestrained movements and many products of industry seemingly have no immediate aesthetic appeal, he observes, "nevertheless, all of them may assume aesthetic values" (1955:9-10). What is required for an activity to have aesthetic value is that an individual be aware of and manipulate qualities appealing to the senses in a rhythmical and structured way so as to create a form ultimately serving as a standard by which its perfection (or beauty) is measured. Sometimes these forms elevate the mind above the indifferent emotional states of daily life because of meanings conveyed or past experiences associated with them, but they need not do so to be appreciated. Perfection of form is enough to satisfy; if the forms convey meaning, that adds to their enjoyment but it is not essential.

Boas supported his thesis with references to the myths, songs, tools, and implements of the Northwest Coast Indians of the late nineteenth century. Equally illustrative are some of the activities of contemporary workers in factories, plants, and offices. The cleaning of tuna by a young woman in Astoria, Oregon, for example, reveals the artistic impulse on its most basic level—absorption with the sensory experience of handling, manipulating, and transforming materials. As Starlein observed about her work, the fish she boned has special qualities, particularly the "soft colors. The reds and whites and purples." The dark meat, used for cat food, is "crumbly and moist like earth." Sometimes, enraptured by sensations and engrossed in fantasies, she does not notice the passage of time, and she violates instructions, holding back the cat food instead of placing it immediately on a conveyor belt. "I hold it out to make as big a pile of dark meat as I can," she said. She concluded her

remarks by admitting that she had been attracted to the plant by the pay. "I knew it would be dull and boring when I came here," she said. "But," she added, in apparent surprise at what she had discovered, "I had no idea of the sensuous things I would feel just from cleaning fish" (Garson 1975:23–24).

To quote Starlein is not to glorify her job or defend the conditions under which she works. Her comments demonstrate, though, that a feeling for form is present in, and sometimes transcends, adverse circumstances. Seemingly unexpectedly this feeling for form renders aesthetic appeal in even the most prosaic activity. Perhaps, it might be argued, this is necessarily so and in fact should be anticipated in other work situations, too, in which there are sensations that, however rudimentary the forms given them, affect people.

Like the touch, smell, and appearance of tuna, sounds and body movements are sensations; rhythmical repetition of them may be perceived as evincing form, and thus gratify for several reasons. Studies of, for instance, blacksmithing, singing sea shanties or chain gang songs, chanting cadence, and working on an assembly line suggest not only that rhythm is required to accomplish certain tasks but also that it is a fundamental feature of what is taken to be artistically pleasing (Vlach 1981:35–36; Hugill 1969:67–68; Lomax; Carey 1965; Walker and Guest 1952:41). Repetition establishes a pattern of efficient movement. It results in surface regularity and evenness on objects, and smoothness in action, expression, and demeanor. Repeated sounds and movements, comprising a recognizable form which may be pleasing in its own right, are the beginnings of (and sometimes epitomize) structure and order, and they are significant for this reason. "The opposite of work is not leisure or free time," write the authors of a landmark report on labor in America; "it is being victimized by some kind of disorder which, at its extreme, is chaos" (Work in America 1978:7). Essential to both art and working is the coherence that private investigator Sandra Sutherland found more satisfying in her job than truth itself.

But rhythm can lead to monotony. So while the body toils, the mind plays. "This'll sound crazy," admitted a keypuncher, "but I like to keep a certain rhythm . . . sound going," varying it in a form of complex syncopation. "I mean I'd move forward when the woman next to me was halfway through another field and then she'd move in when I was halfway through the next," she said. "So you'd get a constant—like, bum, bum, bum zing; bum, bum, bum babum, zing." She added, "Sometimes I had it going with three people, so we'd all be doing it exactly together. I don't think the others noticed it," she said. "We never planned it. I never mentioned it to the other girls," some of whom, however, later admitted to being racers and synchronizers (Garson 1975:155–56).

Other examples could be cited (McCarl, Meissner in Dubin 1976; Jones 1967a; Roy 1959–60; Polsky 1964), but suffice it to say that play, creativity,

artistic production, and aesthetic response are inherent in the work process, even or perhaps especially in situations characterized largely by "surface mental attention" (Whyte 1961:179). Boas attributed this striving to perfect form to two factors, the first of which is a feeling for form and the second of which is a capacity to master technique (1955:58, 62). He did not elaborate on either pronouncement. Nor did he go on to suggest such other factors as an ability, and indeed a basic need, to have an aesthetic experience and the insistence of play.

A feeling for form is fundamental to human beings. Despite an adversity of circumstances, this feeling for form persists as both a source and a product of our humanity. A striving to achieve perfection of form and an appreciation of formal excellence is essential to this sensibility. Although this feeling for form admirably serves the purposes of expediency and practicality, it is not reducible to anything else, including "survival." It is a fundamental quality of the species. But recognizing its existence in themselves and others, human beings tend to rely on it as a means of functioning in day-to-day existence. They are aware that because of this feeling for form—and their ability to achieve formal excellence—they are enabled to transcend emotional indifference and both find and express meaning in their lives. Consequently, they sometimes feel remorse when their activities, or they themselves, are lacking in form, or when the formal excellence they have achieved goes unnoticed or unappreciated. The implications for understanding worker dissatisfaction with their jobs are enormous.

Creating Customs

Frequent worker turnover, extensive absenteeism, threats of slow downs, and acts of sabotage have long plagued American industry, despite gains made by labor unions on behalf of workers collectively. Automobile factories, where some of the highest wages are paid, seem to suffer the most worker dissatisfaction. Perhaps it is no mere coincidence, then, that it is on the line in these plants where the possibilities for creativity and play, and the chances to extend activities into forms with aesthetic appeal, are least likely to occur. Nevertheless, some of the men at the Vega plant in Lordstown, Ohio, overcame obstacles to the expression of their humanity, although ultimately they were opposed by both union and management. The workers invented and implemented an alternative system, redesigning assembly-line methods in such a way that they were both permitted and encouraged by conditions they developed for themselves to perfect form in their assigned tasks on the line.

"Now what happens is that the guys who have their operations side by side, they're relating together," explained Dennis McGee, who works first

shift in the Vega plant. "In other words, they all worked in the same area. They started saying 'Go ahead, take off.' It started like an E break—you asked for emergency bathroom call," he noted. One worker would tell the other, "'Go ahead, man, I think I can handle it,'" said McGee. "I'd run to the front of the car and I'd stick in the ring we used to have, and I'd run to the back then. I mean, I'm not running, really running, but I'm moving," he said. "I put the gas in, I go up to the front of the car again . . . go back again. I'm getting it done, and I'm not having any recovery time. I'm going right back again," said McGee.

Having originated informally, the procedure became increasingly formalized until a clear pattern emerged. Relay teams evolved in which two men would do their job as well as that of two others—for half an hour, and then the other two would perform their own operations and the first team's, who, in turn, rested for 30 minutes. Although the men had been doing this for three or four years, officials of the International UAW denied its existence, apparently unable to cope with it in terms of structures already formulated; the union was quick to point out that it could lead to exploitation by the company. Company representatives opposed "doubling up," and intervened to prevent it, arguing that quality would necessarily diminish.

Joe Alfona and other workers insisted that quality improved. The two people not working the job usually were present so if a problem developed they could attend to it. The audit tickets, claimed Alfona, proved that with doubling up fewer repairs had to be made later. "You get 100% perfect," he said. "Because we don't want no problems, you know what I mean? We're doing a good job."

Public knowledge of these new procedures was slow in coming. A journalist named Bennett Kreman was on hand in the fall of 1973, investigating the threat of a strike which would dwarf the explosive conflict in March of the previous year. Five thousand grievances had been lodged in six months. Only after observing and interviewing for a week was Kreman able to clarify issues, principal among which was the unique one of doubling up, or what Robert Dickerson, committeeman for the local, called an "antidehumanization team."

Speaking for himself and other workers, Dave McGarvey said, "you have to double up and break the boredom to get an immediate feedback from your job, because the only gratification you get is a paycheck once a week, and that's too long to go." Although several men mentioned relief from boredom, the complaint seems to have been more precisely the lack of challenge to their intellect and, as McGarvey implies, not having a sense of accomplishment once the job is learned: a form, the only one permitted to be produced, is repeated over and over again. Trying to work eight hours a day at a single, routine task, without simultaneously playing—for that is essentially what creativity requires—is numbing. As Dennis Lawrence, who works in the body

shop observed, having learned a job, a man "no longer pays attention to what he's doing because it's automatic—bang, bang, bang." On the other hand, when "you're doubling up, you've got the responsibility for two jobs," he said. "You've got to keep your mind working at all times."

Stimulation is necessary in order to perform, yet it cannot be long sustained. Doubling up provides a solution. It offers a way, said McGee, "for me to shuck and jive—all day long, have a good time, help each other and get out the work." Added Alfona, "You have no social life," because of the long hours at the plant. "The only social life you have is in that plant, and if you're stuck on that line all the time—nothing!" However, he said, "If you can get that break where you can go down and rap to your buddy or make a phone call to some chick, it's different."

Alfona summarized his feelings and articulated them to others in the form of an analogy. He asked people to imagine that one of them and a friend have a job paying four dollars an hour. "I bring it down to very easy words so the average man can understand," he said. "So anyway," he continued, "You're going to get paid four dollars an hour to each carry a package up the steps and down. Well, isn't it a little easier for you to break your back and carry two packages up and down for half an hour and your buddy resting," he asked, "and then let him take over and you rest your back? If you want to go get your drink of water or go call your chick, you got the simple freedom to go, see?" (Kreman 1973).

It should come as no surprise, then, given the opposition to team relays, that tensions smoldered at the Vega plant. From his point of view, the man on the line—"the working man himself, the assembler himself," repeated McGee proudly—had devised a system constituting an elegant solution to the much-publicized but unsatisfactorily resolved problem of dehumanizing assembly-line work. Doubling up seemed to make everything fit together beautifully: the assembler was challenged in his work, he generated his own rhythm, he was encouraged to perfect form in his assigned task, he had the time after doing so to relish the achievement, and he could socialize as well. The form ultimately created was a sense of personal wholeness, the feeling of being fully human with the rights and privileges along with the responsibilities of other human beings. Even when prohibited from doubling up, the men refused to abandon the method, continuing by subterfuge to carry it out in modified form. "Even if they say don't double up, what you do—it's not as good as doubling up the way we normally do it—but we'll hang on the car and we'll stand there while the other guy does it," admitted McGarvey. "And the minute somebody comes round, we'll just put our hand in the car," giving the impression that they are performing according to company dictates.

Working and Playing

These examples of a feeling for form in the work situation insinuate that many longstanding assumptions must be reassessed. Principal among these is the notion of work. The head of a prestigious group of management consulting companies, who achieved fame for developing a system to monitor the productivity of workers, recently bemoaned the fact that 45% of the working day is spent "doing nothing" (Pope 1979). Much of this time obviously is devoted to gossiping at the water cooler, betting on sports events, fantasizing and engaging in mental exercises, joking, and so on—what one student of labor passingly refers to as the "seemingly trivial events" in a "humdrum context" from which individuals apparently are capable of extracting "surprisingly rich meanings" (Strauss in Fairfield 1974:35), and what folklorists should recognize immediately as play and creativity which are crucial to day-to-day existence. Unfortunately, however, the words "work" and "play" are usually conceived of as antonyms; job and recreation are segregated; laborers and players operate in different domains. "Creativity" is vaguely distinguished from and also related to both work and play: to create is a serious endeavor, demanding purposive effort; it is likewise somehow often amusing, seemingly separated from reality, and nonproductive. Yet some people work at playing and others play at working, and still more create work as some work to create. In fact, then, the three phenomena are not isolated from the continuum of human experience or from one another. For creativity insists on exertion and the expenditure of energy to accomplish something, as well as an intellectual distancing to transform drudgery into pleasure. Play is never truly formless, an achievement requiring some degree of purposive effort in the name, ostensibly, of diversion. And although work demands purposive effort, it is also creative in that something is brought into being and invested with a new form.

The interrelationships of work, play, and artistic creativity were known to early investigators, among them Ernst Grosse, who, like Boas, viewed much of primitive industry as the production of works deserving the name art. But Grosse went further in his book *The Beginnings of Art,* equating art and play, for he writes that the artistic tendency of primitive people "is substantially identical with the play impulse" (1897:308). By extension, then, it might be suggested that working for most people is an artistically creative endeavor—there is rhythm and skill and structure or order and the perfection of form—which also partakes of and demands play when rhythm becomes monotonous, structure routine, and form repetitive, so as to create new forms.

Humanistic Management

At about the time that Boas commenced his observations of primitive artists, and that Grosse was examining museum specimens of early industry, Frederick W. Taylor began to lecture, read papers, and publish essays on the nature of work in what was then modern industrial settings. Like Boas and Grosse, he was familiar with the craft tradition. For Taylor had rebelled against his wealthy family in Philadelphia, rejecting his father's plans for him to study law at Harvard, and had begun instead an apprenticeship as both patternmaker and machinist to become a common laborer. Within a few years he had been promoted to management status, after which he turned on his former colleagues, as if they were adversaries, in his zeal to extract the greatest amount of productivity for the company, being more committed than his own employers to the goal of increased production. (An obsessive-compulsive individual, Taylor is reputed to have timed his various activities, counted his steps, and analyzed his motions—from his childhood on—in an effort to increase efficiency.) But it was "Taylorism," as set forth in *The Principles of Scientific Management* (1911) and other publications, that had a tremendous impact on American business and industry and that continues to be, according to management consultant Peter F. Drucker (1954:280), industrial sociologist William Foote Whyte (1961:7), and others (e.g., Braverman 1974:87–89), a vital force in modern corporations and other institutions.

 Although the workers-artists studied by Boas and Grosse both conceptualized and constructed a whole object, and many of Taylor's fellows were master craftsmen knowledgeable about the complete process of production, Taylor sought to segment the process of labor. He dissociated that process of work from the skills of workers, separated conception of the product from its execution and concentrated a monopoly of knowledge in those who were construed to be representatives of the company. Taylor's purpose was to wrest control of the labor process from the men in the shop—the "laborers" who were, in Taylor's view, highly individualistic without ties to others, motivated largely by self-interest and money—and to place it in the hands of another group of people—"management"—who presumably would have in mind the company's best interest, that is, the greatest productivity and therefore wealth of the organization. One of the methods that Taylor stressed was that of piece rate payments, basing a worker's pay on the amount produced. Another was specialization. Being confined to one task or to a few simple tasks, the laborer would develop much greater speed than if the tasks were many and varied. A third was standardization. Since, in Taylor's view, there was only one correct or best way to do something, then an industrial engineer should design this operation, the laborer should be instructed in it,

and someone else should supervise the job to ensure that it was done in the prescribed way and that variations were not introduced. Managerial control and discipline required placing jobs within a structure of authority, hence the hierarchical form of organization so common today.

While Taylor did not invent any of these methods and principles or singlehandedly revolutionize the organization of industry, he did, it is widely recognized, assemble and give coherence to ideas prevalent during his day. By articulating a philosophy and giving it a name—"scientific management"—Taylor seemingly created a whole form that was pleasing in its utter simplicity. But a history of factory slow downs, walk outs, shut downs, and sabotage, and the continued complaints about "dehumanization" of the workplace, reveals that there were major flaws in the conceptual foundations of Taylorism. Various attempts to shore up the structure—made by the several schools of industrial psychology and human relations—have not gotten at the fundamental problem. It is now time to suggest a serious reexamination and reassessment of the philosophy, principles, and methods inspiring the organization and functioning of modern corporations, drawing on the studies of early industry by such investigators as Boas and Grosse. For it is the inferences and hypotheses of these researchers that could add the missing human element, and provide the basis for developing a perspective and set of principles involving humanism, which seems to be so greatly needed today.

Recent years have witnessed a growing "social consciousness" in industry and the extension of corporate responsibility to consumer and environmental protection, an insistence on the redesign of work, and a challenge to the philosophy and practice of management (Braverman 1974:85–121; Whyte 1961:6–7). Significantly, one of the critics of management is not only a consultant to industry but also a humanist with a background in religious studies. Philip W. Shay has called into question the mechanistic view of management pervasive in modern corporations, contending that a new discipline of management should be established, "as a practical art with scientific overtones," growing out of a reexamination of basic management concepts using behavioral research as a guide. "Management can cull new ideas from many fields of knowledge, disciplines, and tools and techniques to help focus on a broad horizon," writes Shay. Though he did not do so, Shay could have mentioned studies of folklore and of traditional art and industry as sources of new ideas. Achieving his goal of having organizations "designed for people as they really are, not as classic theorists would have them" requires such sources of information and insight, for it is in their folklore that human beings express, reveal, and maintain their humanity (Shay 1977:19). Exactly what this new discipline of management should be is not quite clear in the writings of Shay and others, but given the increased concern with corporate responsi-

bility in the social sphere, it seems reasonable to suppose that the tools and techniques for running an enterprise will have to be governed by humanistic principles.

To be instituted, this "Management by Humanism," as I think it should be called, requires two significant changes, one in attitude and the other in the data base on which concepts and assumptions are founded. While the complexity of modern business demands some division of labor and a degree of specialization and standardization, it does not compel assembly-line procedures with a nonhuman tempo, a pyramidal structure of authority, or an adversary relationship between "labor" and "management." Innovative and far-reaching experiments at Volvo plants in Sweden have demonstrated this. "We started with the idea that perhaps people could do a better job if the product stood still and they could work on it, concentrating on their work, rather than running after it and worrying that it would get beyond them," writes Pehr Gyllenhammar, president of Volvo. "We decided ... to bring people together by replacing the mechanical line with human work groups," he adds. "In this pattern, employees can act in cooperation, discussing more, deciding among themselves how to organize the work—and, as a result, doing much more" (Gyllenhammar 1977:13, 14). The change in attitude would incorporate what Barbara Garson discovered in her interviews with and observations of a large number of individuals: *"People passionately want to work"* (author's emphasis), she writes, and further, "I realize now ... that work is a human need following right after the need for food and the need for love" (Garson 1975:xi, xiii). It would recognize the art of work, acknowledging that working is a creative endeavor involving a degree of play. This change in attitude might be facilitated—and would certainly be reinforced—by an expanded data base, one that includes folklore and folk technology in the workplace, past and present. For what the president of Volvo came to realize was already being demonstrated on the line in the Vega plant in Lordstown—laborers themselves had evolved a technique, as folklore, seemingly more in keeping with human needs and capabilities than that which had been engineered and thrust upon them. (How easily it is forgotten that workers also manage, just as managers work. And how often it is ignored that there are useful antecedents for management in early industry and important analogues in everyday life.)

Conclusions

Just as Boas had to defend the proposition that primitive industry resulted in products worthy of the name art, so too does it seem necessary to demonstrate that contemporary industry has its art and artists. For it is usually supposed (sometimes with good reason) that the present workplace is

barren of the conditions necessary for art to flourish. It must be stressed that individuals should be recognized and treated as such, and not submerged in the undifferentiated mass of the "labor force" or conceived of as merely a "factor in production." They need a degree of control over the product and some responsibility for its design; instead, many merely carry out others' instructions for reassembling a small part of the whole product. They must have freedom from constraints, but in fact even physical movement as well as communication and interaction—like imagination—are often curtailed. For an individual to be creative, it is generally assumed, the work should be challenging, not routine and stultifying. Little wonder, then, that few students of work employ the framework of art and aesthetics in their research or notice the more subtle attempts of workers to develop and elaborate their tasks into forms having aesthetic value.

It is precisely this perspective emphasizing the art of work that is needed both to understand the nature of homo faber and to improve the very conditions as well as goods and services whose quality is so often deplored. At present, most people whose labor is simplified, specialized, and standardized must content themselves with subtle (some might be tempted to say "pathetic") attempts to develop and elaborate tasks into forms having aesthetic value crucial to their sense of self-worth and well-being. Some of them, of course, dream of independence, usually epitomized by being self-employed like private investigator Sandra Sutherland. Less than 10% of the American population is self-employed, however, and as Sutherland pointed out there are constraints on her creativity, too. The reality for most people, as Sutherland noted in regard to herself, is that they must do the best they can with what they are allowed. But it seems reasonable to assume that if we are allowed to do more, we will accomplish more. For all of us are human beings having a feeling for form, as a condition of our being human, which is insistent and compelling, often having its fullest and finest expression as art and play in situations not of labor and toil but working in a broader sense—one in which we find some degree of personal fulfillment rather than drudgery.

Notes

1. While folklorists have always been attracted to the artistic dimension of much of folklore, and while much of the folklore collected has been from workers and in some way related to work, few of them have examined the nature of workers as artists or considered the art of work. Two exceptions are Robert S. McCarl, Jr., (1974) and Michael J. Bell (1976). For someone who is truly conscious of, and seeks to exploit, herself as artist in an occupational role, see the comments of Dolores Dante quoted by Louis [Studs] Terkel in *Working* (1975:389–95).

8

Aesthetics at Work: Art and Ambience in an Organization

A two-day conference on organizational symbolism was held at the University of Illinois in May of 1979. Eleven papers were given on humor in a machine shop, symbolic behavior in organizations, belief systems, meaning creation, and so forth. A few months later, a national conference on workers' culture was held. Sponsored by The University of Michigan and Wayne State University, this conference concerned a review and evaluation of research on workers' lore, the concepts of class and subculture, stereotypes of workers, and the lore of specific occupational groups. Organization theorists dominated the first conference and folklorists the second. Apparently, participants in one did not know about the other.

Paralleling the many dissertations and articles on occupational folklife in the late 1970s were numerous articles in organization studies on organizational stories, symbols at work and organizational cultures. At the beginning of this decade, Dandridge, Mitroff, and Joyce published an article entitled "Organizational Symbolism: A Topic to Expand Organizational Analysis" (1980). In retrospect, it must be seen as a seminal essay introducing organization specialists to expressive forms and research questions similar to those dealt with by folklorists (without, however, citing the works of folklorists or using the word "folklore"). The authors' list of "types of symbols," for example, brings to mind one of the textbooks in folklore studies, Jan Harold Brunvand's *The Study of American Folklore: An Introduction* (1986). For Dandridge, Mitroff, and Joyce identify "verbal symbols" (myth, legends, stories, slogans, creeds, jokes, rumors, names) similar to Brunvand's category of "verbal folklore"; "actions" (ritualistic special acts, parties, rites of passage, meals, breaks, starting the day) not unlike Brunvand's section "partly verbal folklore"; and "material symbols" (status symbols, awards, company badges, pins) analogous to Brunvand's "non-verbal folklore."

Notable, too, is that the research problems the authors discuss overlap those in folklore studies. "Questions arise," they write, "as to the origin of stories, how they reflect the present organization, and how they participate in subsequent growth or stabilization." Are there industry-wide "symbols," they ask; are certain individuals

This article has been written exclusively for this anthology.

more influential in initiating or modifying them; what happens to these forms of expressive behavior during organizational change; what are the effects of an organization's "symbol system" on the social environment, and vice versa? Although research was carried out separately, with representatives of the two fields seemingly unaware of each other's existence during the 1970s, it is apparent in hindsight that folklore studies and organization studies are frequently complementary.

In March of 1983, the UCLA Center for the Study of Comparative Folklore and Mythology and the Behavioral and Organizational Science Group cosponsored the conference Myth, Symbols & Folklore: Expanding the Analysis of Organizations. Partly funded by the L. J. and Mary C. Skaggs Foundation and the National Endowment for the Humanities, and directed by David M. Boje in Behavioral and Organization Science, Bruce S. Giuliano, President of Ponte Trading Company, and me, this symposium was the first to bring together folklorists, scholars in organization and management studies, and practitioners. Objectives included communicating recent findings in folklore studies and organizational science, encouraging joint research between the fields, and developing transdisciplinary methods based on the humanities. During the following year and a half, there were four more conferences.

Since the terms "corporate culture," "organizational symbolism," and "organizational folklore" began to be used with increasing regularity and frequency after 1980, numerous papers have been given on the subject at the annual meetings of the American Folklore Society, the Academy of Management, the California Folklore Society, the Western Academy of Management, the Organiza-tion Development Network, the Speech Communication Association, the Interna-tional Communication Association, and the American Anthropological Association. Articles on the cultural and expressive dimensions of organizational life have been published in management, folklore, and speech journals, or in anthologies. Among the publications are Terrence E. Deal and Allan A. Kennedy, *Corporate Cultures: The Rites and Rituals of Corporate Life* (1982); *Organizational Symbolism,* edited by Louis R. Pondy et al. (1982); "Organizational Culture," a special issue of *Administrative Science Quarterly,* edited by Mariann Jelinek et al. (1983); *Lead-ership and Organizational Culture: New Perspectives on Administrative Theory and Practice* (Urbana: University of Illinois Press, 1984), edited by Thomas J. Ser-giovanni and John E. Corbally; *Gaining Control of the Corporate Culture,* edited by Ralph H. Kilmann et al. (1985); *Organizational Culture and Leadership: A Dynamic View,* by Edgar H. Schein (1985); and *Organizational Culture,* edited by Peter J. Frost et al. (1985).

In 1983, after serving as the principal organizer of the organizational folklore conference, I gave a paper in Vancouver at the XIth International Congress of Anthropological and Ethnological Sciences called "Directions in Research on Organizational Folklore." Three months later, I organized and took part in a session of papers at the Organization Development Network meeting on "Dealing with Symbolic Expressions in Organizations." The following year I was cochair of a session of papers at the American Folklore Society meeting called "Research and

Management of Organizational Cultures" as well as of a panel titled "Human Resources and Folklorists: Ways of Working Together."

The essay below grew out of several works. The first half of the article concerns the traditions and ambience in one of many units at UCLA being studied as part of a project on organizational folklore. The section that treats the concepts of organization and organizing incorporates some of the ideas in a paper that I gave at the American Folklore Society meeting in 1985 called "On 'Informal Organization': Folklore in the Writings of Chester I. Barnard (1938), CEO of New Jersey Bell Telephone Company." The last section on organizational folklore studies was developed from notes for an introduction to a session of papers exploring the concept of organization in folklore. The present article is intended to define terms and clarify some concepts as well as illustrate one way in which the subject of organizational folklore can be studied—with an emphasis on aesthetic matters.

* * *

"I joke about this being my second home," remarked one person. "It's the only place on campus where you get positive feedback," said another; "it's a good feeling." Said a third person: "Everyone respects you and your opinion. They treat you like a person."

They were commenting on their work experiences in one unit of the university, the Academic Resources Center Math-Sciences Tutorials. The formal organization includes a director, a coordinator, three half-time student supervisors, and nearly three dozen tutors, each of whom meets with 40 to 45 students once a week for a total of nine times during the academic quarter. It is one of many units being studied in a project documenting and analyzing organizational traditions, management practices, and the aesthetic aspects of work life.[1]

Some other statements from employees in this unit expressing their attitudes and perceptions are the following:

> "You have freedom in conducting your sessions; you can experiment. It's *your* work, not what someone tells you to do. You feel creative."

> "There's a sense of bonding."

> "People hang around after work; they talk to one another."

> "This is a home base."

> "You feel like you are someone."

> "People feel protective of one another; they don't want to see anyone get hurt."

> "People spontaneously do things for one another."

"A lot of things happen that bring us closer together."

"You can see a sense of unity."

"I feel that what I am doing is important. This is a home base. I value the friendships I have made. I have a sense of self-esteem."

"You have a sense of pride in your work."

Many of these remarks evince aesthetic concerns, that is, the perception of and response to form. Multiple and varied, these forms include the atmosphere or ambience of the unit, the type of management and supervision, the interpersonal relationships that develop, customs and traditions, spontaneous events and occurrences, and the tutors' own work. Because they have been given aesthetic value, these human activities and creations warrant study in any exploration of "art." Moreover, the pleasant social and sensory experiences of members largely result from, as well as tend to lead to, the generation of "traditions" in the organization.

According to the tutors, the director (Bill McGuire) and the coordinator (Valerie Eichel) "promote that kind of atmosphere," i.e., one in which the tutors feel they are supported and encouraged to be creative. Several questions arise. How do the director and coordinator perceive the unit and their roles as supervisors? If we consider management, like any other human activity, to be given aesthetic values (that is, to be an "art"), then what "forms" do the director and coordinator create; and how and why? What traditions are generated in the unit and among whom, how do they evolve, what meanings are attributed to them, and what effects do they have on participants?

Creativity and Community in an Organization

In what follows I give a brief overview of a few of the traditions in this unit, the attitudes of administrative personnel, and ways in which the administrators communicate their values to others. This is not intended to be a complete ethnography; rather, it is an introduction to several issues in the study of occupational folklife and organizational folklore.

Traditions

As one looks around the office of Valerie Eichel, the coordinator, one sees many objects that document traditions, play a central role in traditions, or are the product and symbol of a complex of traditions. On a wall to the left, for example, are nine mounted and framed enlargements of photographs of an end-of-the-year party, a softball team, participants in a Halloween party the

year before, and other activities involving the tutors, supervisors, and administrators. On a nearby table is a stack of more framed photos, ready to be hung on the wall, documenting different customs and celebrations; there is also a photo album. On the opposite wall is a map with pins in it (marking the present locations of former tutors), which is surrounded by post cards sent by current tutors on their travels or by former tutors from their present locales. On the walls and tops of tables, filing cabinets, and bookcases are mementos including gifts and cards from the tutors to the coordinator and also a makeshift trophy that the unit won by defeating another unit at softball. On the coordinator's desk is a candy dish; during a visit to her office one sees many tutors dropping by, some of whom take a piece of candy. Also on her desk and on tables are photocopied puzzles and games to give to the tutors, announcements of special events such as "secret pals" and "the name game," and a manual. The manual consists of 130 to 150 loose-leaf pages in a red three-ring binder; nearly every page contains one or more cartoons, epigrams patterned after "Murphy's Law," and puzzles and games along with, of course, instructions for tutoring students, filling out time sheets, and so forth.

In the office next door, occupied by three supervisors who are second-year tutors, there are mounted on one wall Polaroid snapshots of all the tutors. Each desk area is highly personalized with plants, post cards, and memorabilia. The supervisors decorate the office each holiday, combining materials accumulated by the director and the coordinator with items of their own.

There are many traditions in the unit occurring in the suite—as well as traditions generated in tutorial sessions and among networks of individuals when they are away from the suite—that are not documented or that do not have permanent objects serving as testaments to their existence. Among these are games, joking and bantering, the custom of everyone calling everyone else (including the administrators) by their first name, spontaneous food sharing, parties, and ad hoc celebrations. All the traditions occurring in the suite originated spontaneously. Some were suggested or initiated by one or more tutors, supervisors, or administrators, or by a combination of personnel. Some, many, most, or all the people in the unit participate in one or another tradition. Some traditions in the unit have been perpetuated from quarter to quarter or year to year while others are unique to a particular time and set of circumstances; even if repeated on other occasions, the activities always differ in some ways. What remains constant, however, is a certain feeling and a set of values pervading the unit out of which the traditions grow, and also a process of feedback and response affecting these activities.

Consider Halloween. Three years ago the coordinator began making a costume, which she intended to wear as a surprise. Just before Halloween, however, one of the tutors said he thought the staff should dress in costume;

the coordinator suggested he organize this. On hearing about the costuming, another tutor urged that there be a prize; the coordinator concurred, and proposed that this tutor be in charge. A third tutor thought a party with refreshments was in order; the coordinator agreed, asking this person to be responsible. The coordinator then prepared a colored flyer identifying the three tutors with their suggestions; the flyer noted that the director was not aware of the proposed activities and asked that he not be told so that it would be a surprise. The coordinator showed up in costume, which no one had expected. The director and some tutors took individual and group photos. The second and third years new tutors saw photos of and heard about previous events (which included the coordinator dressed in a blue Martian suit the first year and in mouse costume the second). Now some of the tutors carve jack-o-lanterns; the supervisors decorate their office with cobwebs, fake spiders, and other things appropriate to the occasion; and virtually all the tutors wear a costume (often, like the coordinator, of their own making).

Because several people were taking photos of special events, and they and others enjoyed looking at them, the coordinator left a stack of prints on a table near the door of her office. Eventually she put them in an album to protect them from frequent handling (and she enlarged others to put on the wall). People look at the photos after an event, of course. Some tutors examine photos before Halloween to see how people have dressed in prior years. If they are waiting for students to tutor or seemingly have nothing else to do, tutors come into the coordinator's office to look at the album. Beginning to feel melancholy toward the end of the year, some of the graduating seniors dwell on the photos. Former students who have returned for a visit also tend to look through the album or at the photos on the wall.

The map on the opposite wall contains pins that mark where former tutors are in graduate or professional school. The coordinator had been keeping a list of the whereabouts of former tutors. "And I was having a conversation with somebody that any tutor could travel across the country by making a chain of extutors and almost not have to pay for a single hotel room." The source of the idea for a map is now forgotten; all that the coordinator recalls is that the director and she began looking for and finally found a wall map large enough to clearly identify cities in the United States.

"I didn't realize the impact that this had [or would have] on the tutors," said the coordinator. "I don't tell them what it is. I wait for them to come in and ask," she said. "They ask, 'Is this all the places you've been to?' and I say, 'No.' 'All the places you have relatives?' And I say, 'Sort of *extended family.*'" Eventually the tutors learn that the cities marked with pins are where the extutors now are. "They'll come in and they'll say, 'I'm going to go to graduate school *here.'* And I say to them, 'Well, you show me a letter of acceptance and then you'll get your pin.'"

Thus, a cluster of traditions has been generated around the map. Installed initially by the coordinator and director as a way of keeping track of former tutors but perhaps also as a statement of pride in their extutors (several times I was told that there is a 100% rate of placing former tutors in graduate or professional schools or in their "dream jobs"), the map has become a symbol to current tutors. It pleases them to know they will be remembered after leaving. Judging from their comments, the map gives at least some of them personal objectives and motivation to achieve them. "It surprised me that having a pin on the map is a very important thing," said the coordinator. One tutor recently announced that he intends to go to medical school at Harvard; his will be the first pin in Boston, he observed proudly. Others remark on where they aspire to go, and ask about who is represented by different pins in various places. The post cards taped to the left and below the map, sent by present tutors on vacation or by former tutors who have relocated, further communicate a family or community feeling.

The softball team came into being because of this feeling. Having gotten to know one another through other activities in the unit, many of the tutors have become fast friends. They want to do things together. Spontaneously several of them organized a softball team (and more recently a football team) in February. Too late to be a scheduled part of intramural sports, the softball team nevertheless found another unit to play. Several tutors organized refreshments. The director and coordinator attended the game. The tutors' team won. Members of the other team were chagrined at losing; but more, they were distressed that none of the supervisors or administrators from their unit had attended, which suggested to them a lack of concern or support.

Some activities have become more formalized, and are planned and scheduled by the administrators because of their value in stimulating communication and promoting interaction. On the second day of training in the fall, for example, the coordinator and director insist that the tutors take part in a Guest-Host custom, which requires them to get to know all of the staff from the start. "I put everybody's name on a piece of paper and have them draw a name out of a paper bag. They are responsible for that person the entire rest of the day," said the coordinator. There is a potluck lunch on the second day, for which the tutors provide lunch. Individuals from outside the unit who affect or are affected by the unit (e.g., higher-level administrators, people from the Office of Residential Life, and so on) are invited guests.

The coordinator also has initiated a Secret Pals activity once a year, an idea she got from a teacher-friend who called it Secret Santa. Each tutor is assigned to another person for whom he or she must do things "to improve the quality of that person's day every day for a week without getting 'caught,'" that is, without his or her identity becoming known. The Name Game is another activity instituted by the coordinator and director. They note things

that tutors tell them about their backgrounds and experiences. Eventually they compile a questionnaire several pages in length. Each item describes a tutor. Tutors must fill in blanks without querying one another directly. The tutor who correctly completes the most blanks receives as a prize one "unquestioned mistake" redeemable at any time. Stories are told about tutors who did not recognize descriptions of themselves, about some who made major mistakes later but redeemed their coupons without reprisals, and about tutors who were surprised that anyone had actually listened to them and cared about who they are and what they have done.

Why do the coordinator and director initiate some of these activities and participate in and encourage others in the suite? The answer lies in what they value, have experienced, take pleasure in, and assume to be the nature and purpose of organizing.

Administrative Values and Concerns

The principal value is that of the social and intellectual growth and the well-being of people. The coordinator and director express this value in their behavior, demeanor, and words, and both in formal, structural ways and informally and spontaneously. This value has been influenced by their own organizational experiences (and undoubtedly other factors as well). It is reinforced by events in the suite and by what the tutors accomplish and achieve.

"Where much of this came from," said the coordinator, "was a number of years ago I was in charge of a program the goal of which was to assist freshmen and transfer students in their adjustment to the university." She was discussing with a counselor the problems of students. "One of the comments she made to me was that the biggest complaint or misgiving many students had about their education is that they had been at UCLA for four or five years and had never made a single new friend." Their networks consisted of a few people with whom they had attended high school. "And what happened was that in four or five years here they had not grown in any substantial way in terms of their involvement with new people. I think that's a really sad thing, because this is a community of 70,000 people."

The organization of the tutorial program only aggravated this. "The tutors make their own schedule, they work with their own students, they come and go as they please and they really don't have any structured, formal reasons for interacting with other tutors. They can come in and do their job without so much as a 'hello' to other people. That's pretty much what was going on when I took this job."

She continued: "Here was a group of 30 to 40 upper division and graduate students working in a fairly confined space, and many of them didn't

know each other. I set as one of my goals to make sure that that ceased. And now every tutor knows every other tutor at least enough to say 'hello' and call them by name. Minimally. As it turns out, they have developed an incredible support system for each other."

This concern about friendships and support had a basis in personal experience earlier when the coordinator was in college. In her second semester at college, she was paired with a roommate whom she found intolerable. Her complaints fell on deaf ears. "Everyone else said, 'Do the best you can.' The dean of students didn't care. Nobody cared." After weeks of anguish, the only remedy for which seemed to be to leave school, a house mother "took pity on the situation," said the coordinator. "I think that had a significant impact on the way I deal with students, because I know what it's like to start out badly, on the wrong foot. I think that's why many of the horror stories I hear are very real to me—I've lived it."

The coordinator began working in the unit half a dozen years ago on a part-time basis shortly after the current director was appointed. Three years ago, after earning her Ph.D. in kinesiology, Valerie Eichel became a full-time employee. She views her role as "helping people go in directions they might not see by themselves." To illustrate, she told me about a former tutor who had visited the unit recently and described a difficult job interview that he had just been through (successfully). Her comments to him emphasized the fact that his experiences as a tutor had given him the opportunity to "see yourself as others see you; you are constantly being put on the spot by students. So you have a great deal of training that most undergraduates don't have in terms of extemporaneous speaking" as well as confidence in himself and his abilities.

"The whole point of the story," said the coordinator, "is that [the director] and I see each person who works in the unit as unique and as having distinct talents. Granted, there are certain aspects of the job that are required and there's a necessity to have it done a certain way across individuals"; hence, formal rules and procedures, particularly record keeping. "But there are other aspects of the job where people can develop who it is that they are. I see what we do as helping them develop whatever the potential talents are that they have."

Much of what is emphasized is self-confidence and self-esteem. Tutors remark on the feedback and support they get from one another and from the coordinator and director. They comment on the friendships they have made with one another and with students they tutor, and about some of the spontaneous activities that grow out of and express a sense of camaraderie. Many speak of the unit as their "second home" or as "home base." They mention their freedom to create and experiment in their tutorials with students, and the pride they feel in their work. They note the pervasiveness of

laughter in the unit and in tutorial sessions, including being able to laugh at themselves. Over and over again they refer to the "confidence" they have in themselves and one another, to having "changed as a person," to being "more outgoing," and to being "respected" by students, fellow tutors, and administrators. They tell stories about how this tutor or that one seemed to be "transformed." They mention that a high-level administrator speaks to them at the beginning of the year, impressed that he cares about them and what they are doing. They speak of the coordinator's openness and of the enormous amount of time and effort she devotes to helping them prepare applications for admission to graduate school and writing letters of recommendation.

"I usually point out to them, 'How many people do you think have had a job like this as an undergraduate?'" said the coordinator. "And then I ask them, 'How many people do you tutor a quarter?' They'll say to me (hypothetically, if they're working half time), '40.' 'Okay, 40 people. You've been here five quarters; do you realize you've touched the lives of 200 people with this job?' And I get the same reaction each time: 'Wowww, I never thought about it that way.' When they start to realize those things about themselves, they begin to walk into new situations with a little more confidence."

The coordinator continued: "Being very bright, they tend to hide that from people, because it's not a trait that's always rewarded—especially by the people they're competing with. Here they're allowed to shine. 'It's okay to be a high achiever.' That may be something they're not getting from anywhere else. They're getting a lot of real positive messages from a lot of different sectors [here]. They get it from [the director] and me, they get it from their students. The other place they're getting it is in the training; we have [the higher level administrator] come here and talk to them. . . . We're talking about an administrator from Murphy Hall, one of the people you hear about, whose name you might know, who you occasionally see written about in *The Bruin,* who is actually there in real personhood standing in front of them, talking to them. Every year without fail several of the tutors will come over to me to tell me how special they felt because this person took his time to spend with them. They don't get that elsewhere in the university."

A guiding principle of the unit is that of, in the words of Bill McGuire, the director, "a value of the importance of people." Having been in organizations where this principle was not always dominant, he knew from firsthand experience the frustrations, turnover, and "burnout" that result when and where people seemingly are not appreciated. Making the value of the importance of people pervade the unit required certain actions and structural changes when he was appointed director in 1980. "We [the unit as a whole] had to do some things to establish our credibility, both among the faculty and the students," said the director. "To do that, we had to be internally credible.

The people who worked here had to believe that what they were doing was a positive thing, and that they would be supported." A problem in this unit and others with tutorial programs was that the tutors "were held accountable to anybody who decided that they ought to be accountable." Individuals from outside the unit could—and sometimes did—interrupt tutoring sessions to administer tests, make demands on tutors, evaluate tutors in front of their students, and so on. "This gave the tutors no feeling of self-confidence, no feeling of worth," said the director; "they were pawns. They felt as though, for them, there was no support structure. The administration of their own unit would not back them up when confronted by someone from another unit."

He continued: "I decided that would not happen here. So the first policy was that the tutors were responsible to this unit, to its director and any other administrators within the unit, but that anyone from outside the unit had no right at all to interrupt a session. Any kind of interaction between individuals from other parts of the university and the staff of this unit would happen through me."

Another structural change was aimed at "the prevailing student attitude that the organization, UCLA, and anybody who represents it at any point, is the servant of the students. We decided to be sure that our people [the tutors] knew that there were certain limits that were set for the students [they served]." Among these limitations were that students were not free to call tutors at all hours of the day and night, that they could not fail to keep appointments with their tutors, and that they could not demand tutors' assistance only hours before an exam or expect tutors to help them miraculously achieve high grades. As a consequence, "we have very strict policies" regarding services rendered to students. However, "those by themselves would lead to a very negative perspective," said the director. "So we started putting in many 'positives' for the tutors so they didn't end up feeling like they were just policemen. We gave them some positive things to do for the students, gave them some materials which would be helpful. . . . At the same time we also said to ourselves, 'What can we do for these people?' [the tutors]. We are asking them to not only help a person with a course, but keep an ear out for personal problems, deal with immaturity, and do a bunch of other things." Hence, many of the activities initiated or encouraged in the unit originate in the desire to recognize and reward the tutors for their efforts, have them realize and truly feel that they "are a valuable part of the operation," and promote a "feeling of belonging."

To these ends, an effort is made to get people to know one another, to learn about each other (including realizing that the administrators, too, are people), to explain the rationale for policies and procedures, and to treat people fairly. "This takes much of the intimidation of authority away from the staff. They see us after a couple of quarters as people who are doing part of the

overall task. And they see themselves as people who are doing another part of the overall task . . . rather than as somebody just being a cog in the wheel and not counting for much."

One of the factors motivating such concerns is the director's own value system. "I suppose if you want a bottom line, for me it comes down to the fact that I have to like the person that I see in the mirror in the morning. That means there are certain kinds of things which need to be happening in my life," he said. "One of the guiding principles for me is that if you give up an opportunity to become involved in a situation in a positive way, you usually don't get that chance again. And so life comes down to a series of choices to become involved or not. I would end up feeling very sad for myself if I got old only to discover that my choices had been to not get involved."

When asked whether the ambience apparent in the unit could be generated elsewhere, the director replied in the affirmative, "because the things that begin it are actually very simple. What needs to happen is that you need to provide some behavior which is a catalyst. The behavior needs to give people permission to be themselves." An example is their urging new tutors to get to know one another and call each other by first name. "It's hard to get a sense of belonging when you've got an anonymous stature," he said. "If you say that the atmosphere here is one where you are an individual and you count as an individual and you have an identity which is important to us, all sorts of things flow from that. I think all of that can be done by management. You can say, 'This is the atmosphere we want to have,' and once you give people permission it feels good enough that they'll find ways to enhance it," he said, citing the impromptu softball and football teams, ad hoc field trips, and other spontaneous activities among the tutors.

"I made a decision some years ago that I only wanted to do things that were fun," said the director. "If something wasn't fun, I wasn't going to do it. I've gotten a lot of flack for that: 'That's the biggest crock I've ever heard!' " In addition, "I keep asking myself how I want to be treated and making the assumption that others probably want to be treated in a similar way, and trying to work out ways that will make that happen." Said the director: "*If you really want to know a person, walk a mile in their shoes.*' Valerie and I have done all of the jobs that other people in this unit do," including tutoring, clerical work, and supervision. "We know the kinds of situations and feelings involved in doing those jobs." New tutors are required to work one hour in the central office tallying other people's time sheets so they appreciate the increase in workload for the coordinator and supervisors when errors are committed, one hour handling student assignments with the director so they understand the need for certain policies and procedures, and one hour working at the registration desk so they learn about what happens outside the unit.

Many of the behaviors, attitudes, and concerns of the director and coordinator, and what they do with and for the tutors, serve as models on which tutors base their own behavior. "The kind of thing that we ask our people to do is so complex that describing it would take all of their employment time and they would never get to put it into practice," said the director. "As it is, it takes us three very hard days [during training] to give them a sketchy introduction to what it is we want them to do. The hardest part of all of this," he said, "is that what we really want from them is for them to invest their personality, their life experiences, and so on in a relationship which is temporary—the relationship which they have with their students for a quarter." He continued: "We want them to do this in a way which establishes a really strong rapport very rapidly because we have precious little time to impact on students' academic life as it is, and waiting for a long time before this rapport is generated is not very productive. The tutors have to be willing to first open up about themselves. . . . They have to be very receptive to other people. . . . They have to be willing to become involved. . . . "

In sum, said the director, the tutors "have to give all of their personhood and expect all of their students' personhood in return. If that happens, then everything we want as a result will flow by itself. But it's hard to sit down with a person and say, 'This is how you express your personhood'. . . . The easiest way to do this is to show them by example, so we are to them [the tutors] what we want them to be to their students. . . . We provide the model for the kind of interaction we want them to have."

"We make it so that what tutors are supposed to do here is all that they see," continued the director. "Everything that they see around them is exactly what they're supposed to be doing. You've seen our map with the pins in it for where all our people are? There's a message there, a lesson for the tutors that says, 'You are so important that even after you leave here you are still important to us.' We hope that's communicated to students in 'You are going to be important to me even after we stop seeing each other every week.'"

"What really made an impact on me when I was hired," said a tutor who is also a supervisor, "was the fact that they kept stressing that your job as a tutor is important: not just to help students grow scholastically, but helping them to grow as a person." Many of the students rarely have someone to talk to or someone who cares about them and what they are doing. "You may be the only person on campus to recognize them and say 'hello,'" the tutor continued. "It really made me feel that what I was doing was very important. That's part of the reason that I feel so good about this place."

"I'm amazed at the sense of belonging and the sense of ownership that people do develop working here," said the coordinator. She gave as an example tutors stepping in to answer questions from students who come to

the suite, relieving the coordinator of the task. "It also gives them [the tutors] a part in the management of the unit because they know they have the authority, and they take the responsibility to help."

A model for behavior that has evolved over the years is the manual that is given to the tutors. An obvious purpose of such a manual is to set forth the rules and regulations and the policies and procedures governing the unit—the formal or structural aspect of the organization— communicating what needs to be done, who should do these things and how, and why the tasks must be carried out in particular ways. Consisting of 10 sections, the tutorial manual provides an introduction to the matter of tutoring, explains what occurs weekly in the unit during an academic quarter, offers insights regarding student motivation, characterizes departmental policies and procedures (including peer observations and evaluations as well as the making of demonstration tapes of the tutors for their own review), gives advice to tutors, sets forth instructions for submitting time cards, addresses the matter of excuses (from both students and tutors), provides general guidelines, contains an index to references, and offers "Things to Keep You Busy When Your Students Don't Show Up." (Developed before tighter procedures were instituted in the unit to reduce student "no-shows" at tutorials, the puzzles and games in the manual now serve other purposes or are turned to for other reasons.)

Initially the manual was 40 or 50 pages long and consisted of a formal list of procedures and policies. Finding the manual formidable, boring, and inconsistent with the ambience they were promoting in other ways, the director and coordinator made many changes in it over time. It has grown to 130 to 150 pages in length, largely because of the incorporation of numerous cartoons, humorous epigrams, and puzzles.

The first paragraph emphasizes that, because of the complexity of tutoring and the interactions between tutors and students, this manual is a guide only, not a how-to-do-it book. "Your own individuality and your experiences will remain your single greatest source of ideas and strategies." Below this paragraph, set off with asterisks, is "OPPENHEIMER'S LAW: There is no such thing as instant experience." The next paragraph indicates that throughout the manual are "suggestions that will allow you to avoid some of the chronically troublesome situations" that arise in tutorials. There is a cartoon below this passage suggesting some of these problems. Then there is a short paragraph that explains the functions of professors and teaching assistants, contrasting these with the nature and purpose of tutoring; it warns that confusion over these functions will reduce the tutors' effectiveness.

Next in the introduction is a section on "General Tutorial Considerations." A brief statement notes that tutorials cover course content, but "good technique for any subject is characterized by"— following which

are stated and explained four qualities (which also are illustrated with cartoons). One is *"sensitivity* to individual personalities, strengths, and needs." A second is *"respect* for the role each person plays in the tutorial encounter." The third is *"confidence* in the ability of each person to achieve the goals of the session and the course." The fourth is *"mutual trust* which allows views and feelings to be expressed openly."

A section in the introduction that follows the above reads: "The attainment of the supportive and stimulating environment suggested above demands that the tutor exercise four basic counseling skills." Like the qualities or techniques mentioned earlier, these are listed (with emphasis), explained, and graphically illustrated. The first is *"awareness:* become aware of the student's *and your own* attitudes toward both academic and personal matters which relate to the tutorial session." The second is *"empathy:* attempt to understand the student's triumphs and defeats, anxieties, and problems by touching similar feelings and experiences in your own life." The third is *"sharing:* many of a student's fears are based in a feeling of singular difficulty. Sharing of your own experiences with the student helps allay these fears and increases the student's self-confidence." And a fourth is *"confrontation:* confront the student with course-related or other problems before they get out of hand. These confrontations should be candid, but handled with the gentleness of someone who cares."

The seventh page of the first section lists the "Ten Commandments of Tutorial"—in Gothic script. The first is "Thou shalt not do thy students' homework." The second is "Thou shalt not turn in thy time sheets late." The fifth is "Thou shalt not attempt to reteach the course."

On yet another page, without comment, is a large box in which is typed the title "That's Not My Job" followed by "This is a story about four people named Everybody, Somebody, Anybody, and Nobody. There was an important job to be done and Everybody was sure that Somebody would do it. Anybody could have done it, but Nobody did it. Somebody got angry about that, because it was Everybody's job. Everybody thought Anybody would do it, but Nobody realized that Everybody wouldn't do it. It ended up that Everybody blamed Somebody when Nobody did what Anybody could have" (adapted from Xeroxlore of anonymous authorship).

Infusing the tutorial manual are sensitivity and seriousness of purpose tempered by humor. These same qualities are expressed in many other ways by the director and coordinator, as indicated earlier. They are evident in the remarks and behavior of the tutors, too, as they interact with one another and with their students. Personnel at all levels seem to enjoy themselves, interact cordially with one another, and even identify with the unit. This ambience results largely from people wanting pleasant social and sensory experiences within an organization that provides services to others while simultaneously

serving the providers. The ambience comes about because of an orientation of mutual support that, once established, draws strength from itself.

"I think there's something special that Bill and Valerie do, because they try to promote that kind of atmosphere around here," said a tutor who is also a supervisor. "In training, when everybody first gets to meet one another, Bill and Valerie really stress the fact that we're a family-knit unit and we really like to do things together. They don't know why it happens, but 'it just happens that way.' So I guess people feel that it's supposed to happen that way. But it really does happen," he said. "I don't know if it's because of the magical words that they say, or because of the things we do around here [i.e., the impromptu social activities]. But it happens that way."

Some of the feeling of "family" or "community" is communicated and demonstrated by traditions, whether spontaneous and unique or repeated from one year to the next, which also establish and express some of the character or ethos of the organization. Halloween, for example, which has been celebrated three years in a row, "for the people who are working here for the first time, this represents a tradition-in-the making, a new way of seeing things, a new aspect to the identity of the place," observed the director. "And a new set of memories that can be added to the mental picture of not only our unit but the university."

The attitudes and the traditions that reflect or reinforce them illustrate both the importance and process of aesthetics at work. Although the subject of art and ambience in a tutorial unit within a university seems far removed from conceptions of "folk art" as naive painting and sculpture of an earlier era, there is precedence in folklore research for examining tradition and the aesthetic impulse at work in a contemporary organization. On the other hand, there is precedence in studies of organizations for considering the informal culture and traditions that develop.

Research on Occupational Folklife and Art at Work

A large body of literature on occupational folklore and folklife has been amassed since the early decades of this century. Until the 1970s, this litera-ture tended to dwell on such "primary industries" as logging, seafaring, ranching, mining and railroading. It emphasized narratives, songs and beliefs and superstitions (for an overview, see Green 1978). More recent research has broadened the scope of occupations to include modern transportation and telecommunications industries, manufacturing companies (e.g., aircraft and textile), firefighting, bartending, parks and recreation services, and trade schools. The kinds of expressive behavior also have been enlarged to include personal experience narratives, celebrations and festive events, and exam-ples of art at work (e.g., Bell 1976, 1983; Collins 1978; Dundes and Pagter

1978; Ice 1977; McCarl 1974, 1976; Messenger 1976; Mullen 1979; Nickerson 1976; Santino 1978; Shuldiner 1980; Stoltje 1979; Swanson and Nusbaum 1978; Fine 1985).

The earliest research on occupational traditions was largely documentary. As with other examples of folklore in various social settings, the intent was to record the traditions before they disappeared. Later analysis examined the origins of particular stories or songs as well as their development and change over time. Some research considered functions, investigating, for example, the role of beliefs and rituals in reducing anxiety in the face of environmental uncertainty or of customs and rites of passage generating a sense of community and esprit de corps among many of those taking part in them.

Some recent research on art in the workplace addresses similar questions about function. Focusing particularly on "homers"—items that workers make for their enjoyment and use—these studies suggest that workers derive a sense of self-esteem and self-worth from such activities that they do not get from their jobs. For many, the job is meaningless and their treatment at work demeaning; art is meaningful, a source of pride, and a symbol of what can be accomplished when given the opportunity. There are obvious implications and ramifications for management and organization design, which an increasing number of researchers are pointing out in their publications (e.g., Dewhurst 1984; Lockwood 1984).

A logical extension of the research on workers' culture and occupational folklore or folklife would embrace at least three considerations. The most fundamental is to realize that the workplace usually is part of an organization (be it a bar or restaurant, a factory or mill, the cabin of a commercial jetliner, or the office of a unit in a university). Even cottage industries and many traditional crafts are the product of collective effort that, however informally structured and supervised, is orchestrated.

Second, although the constructs "group" and "community" are appealed to in research on occupational traditions, often only a few people are interviewed and representatives of only a few segments of the organization are included in the research as subjects and "stakeholders." If the researcher realizes that the workplace is not an isolated social setting but is an integral part of a larger phenomenon, then the researcher would include other populations in the inquiry. Not only will this enlarge understanding of the circumstances studied, but also, in so-called action or applied research, it increases the likelihood of bringing about improvements in work conditions, administrative sensitivity, and working relations.

Few of us claim that the formal organizations in which we participate—particularly those that serve as a workplace and a source of livelihood—are free of problems or need no improvements. Rarely would

one cite a formal organization as a paragon of excellence, much less contend it is perfect in all respects. But when people do refer to one supervisor, work situation, or organization as "better" than another, what do they mean? What happens, and why, to precipitate positive comments and attitudes? The value of documenting and analyzing instances of people who feel a sense of personal satisfaction, fellowship, and self-esteem is that the research can uncover what activities and situations promote these feelings. A third consideration, therefore, is to investigate circumstances in organizational life that in the view of the participants bring out the best in them.

I have described some aspects of research in progress concerning traditions, attitudes, and activities in an organization that result in positive feelings among people regarding the unit, one another and themselves individually. This research is part of a larger project begun a few months ago to identify and analyze positive management practices and networks of support as perceived by a cross-section of participants in a variety of units. The research neither assumes perfection nor ignores problems. Rather, it seeks through a comparative approach to discover what organizational participants perceive to be "better" in order to understand what members of organizations expect socially and aesthetically and to derive principles for improving organizations and their design and administration. A necessary foundation for this inquiry is concepts of "organization" and "organizing."

On Spontaneous Organizing and Informal Organizations

In 1938, Chester I. Barnard published *The Functions of the Executive,* which many today consider a classic work partly because of its extensive treatment of the concept "organization." Barnard writes that an organization comes into being whenever "(1) there are persons able to communicate with each other (2) who are willing to contribute action (3) to accomplish a common purpose" (1938:82). Perhaps because Barnard was an executive, and certainly because his book examines the functions of the executive, he was concerned with "formal" organization as an *enduring* institution. Barnard characterized two other kinds of organization, however, that are of special interest to contemporary folklorists.

In addition to formal organizations, writes Barnard, there are "spontaneous organizations." He defines spontaneous organization as an association of two or more people who contribute efforts simultaneously, sometimes without announced leadership, to accomplish a common purpose. He gives as examples the organizing of rescue efforts, on the one hand, and on the other games or similar activities in which people cooperate for purposes of amusement. One could add many instances of celebrations,

parties, get-togethers, sports, impromptu group lunches, and so on. Such "organizations" are new, rapidly created out of internal impulse, and usually short-lived. They qualify as organizations because they constitute "systems of effort" that accomplish common goals through cooperation and coordination (Barnard 1938:102). They also exemplify the fundamental process of organizing, in that people contribute action to accomplish a common purpose; it does not matter that the objectives are humanitarian, social, or aesthetic.

Yet a third type is that of "informal organization." As Barnard describes it, an informal organization (in the context of a formal organization) includes or produces "customs, mores, folklore, institutions, social norms and ideals" (1938:116). Sometimes these customs and norms contrast with the official procedures, policies, and proclamations of the formal organization (see e.g., McCarl 1978, 1980, 1984a; "Works of Art, Art as Work and The Arts of Working" 1984; Smircich 1983; Jones 1980a). Barnard championed informal organization in a formal organization as "necessary to the operation of formal organizations as a means of communication, of cohesion, and of protecting the integrity of the individual" (Barnard 1938:123).

Continuing to distinguish among these three kinds of organizations, Barnard insisted that informal organization precedes formal organization. This is because "the possibility of accepting a common purpose, of communication, and of attaining a state of mind under which there is willingness to cooperate" demands "prior contact and preliminary interaction" (Barnard 1938:116). Obviously, a major institution does not simply spring into existence; it is the outcome of human endeavors, originating in people's ability to communicate with one another and willingness to contribute action to achieve collective goals.

On the other hand, informal organization must have a degree of structure and formal accoutrements to persist. This is so even when the object of association is social, for people are impelled as a condition of their existence *to do something* and to seek purpose to their actions, contends Barnard. A party, a game, or a ceremony requires for its success a degree of structure, order, and consistency (see, e.g., Humphrey 1979). Hence, there is interdependence. Features of a formal organization are essential to order and consistency, and qualities of an informal organization are essential to vitality; "there cannot be one without the other," writes Barnard. "If one fails the other disintegrates" (1938:120).

To summarize Barnard's views, formal organizations arise out of informal organizations, giving the latter structure. In turn, when formal organizations are generated, they bring into existence and require informal organizations whose effects are the establishment of norms and ideals, customs and

mores. Formal organization always has its informal qualities; and spontaneous or informal organizations require a degree of structure in order to function and survive.

What Barnard characterized are not necessarily different kinds of organizations but perhaps different aspects of the process and outcome of organizing. The so-called *formal organization* is really the structural element with a formal division of labor (the organization chart and written job descriptions), clearly stated rules and regulations, lines of communication and a chain of command, and so on. *Spontaneous organization* is less an entity than a process—that of organizing when and as the need arises, often without manifest rules and rarely with the organization enduring beyond immediate necessity. An *informal organization* consists of the daily activities of people, generated in and modified by particular circumstances of interaction that are largely traditional and expressive—the "folkways" that Barnard mentions (see Peters 1978; Trice et al. 1969).

Much is expressed in informal interactions and spontaneous groupings that would not be communicated through official documents, and this information as well as the vehicles by which it is transmitted affect individuals' experiences, knowledge, attitudes, and feelings. An important consequence of so-called informal organization, workers' culture (McCarl 1979; Lockwood 1984), or folklore in organizational settings (Jones 1985b; Dandridge et al. 1980; Fine 1984) is that of, in Barnard's words, maintaining "the feeling of personal integrity, of self-respect, of independent choice" (1938:122). This is because the interactional aspect of organization is dominated by choice and personal attitudes, not by an impersonal goal or authority. "Though often this function is deemed destructive of formal organization," writes Barnard about the preservation of self-respect through folklore, "it is to be regarded as a means of maintaining the personality of the individual against certain effects of organizations which tend to disintegrate the personality" (1938:122).

I cite Barnard's observations because of their relevance today. Nearly 50 years ago, the chief executive officer of New Jersey Bell Telephone Company, writing about the functions of the executive, realized that we need to know about folklore to understand, function within, and administer organizations (see also Pauchant 1985; Wolfe 1974). Some officials and executives deny or ignore the existence of the expressive and symbolic aspect of organizations; yet simultaneously they acknowledge that an organization cannot be understood from its organization chart, charter, or official rules and regulations. "'Learning the organization ropes' in most organizations," writes Barnard, "is chiefly learning who's who, what's what, why's why, of its informal society" (1938:121). "Despite its importance," however, writes Barnard, *"informal* organization in formal organizations is ignored as far as possible" (1938:289 cf. 121, 128, 286).

Obviously, two individuals with administrative responsibilities who do not ignore informal organization or traditions at work are the director and the coordinator of one of the units that provides tutorial services for students at UCLA. Bill McGuire and Valerie Eichel are well aware of the structural features required for an organization to endure. But they also realize the necessity of informal organization and spontaneous organizing. Their concern is epitomized in many ways, even in the tutorial manual. Containing information about necessary procedures and policies—a structural element—the manual is infused with a spirit of good humor and playfulness—qualities of informal interaction and spontaneity.

Barnard concludes *The Functions of the Executive* by noting that at the heart of his study is a "deep paradox and conflict of feelings" in people's lives vis-à-vis organizations (1938:296; see also Hurst 1984). Organizing is a fundamental human endeavor; social action is scarcely possible without it. We can neither escape the impulse to organize nor elude the organizational presence in our lives. But sometimes formal organizations (or the structural aspects of organizing) seem to demand much of a person and perhaps give too little in return. As the director of the tutorial unit observed, "There's a lot of structure even here at UCLA that does not have a value on people at all—that has a value on budgetary constraints or organizational survival." The result is frustration, "large amounts of turnover," and, for those who persevere, "burnout."

It is not surprising, then, that formal organization or the formal aspect of organizing—however necessary it might be at times—generates mixed feelings. Few people in the tutorial unit enjoy the paper work, for example, that is required to provide services to several thousand students a year. Record keeping, accuracy, and completing tasks in a timely way are the bane of many people's existence. The week is emotionally draining for the staff because of the burdens of data maintenance and the many emergencies that arise.

Nevertheless, there are pleasurable moments and memories. Tutors speak of the friends they have made with other tutors and their students, their experience of the unit as a "second home" or as a "home base," the enjoyment of being able to socialize with others, the satisfaction of affecting in a positive way the lives of others, the creativity that is encouraged in the unit, and the sense of pride they have in their work. "I get a lot of pleasure when one of my tutors comes in and says they had a really good session, and proceeds to explain why," said the coordinator. "I get a lot of pleasure out of hearing that one of my tutors has just gotten into grad school, professional school, or a dream job. I take a great deal of pride in that kind of accomplishment. I take a great deal of pleasure in seeing people grow. . . . Many of the extutors who come back during their vacations go home and then they come here. The first two places they are is home and here. That gives me pleasure, because I know

there's a lot of warmth and good feelings associated with the time they've spent here. Halloween in a funny kind of way, I take a great deal of pleasure in. Because we have a very mixed ethnic group here, and for some of the tutors it's the very first Halloween they've ever had."

A balance between the structural-technical dimension and the human side of organization may be possible, if this unit can be taken as evidence. Certainly a step toward resolving the conflict in feelings about the formal requirements of organizing entails recognizing fundamental human needs and striving to fulfill expectations of meaningfulness, fellowship, and personal satisfaction—all of which is in the realm of aesthetics and tradition as revealed by studies of folklore in organizational settings.

Organizational Folklore Studies

Often folklorists have been aware implicitly of "organization" when studying expressive forms and processes manifested in interactional networks. Inspired by nationalism, for example, many recorded popular traditions in contrast to the "official" culture of administration, literature, and art. Some have documented children's play of a "spontaneous" nature, opposing it to the structured activities formally scheduled and imposed by teachers or principals. Those who write about folk religion usually conceptualize it as being juxtaposed to the body of doctrine and practices of "organized" religion. To understand work life, folklorists have eschewed the printed rules, regulations, and policy manuals, seeking instead to observe and note the customs and techniques generated in face-to-face interaction. Even many who define the word "folklore" distinguish it as "informal" and "unofficial" in contrast to the written, the formal, the official—whether in business, government, schools, or other contexts.

What folklorists rarely have done, however, is to consider the ramifications and implications of the fact that many instances of folklore are examples of informal or spontaneous organization; nor have they examined the generation and manifestation of folklore in terms of the concept of organizing. Perhaps this neglect is owing in part to the connotation of the word "organization" as a formal institution and enduring entity. Or maybe in shunning formal organizations folklorists have spurned the *concept* of organization.

One value in exploring organization and organizing as these relate to expressive forms and processes in interactional, communicative, and experiential networks (Blumenreich and Polansky 1974) is that these concepts offer a new way to look at folklore. How *are* celebrations, games and play, ethnic display events, and other expressive forms organized? Ascertaining this might help answer questions about why various forms and examples of

folklore are generated, modified, or perpetuated as well as what their meanings and functions are.

A second reason for exploring these concepts through a study of folklore is the potential contribution to be made to the body of literature on organizations that, to date, is based largely on research on "organization" conceived of as a formal and enduring institution. Folklorists are well aware that every formal organization has its informal and traditional dimension; and they should know that organizing is one of the universals in human experience. Unless folklorists communicate their understanding to those who write about, design, and administer formal organizations, they can scarcely expect the institutional aspects of social life to conform to their values and vision.[2]

Research on organizations also brings to the fore such concepts as "aesthetics" and "art." As long as these matters are thought to be a world apart, then they are not a part of our world. It is abundantly evident, however, that the aesthetic impulse—a desire to create, and a need for pleasant sensory and social experiences—is a vital aspect of organizational life and work. "You feel like you're doing something important," said one of the tutors; "you have a sense of pride."

To conclude, my intent has been to suggest some of the ways in which organizational folklore can be examined in order to develop the emerging field of organizational folklore studies. By "organizational folklore" I mean the subject matter for study, which may consist of, variously, *folklore in organizational settings, folklore about organizations,* or examples of *folklore as instances of organizing.* All three are evident in the data on the tutorial program described above. The softball team and its games, the Halloween party, and other impromptu, spontaneous and ad hoc traditions exemplify folklore as instances of organizing. Stories about members or former members of the unit, and stories told by others about the unit and its members are examples of folklore concerning organizations. A whole host of traditions generated in tutorial sessions, among networks of tutors and among the various levels of personnel in the unit comprise folklore in organizational settings.

By "organizational folklore studies" I mean *that inquiry into expressive forms and processes manifested in people's interactions in which the concepts of organization and/or organizing are primary.* An analysis of how traditions are spontaneously generated and informally organized, a study of informal organization within a formal and enduring institution, and research on the impact of formal organization on folklore (and vice versa)—all are examples of organizational folklore studies. This research is primarily descriptive, not prescriptive. There are often implications and ramifications of a practical nature, however.

Conclusion

Among other lessons, activities in this tutorial program suggest how vital the element of "play" is, even—or especially—in an enduring institution. Usually associated with the creative process, and often thought of as an antidote to "work," playfulness seems to be necessary for physical, intellectual, and spiritual survival. "I always make sure there's a playful element in many of the aspects of what goes on here," said the coordinator of the tutorial program, who added, "I don't know how well that would work outside the university" because "people take themselves too seriously. . . . Let's face it, if someone's busy playing volleyball, then they're not being 'productive' in terms of time-cost efficiency. Except I think they're more efficient, and time is better spent. . . . " In addition, she said, "most people hate their jobs, they hate where they work, hate the environment they're in; I mean nothing about it makes them happy. Why should they want to be playful in that environment?"

How people feel is made abundantly clear in the stories they tell, the language they use, and the customs that they engage in (or do *not* participate in or organize spontaneously). Either discordant notes are struck in the folklore, or the traditions strike a responsive chord. Much has to do with the attitudes pervading the organization, what the values are, and whether the technology of organizing is balanced by humanistic concerns which, fundamentally, are social and aesthetic in nature.

At the beginning of his book, *The Functions of the Executive,* Chester I. Barnard lamented being unable to "convey the *sense* of organization, the dramatic and aesthetic feeling. . . . " He contended that many lack interest in the scientific study of organizations "because they are oblivious to the arts of organizing, not perceiving the significant elements. They miss the structure of the symphony, the art of its composition, and the skill of its execution, because they cannot hear the tones" (Barnard 1938:xiv). While much research remains to be done in the study of organizations, the matter of art, aesthetics, and ambience at work seems an appropriate place to begin.

Notes

1. The research in progress was funded in part by a grant from the Academic Senate in combination with support from the UCLA Research Programs and the office of the Administrative Vice Chancellor. I am indebted for some of the information in the present article to the following individuals in the Ph.D. program in folklore and mythology who are serving as research assistants to the research project: Ms. Susan Montepio (folklore and applied anthropology), Ms. Susan Scheiberg (folklore and communications), and Mr. Peter Tommerup (folklore and behavioral and organizational science).

 Early in this article I refer to the "name game." The coordinator and director of the unit compile a three- or four-page questionnaire deriving information from the tutors' Person-

nel Action Forms (PAFs) and casual remarks made by or about them. The coordinator and director include themselves in the questionnaire, their superior and others who have become involved in the unit. Everyone participates in completing the questionnaire. At the end of the day there is a pizza party at which the director and coordinator read the correct answers and the tutor with the highest score receives an award, that of one unquestioned excuse.

In 1987, the Name Game took place on Thursday, 5 March. One question is "In _____'s complete name with title, the first two letters and the last two letters used to be the same." The answer is "Ms Valerie Eichel, M. S." Valerie Eichel, the coordinator, now has a Ph. D. After earning her master's degree several years ago, her father asked what she would do with it. She replied that at least she could write MS before and after her name.

Another question reads: "An avid fisherman, _____ met his match when he discovered fishing gear in the trunk of _____'s car." The fisherman is Edward (Chip) Anderson, Director of Preparatory Programs in the College of Letters and Science (under whose supervision this tutorial unit falls), and the owner of the car is Bill McGuire (director of this tutorial unit) who carries fishing gear.

Every question grows out of, or leads to the telling of, a story that intensifies participation. The questions, seeking answers to them and hearing the answers contribute to participants' learning more about each other—particularly discovering personal information resulting in subjects' being seen not in formal organizational roles but as fellow human beings.

Other questions this year that included nontutors are "Traditions are not a hit or myth affair to _____ and _____" (Michael Jones and Peter Tommerup, from the Center for the Study of Comparative Folklore and Mythology, who were conducting research in the unit), "If you want to talk to an expert on Appalachian folk art, _____ is the person you need to find" (Michael Jones, author of a book on chairmaking), " and _____ literally pounds out his music" (Peter Tommerup, who plays the hammered dulcimer and who has prepared an instruction manual and demonstration tapes, published by Kicking Mule Records), and "It may seem like a long way from ARC [Academic Resources Center, of which this tutorial unit is a part] to the Jayhawk Cafe [in Lawrence, Kansas], but not if you ask _____" (Michael Jones).

2. "[T]he organizational current . . . moves to the fore because it proposes to reveal what is of most concern in a future-oriented society—the present state of the modern world and its guiding structures for the future," writes Bronner (1986:128). He continues: "[A]s folklore studies increasingly moves outside the academy, as it becomes more subject to organizational differentiation, and as it lodges in governmental agencies, foundations, corporations, museums, and libraries, then the keyword *organization* may balloon into a prominent theory of folklore studies."

Part Four

Methods and Concepts

9

Aesthetic Attitude, Judgment, and Response: Definitions and Distinctions

In the early 1970s I published a series of articles on aesthetics, a concept essential to folk art and material culture. It is also vital to work life and organizational settings, I realized later.

Over the years I have given papers and published on various matters regarding methods, concepts, and perspectives in the study of different aspects of folklore. In 1976, for example, I published "The Study of Folk Art Study: Reflections on Images" (1976d). In 1977 I gave a paper called "Ask the Chairmaker" at the meeting of the American Studies Association. And in 1983 I read a paper at the American Folklore Society meeting titled "Researching Folk Art: Matching Questions with Conceptions," later published (revised and coauthored with Verni Greenfield) as "Art Criticism and Aesthetic Philosophy" (1984). Obviously, all of these works concern folk art and its study.

Some methodological pieces related to history are "Black or White Origins of the Spirituals? The Gray Areas," a paper presented at the annual meeting of the American Folklore Society in 1976; "Bibliographic and Reference Tools: Toward a Behavioral History," a presentation at the Conference on Folklore and Local History (1980); and "Another America: Toward a Behavioral History Based on Folkloristics," a paper given at the American Folklore Society meeting in 1981 and later published (1982a).

Elsewhere in this volume I have mentioned papers and publications on perspectives in the study of eating habits. I also wrote about fieldwork. Among the works are "Alternatives to Local (Re-) Surveys of Incidental Depth Projects," given at the California Folklore Society meeting and then published (1976a); "In Progress: Fieldwork—Theory and Self" (1977); (with Robert A. Georges) *People Studying People: The Human Element in Fieldwork* (1980); and "Folkloristics and Fieldwork" (1985a).

I gave the paper below at the annual meeting of the American Folklore Society in 1980. Despite the existence of an ever-growing body of literature in folklore studies on aesthetics, it seemed to me that several related terms often were not

This article is a revision of a paper originally delivered at the American Folklore Society Meeting, held in Pittsburgh, Pennsylvania, October 16–19, 1980.

defined or distinguished from one another. My intent was to characterize both the negative and the positive aesthetic response, to differentiate attitude from reaction, and to suggest that matters of taste affect judgment.

One of the ways I have dealt with these concepts in classes on folk art is to show students a set of slides, telling them at the outset that these images are simply there to look at. But I also instruct the students to be aware of and to note how they or others in the room react to the photos and the subject matter. Among the visuals are photographs of stained glass windows and lamp shades, corn husk dolls, arrangements of kitchen utensils in drawers, clothing, scarecrows, knots, quilts, owner-built or -remodeled houses, and chairs.

To some students the chair in figure 9.1 seems rather simple but nevertheless pleasing for its organic quality: the front posts curving outward, and the back posts curving both out and back. The eight-sided posts (and stretchers) suggest greater strength and almost invite grasping. When looking at the curved slats and shaped arms, one can imagine sitting in the chair; the tactile sensation becomes vivid. And one can almost feel the rocking motion of the chair (the haptic experience, or the memory of this experience and appreciation of it without having to actually experience it in the present). Students also notice the narrow space between rockers at the back, contrasted with the much greater distance in front (a matter of 4 inches or so versus 18 or 20 inches).

Chester Cornett made the chair in the mid-1950s. The man who was using it in the 1960s could not speak highly enough of its comfort. He remarked several times about how you could rock backward with no fear of tipping over. He demonstrated, rocking vigorously. He invited me to sit in the chair and challenged me to try to tip it over.

The chair typifies Chester's style. A characteristic mode of construction was to shape posts and stretchers eight-sided with a drawing knife (or even ax or pocket knife) rather than to turn them on a lathe. The seeming "organic" quality was a distinctive and characteristic mode of presentation of Chester's work resulting from bending the component pieces (posts and slats) by driving them into a press in which they dried in curving forms. This quality grew out of Chester's concern about making a chair that "sets good." His distinctive and characteristic manner of execution, I realized on examining nearly 100 of the chairs he had constructed, was that of focusing on some aspect of chair design, construction, or purpose and developing it—as a concept—on one or another chair.

In regard to this chair, for example, he dwelt on the concept of rocking, imagining how to improve the design of a rocking chair so that there is no possibility of tipping over backward (which in turn enhances the user's positive aesthetic experience—or anticipation of it—by eliminating any fear of accident in use). One of his early chairs (see fig. 9.2) has many different kinds of turnings on the front posts, the back posts, the stretchers, and the arms. Rather than settling on one form and repeating it throughout the chair as other craftsmen did, Chester experimented with variations on a theme, exploring the concept of turnings. Some chairs are short, their seats close to the floor and their balance (achieved by controlling the height of the back and the extent of thrust of the back posts backward and outward) such that they can be tipped back by the sitter with virtually no effort and held in that

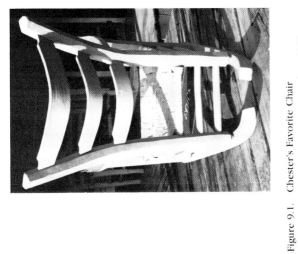

Figure 9.1. Chester's Favorite Chair

This chair, made in 1954 or 1955, was made with an ax and a hatchet. Pegs, arms, outward curve of front posts, and outward and backward flare of back posts are typical chair traits Chester manifested throughout his career. Owing to the narrowness of the space between the rockers at the back, it does not tip over backward. It is one of many examples of Chester's approach to chairmaking: that of experimenting with some aspect of design, material, construction technique, or use.

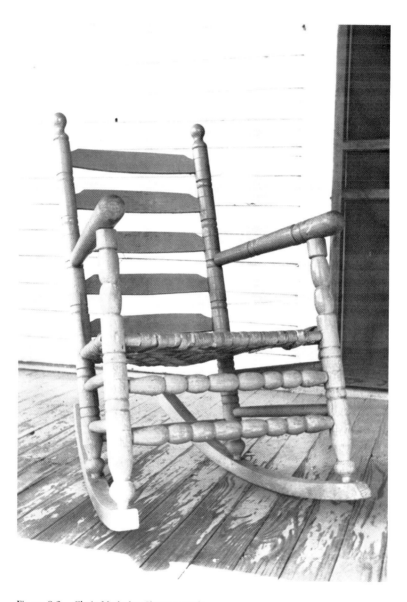

Figure 9.2. Chair Made by Chester, 1942
 The last chair Chester made before being drafted was of white oak. As
 in most other chairs that he made, he focused on one of many aspects
 of what a chair is or can be—in this case, it is that of "turnings." Rather
 than simply repeating a single design throughout the chair as chairmak-
 ers tended to do, Chester created a series of variations in turnings and
 spools, each set reminiscent of and yet different from every other set.

position (or even rocked on the feet of the back posts). Yet other chairs are taller with higher seats and balanced more vertically; these epitomize the concept "dining chairs," as opposed to the "settin' chairs" (see fig. 9.3).

My point is that Chester's style was "conceptual." Dedicated to craft work and committed to making a good chair, he took into account not only decorative qualities, use, and usefulness, but also tactile, kinesthetic, and other sensations. When reacting to and judging utilitarian art forms, we are affected in subtle ways by these considerations.

When many of the students see a photograph of Ukrainian Easter eggs, they gasp. Some of them, they say later, are inspired by the vividness of colors and complexity of designs; their eyes linger on the screen, and they begin to think of related matters—how to incorporate these colors or designs into their own art work, how they wish to touch or to have some of these decorated eggs, and so on.

Many of the students laugh when they see a photo of a bald-headed man contest in France, the winner seated in a chair with someone to his left inspecting his head with a magnifying glass.

Reactions to a photo of a chicken-plucking contest in the United States are mixed. It strikes some people as funny, others as "gross." It brings back memories to some who in youth had watched a family member clean chickens or who had participated themselves. These memories might be pleasant or, when students remember the smell of the chicken feathers (or entrails), they might be unpleasant.

One photo is of a tattoo artist standing bare-chested in the doorway of his parlor. His upper arms are covered with his art. Reactions are mixed, but most students seem to cringe physically when they realize he has a metal ring in his right nipple, which is pierced.

The forms that seem to evince amazement—even spontaneous "ooohhhhs" or "aaahhhhs" when students see several slides in sequence, are small figures made of cement (e.g., figs. 9.4, 9.5, 9.6). Oscar Gunnarson, of Lindsborg, Kansas, made his living in construction by pouring concrete foundations, driveways, and sidewalks. For personal pleasure and as a hobby, he constructed miniature scenes of funerals, weddings, elderly men playing checkers, and other activities out of the materials used on the job. Students are struck by the incredible life-like quality of the figures and the expressiveness of their faces. Eyes "glued" to the screen, students seem almost lost in reverie and are truly appreciative of the forms that Gunnarson created. Just as the figures appear to be real people frozen in a moment of time, time seems to stand still for the students as they look at the screen.

The same cannot be said of other slides that I show. The photos are of a house ill-cared for during the last weeks the tenant lived there. She had brought in cats and a dog, but then left for several days. One photograph of the bedroom floor shows gray tufts in black lumps and circles—cat hair trapped in feces and urine stains. Another photo is of a refrigerator, the door having just been opened after the refrigerator was left unplugged for six weeks—foodstuffs in it all the while. Clouds of insects swarm around a piece of pizza covered with mold an inch thick. Brackish water fills the dehydrator drawers, a stalk of blackened celery protruding from the lumpy, rotting mess. "Ugh!" say some of the students, who squeeze their eyes together. "Yuck!" They begin fidgeting. They move their heads, looking

Figure 9.3. Examples of "Settin'" Chairs

These chairs show the range of Chester's designs: (left) chair with single pegs (ca. 1960); (center) redbud chair with black walnut double pegs and slats notched at ends (ca. 1961); and (right) sassafras chair with black walnut pegs (November 1965). The last chair is more of a dining chair because of its higher seat and back—another example of Chester's experimentation with design and use in order to extend the concept of what a chair is and how it can function.

Figure 9.4. Oscar Gunnarson, Concrete Figures

In the 1940s and 1950s, Oscar Gunnarson, a construction worker in Lindsborg, Kansas, made many figures from concrete. The attention to detail, the lifelike quality, and the fact that they are made from the materials of their creator's job often provoke "ooohhhs" and "aaahhhs" from those who see these figures. Time seems to stand still for viewers who are drawn into the world that Gunnarson created.

Figure 9.5. Detail of Concrete Figures

Figure 9.6. Detail of Concrete Figures

elsewhere—anywhere other than at the screen. They become "chatty" in a nervous sort of way, looking at and talking to one another or me about anything except what is related to the photograph, and even intruding on or disrupting each other's remarks. Time seems drawn out. There is visible relief when I advance the carousel, showing slides of less disgusting and more pleasing things.

We analyze the experience. Students describe the physiological sensations of pleasure or disgust that they had; characterize attitudes, feelings, and emotions; and refer to associations. I show other slides I have made from ads in magazines. My purpose is to develop ideas about the aesthetic experience as either positive or negative and as a unique configuration of physiological condition and intellectual state, to illustrate some of the verbal and physical responses that express the aesthetic experience, and to examine how taste and context affect response or judgment—matters addressed below.

<p style="text-align:center">* * *</p>

Several people have written about aesthetic matters in regard to the traditional arts. Among them are Franz Boas (1955), Ruth Bunzel (1972), Alan Merriam (1964a, 1964b), Robert F. Thompson (1968), Dan Crowley (1966), Tom Burns (1974), Roy Sieber (1959), Bill Ferris (1975), Robert Bethke (1974), Michael Jones (1971a), Barre Toelken (1969), and others. Essays by these individuals are, potentially, of great importance. Yet there is the likelihood that misunderstandings will arise and that research findings will not be appreciated. The reason for this is that certain terms are used similarly but with different meanings; that different terms are employed for what seems to be the same phenomenon; and that in most instances it is up to the reader entirely, with little or no assistance from the author, to infer what is meant by a term.

Used variously, and usually without definition, are such words as *aesthetics, the aesthetic,* and *an aesthetic.* In addition, the word "aesthetic" also is used as an adjective, qualifying some phenomenon—such as attitude, judgment, or response—but it is not always clear just what that phenomenon is. Confusing matters even more is the use of the word *taste.* For some it seems to be the equivalent of *the aesthetic,* for others *aesthetic judgment,* and for yet others the word *taste* is an object of loathing and should not be included in discussions of aesthetics at all.

One example of an area of confusion and source of debate is chapter 13, "Aesthetics and the Interrelationship of the Arts," in Alan Merriam's book, *The Anthropology of Music.* For the most part he is concerned with *the aesthetic* and with whether or not it exists among selected populations—the Basongye in Africa, and the Flathead Indians. By *the aesthetic,* Merriam seems to mean a complex or system comprising a well-developed philosophy and verbalized principles regarding form, its excellence and appreciation. In much of the

chapter, Merriam refers exclusively to *the aesthetic,* reviewing his testing of whether his subjects have a concept of "aesthetic," a philosophy of form, and a set of verbalized principles (they have none of these, he concludes). Confusing to many readers, however, is that in the first page and a half and then again toward the end of the chapter Merriam speaks of *an aesthetic.* On page 269 he uses both *the aesthetic* and *an aesthetic* in the same sentence. This passage has been the subject of debate since the book was published in 1964. It reads as follows:

> We may pose the crucial question, then, of whether AN AESTHETIC exists if it is not verbalized; the answer seems clearly to be that it does not, at least *if we use the Western concept of THE AESTHETIC, which is exactly what has been done in these pages.* [italics in original; other emphasis added]

In the writings of Sieber (1959), McAllester (1960), and others, *an aesthetic* appears to signify some particular kind of response to form. Does it mean the same to Merriam? The question gains poignancy when one reads the sentence that follows the passage quoted above, in which Merriam acknowledges that people produce art, evaluate objects, and judge performances, but nevertheless he insists that without verbalization of philosophical principles they do *not* have *an aesthetic.* The research of Crowley (1966), Bauman (1972), and others indicates that people do in fact perceive and react to form within the context of performance or production, even though they have no philosophy comprising *the aesthetic.* How could that be? What is an *aesthetic response,* or *judgment?*

To put to use some of the findings of various researchers, then, clarification of terms is required. Fortunately, enough writers appear to share implicitly a sufficient number of conceptions that it is possible to propose some concepts. I offer for further consideration and testing, as hypotheses, the following distinctions. The term *the aesthetic,* as Merriam's work suggests, refers to a system of philosophical discourse and articulated principles regarding form; it is rarely found in regard to the traditional arts. This does not mean that there is no perception of form or that there is no concern for formal excellence. There is in fact an *aesthetic attitude* comprising an ability to perceive form and a willingness to have an aesthetic experience. *An aesthetic response* (reaction, experience) is a unique configuration of intellectual state and physiological condition that occurs usually without a philosophy of "the aesthetic" and is accompanied by rudimentary expression rather than articulated principles. An *aesthetic judgment* is an evaluation of form, based on a response and expressed through physical acts or (usually) limited rather than elaborate verbalization. *Taste,* that is, likes and dislikes, affects in fundamental ways *aesthetic attitude, aesthetic response,* and *aesthetic judgment. Aesthetics* is the subject for consideration. It need not

include *the aesthetic* at all; it does, however, consist of discussions of *aesthetic attitude, aesthetic response,* and *aesthetic judgment,* but figuring most prominently is *taste.* Having made such distinctions, it is necessary now to discuss the terms as they relate to folklore studies.

The term *the aesthetic* tends to be employed when one is referring to the systematization of knowledge, perception, and principles of form. It is a favorite term of "the aesthetician," whose preoccupation, understandably, is constructing criteria of evaluation, verbalizing principles of formal excellence, and formulating a philosophy of the beautiful. The classic discussion by Merriam should disabuse anyone of supposing that *the aesthetic* has much relevance to the folk arts. For as Merriam demonstrates, there is no evidence that people involved in the traditional arts respond solely to a song or an object abstracted from the context of performance or of manufacture and use; that they conceive of themselves as engaging principally in art for art's sake; or that they articulate principles as an essential part of their judgment of form. But in regard to activities and objects encountered daily and routinely, many individuals do in fact function in terms of an *aesthetic attitude* and have an *aesthetic experience* as signaled by an *aesthetic judgment,* all of which is affected by *taste.* How can this be?

"All human activities," writes Boas (1955:9) "may assume forms that give them esthetic values." While a word or a cry or unrestrained movements and many products of industry seemingly have no appeal, he observes, "nevertheless, all of them may assume esthetic values." What is required is a manipulation of the sensuous qualities of materials in rhythmical ways to produce a structure serving as a standard by which its perfection is measured. Throughout his book he speaks of "the perfection of form"—both striving to achieve formal perfection and the appreciation of formal excellence. He writes that "we cannot reduce this world-wide tendency [to perfect form, and to appreciate formal excellence] to any other cause than to a feeling for form. . . . " In other words, people have as a fundamental feature of their being human the impulse to emphasize the form of objects they make and the activities they engage in, as well as the compelling need to take pleasure in the achievement of formal excellence.

Whether articulated or not, and whether subject to philosophical discourse, people have an *aesthetic attitude.* For fundamental to being human is a feeling for form: an ability to master techniques to perfect form, and the capacity to appreciate formal excellence. Sometimes the forms produced elevate the mind above the indifferent emotional states of daily life because of meanings conveyed or past experiences associated with them, but they need not do so to be appreciated. Perfection of form is enough to satisfy; if the forms convey meaning, that adds to their enjoyment but it is not essential. What is crucial is that there is a feeling for form fundamental to

being human; without this quality there would be no "perfection of form." Because of the existence of a feeling for form in all human beings, however, serving as the basis of an *aesthetic attitude,* human beings have in the course of their daily activities an *aesthetic response.*

An *aesthetic response* is a reaction to form that one perceives. That this response exists is apparent in the writings of Sieber (1959), Bauman (1972), Ferris (1970), Burns (1974), and others. Precisely what this response is, however, remains to be ascertained. As a working hypothesis, I propose that an *aesthetic response* consists of a unique configuration of intellectual state and physiological condition in reaction to the perception of form or to some aspect of the generation of form. Although positive experience always is emphasized in the research literature, there is also a negative reaction. When positive, physical sensations of muscular tension and of release mark the aesthetic experience (response, reaction), along with a heightened aware-ness of form, the subordination in importance of other stimuli, and the suspension of time. In combination, the physiological condition and intellec-tual state have as their outcome a feeling of well-being, sometimes even a sense of "oneness" or unity of self with the object of attention and/or with others in the event. Hence, not only is an *aesthetic experience* enjoyed when it occurs, but also the conditions precipitating it often are cultivated so as to trigger the response. Remarked one woman about going to folk dance clubs for many years: "The reason I went to so many ethnic events throughout a lifetime is because of the possibility of that happening. It's so exciting when it happens. It's worth it for the event and for the memory—for that. . .highly. . .heightened. . .*something* happening!" Another person de-scribed to me with much enthusiasm a performance she had just seen. When asked to analyze her response, she insisted several times that it was principal-ly "a gut reaction." Both statements suggest that people perceive and respond favorably to some forms of expressive behavior, that they cultivate a situation hoping to trigger in themselves a certain kind of response, and that the experience they have is marked by actual physical tension and then release ("a gut reaction") and also embraces a certain intellectual state of intense involvement.

But reactions also might be intensely negative. The word "aesthete" is from the Greek "aisthētē," one who perceives form. The word does not mean one who perceives good or pleasing form only, or one who necessarily likes the form that is perceived. A negative response, like a positive experience, is a unique configuration of intellectual state and physiological condition; but they are of a different nature and result. The tension created in a negative aesthetic response goes unrelieved. The intellectual state is one that welcomes, indeed cries out for, other stimuli to distract attention, and time is drawn out rather than suspended. The result is not a feeling of well-being at

all, but of doubt, loathing, or even disgust. Examples come readily to mind, making further discussion unnecessary.

The term *aesthetic judgment* tends to imply expression of opinion—a verbalization that testifies to the existence of a reaction to form. But this judgment, when expressed, rarely is manifested as the articulation of principles of performance or production informing one's reaction. Rather, the judgment usually is intuitively based, seeming to spring forth without conscious consideration or effort. The judgment may be signaled by a simple action—choosing one item rather than another, or applauding spontaneously, and so forth—or by some simple expression. Commonly a respected narrator is said to be simply "good," an effective cadence caller "experienced," an object "nice." Some events, performances, or objects are reacted to, judged pleasing, and complimented by rudimentary vocalizations, such as the exclamations "oooohhhh" and "aaaahhhh." That such kinds of involuntary expressions of *aesthetic judgment* are archaic and fundamental as well as probably universal helps account for why reference to them has proven successful in advertising. In 1977, for example, General Motors published in magazines an ad for several Buick models that was captioned at the top in large type: "Oohs, Aahs and MPGs." More recently, Pizza Hut has been airing commercials showing happy, smiling people consuming thick slices of pizza, their actions punctuated by exclamations of "oooohhhh—mmmmmmmmmmm—aaaaahhhhh!"

Because of the fact that *aesthetic judgments* often are expressed in this way, the topic of *aesthetics* could easily and profitably be referred to as "the ohhh-ahhh/ugh-yuck complex." If you've ever been to an elaborate and well-rehearsed fireworks display, you know what I mean by the "ohhh-ahhh" aspect of the complex. On the other hand, if you have had the experience of surveying your well-kept, manicured front lawn, spying in the middle of it a pile of fresh droppings from the neighbor's dog, you will appreciate the "ugh-yuck" dimension of the complex.

Yet to be considered is the matter of *taste*. The term refers to preferences based on associations and involving reactions to some aspects of the context of performance or production. In some writings, especially those in which *the aesthetic* is the focus, the word *taste* is used pejoratively; referring to something inferior, it is insignificant to our studies. In fact, however, as suggested by reports by James West (1945), Dan Crowley (1966), and others, the matter of *taste* is crucial to understanding the nature of *aesthetic response* and *aesthetic judgment.* As such, *taste* should be the primary concern in discussions of *aesthetics.*

Taste is a matter of likes and dislikes—which is generally acknowledged. There is some dispute over what exemplifies "good taste," however, and what epitomizes "bad taste." But one thing is certain: Everyone has preferences,

and these preferences are not standardized as norms of beauty. The uniqueness, rather than consistency of preferences, is so widely recognized in everyday activities that it is even expressed in a Wellerism: " 'Everyone to his own taste,' said the farmer as he kissed a cow."

The reason that this topic is so important to our studies is that *taste* serves as the framework within which an individual responds to form—whether positively or negatively—and expresses a judgment. It includes associations, relates to the context in which form is generated or experienced, and considers such matters as appropriateness. Affected by values, beliefs, and experiences, *taste* determines the nature of *aesthetic response* and *judgment.* If one finds nudity morally offensive, for example, then one is not very likely to exclaim "ooohhhh" or "aaahhhh" while thumbing through a recent issue of *Playboy.* If one disapproves of ostentatiousness, then this attitude will affect one's response and judgment, as it did one chairmaker who told me, "I like a *decent,* plain-made chair"; in his opinion the ugliest chairs he had seen were those with turnings and finials made by another craftsman in the area. Some other people, however, found these ornamented chairs more appealing than unornamented ones.

It behooves us in our research and writing, then, to take seriously and to consider the implications of such a statement as "I may not know what art is, but I know what I like." For *taste,* which is affected by experience, sensibility, and values, establishes an assumptive framework within which form-in-context is perceived, reacted to, and sometimes commented upon. "My favorite song is Stardust," remarks one man. Why? "Because the band was playing it when I met the woman who later became my wife." On the other hand, the same person might say, "I hate the song Stardust." Why? "Because the band was playing it when I met the woman who later became my wife." In the first instance a certain pleasant association endears the person to a particular form, and this association, related to the context of performance, is instrumental in producing an *aesthetic experience* signaled no doubt by some such expression as "aaahhhh." In the second instance, the *judgment* is likely to be "yuck!"

According to Carpenter (1969), Schneider (1956), and others, in many societies there is no concept of "art" or of "aesthetic." Even in our own society, in regard to what people make and do in everyday life applicability of the notion "art" is severely restricted. Just walk into someone's kitchen and ask if the well-ordered, neatly arranged cans and boxes and bottles in a cupboard, or utensils in a drawer, are a form of art: You'll be laughed out of the room. Nevertheless, James West (1945) observed that some residents of a small town in Missouri took "aesthetic pleasure" in the labeling and arrangement of jars of home-canned goods on a shelf. But so loath were they to speak of "beauty" that when admiring the countryside they were inclined to say

simply, "Them hills ain't hard to look at." Obviously, then, a philosophy and an articulation of principles of form are not necessary for people to have an *aesthetic response* or to make *aesthetic judgments.* What is required, and what all of us possess as a fundamental feature of our humanity, is a feeling for form affected by multiple experiences and expressed in varied ways.

By way of conclusion, it is sufficient to repeat that if indeed, as Boas suggested and as the most desultory observation confirms, human beings possess, by virtue of their humanity, a feeling for form, then it is no surprise that there is an *aesthetic attitude*—a predisposition to give form to many activities of human endeavor, and to appreciate the achievement of formal excellence. Nor is it surprising that success in perfecting form may stimulate an *aesthetic response,* a unique configuration of intellectual state and physiological condition, or that an *aesthetic judgment* might be expressed as some simple physical act or rudimentary vocalization. If there is any surprise at all it is that this feeling for form is directed toward so many humble and commonplace activities in our day-to-day existence: the way we dress, prepare and serve and eat food, decorate our homes, interact with others, celebrate events, and so forth. The task of the folklorist, then, is to document and analyze some of these many instances of *aesthetic attitude, response,* and *judgment,* as all are affected by *taste,* for otherwise the field of *aesthetics* will be incomplete, preoccupied as it has been with *the aesthetic.*

The Material Culture of Corporate Life

In March of 1983, the Center for the Study of Comparative Folklore and Mythology and the Behavioral and Organizational Science Group in the Graduate School of Management (GSM) at UCLA jointly sponsored an international conference on organizational folklore, which I directed with David M. Boje and Bruce S. Giuliano (the former a member of the faculty in GSM and the latter the president of Ponte Trading Company).

Called Symbols, Myths & Folklore: Expanding the Analysis of Organizations, the conference brought together 139 folklorists, organization theorists, and practitioners. Twenty-three presentations and six workshops filled the three-day event. Papers concerned ceremonials and rituals as well as aesthetic expression and play, the effects of folklore on organization and performance, leadership needs of the 1980s, and quality-of-work life issues approached through expressive behavior. Workshops focused on organization change, leadership, identity, ambience, formation, and continuity (always with particular attention to ritual, play, narrative, and aesthetic expression).

The conference was reviewed by Arthur Regan (1983) and by Marshall Ingwerson (1983). Charles Camp, who was then secretary-treasurer of the American Folklore Society, asked me to send him a description of the organizational folklore conference for publication in the American Folklore Society Newsletter, of which he was editor; it appeared in 1983.

Four other conferences were held in the United States, Canada, and Sweden during the following year and a half. I prepared a report of one, which was published under the title "Corporate Natives Confer on Culture" (1984a). The proceedings of another, Conference on Organizational Culture and Life in the Workplace (Vancouver 1984), were published as Organizational Culture, edited by Peter J. Frost et al. (1985). For the first conference, held in Oakland, California, I was invited to describe a course I was then giving on organizational folklore. For the second one, I was asked to speak on ethics, particularly some of the concerns about, and early objections to, applied folklore (voiced, for example, by Richard M. Dorson (1971).

This article originally appeared in a special symposium double issue of Material Culture 17, nos. 2–3 (Summer-Fall 1985), pp. 99–105.

I referred to the second conference, and particularly ideas voiced by Linda Smircich, in an introduction to a set of articles in a special section of *Western Folklore* (1984) called "Works of Art, Art as Work, and the Arts of Working—Implications for the Study of Organizational Life. Smircich had published "Concepts of Culture and Organizational Analysis" in a special issue of *Administrative Science Quarterly* on organizational culture (1983). At the Vancouver conference on organizational culture and the workplace, she went beyond this article to challenge the notion that culture is or necessarily should be the metaphor for understanding organizations. She suggested that organization is the paradigm of culture, not the opposite. Insisting that we must "re-conceptualize culture, organization, and ourselves," she emphasized the need to shift research from a preoccupation with culture in organization to analysis of "organization making." Organizations are, she said, "representations of our humanity—symbolically constituted worlds, and symbolic forms"; they are "displays of the meaning of life." We should consider organizational life as a symbolic construction, she proposed, focusing on symbols rather than culture and paying attention to how we "make" organizations (as participants, and as researchers entering them for purposes of study).

Not long after this, when he was editor of *Material Culture* (the journal of the Pioneer America Society), Simon J. Bronner solicited statements from specialists on material culture to assemble as a symposium. The list included Jules David Prown, John Michael Vlach, Dell Upton, Warren E. Roberts, Allen G. Noble, Thomas J. Schlereth, and me. We were asked to respond to several questions, among which were whether or not there was or could be a discipline of material culture studies, what the methods of material culture research ought to be, and what concepts and assumptions should prevail in the study of objects. Authors' reflections appeared in a special double issue of the journal (1985c), called "Material Culture Studies: A Symposium."

Essays were published without titles. However, I had called my paper in manuscript form "The Material Culture of Corporate Life." I did this for two reasons. First, I think that the material culture of organizations (whether they be incorporated or not) is one of the most overlooked, yet one of the most pervasive and important aspects of our lives as a means by which we construct our social realities; therefore, it deserves greater attention in future, which is one of my points in the article. Second, it seemed to me that Bronner was calling for not only conceptual and methodological musings but also organizational considerations. Earlier, after conferring with members of the Pioneer America Society and with members of the editorial board of the organization's journal, he had initiated a change in the name of the journal from *Pioneer America* to *Material Culture*. Obviously there was a sense of organizational purpose and objectives. Also, his questions to seven specialists writing in the symposium on material culture studies seemed to address matters of mission, philosophy, and values. Why study material culture, and how to do so? Given the many disciplines represented by material culture specialists, is there really any sense of common goals or identity, methods and approaches?

"The Material Culture of Corporate Life" appears below. In it, I define such organizational concepts as *objectives, goals, values, philosophy, purpose,* and

mission. At the end of the essay I state what I think are some of the objectives, goals, and so on of the professional association of material culture studies. In doing so, I imply that the concept of organization is relevant not only to the study of much material culture but also to the field of material culture studies as a representation of ourselves.

* * *

The setting is the offices of the Management Development Department of a major corporation in southern California. Located in a building in Marina Del Rey, this department is physically separated from corporate headquarters in Beverly Hills, where the group vice president is. A move to the corporate building is imminent, for the department (whose members now number more than two dozen) has rapidly outgrown the available space. Desks for several individuals have been squeezed into the reception area; staff must share offices even though they may be carrying out quite different functions; the noisy computing and photocopy rooms are uncomfortably close to where people are trying to concentrate on developing training programs; and a number of rooms have been given over to multiple uses, adding to the confusion and noise. The production room, for example, often serves as a hallway between the front and back offices. Recently a sign was posted on the production room door: DO NOT USE THIS ROOM AS A HALLWAY. Obviously it was to no avail, for a second sign soon joined the first: THIS IS NOT A BARN. PLEASE CLOSE THE DOOR! Later someone crossed out the word "not."

The signs are expressive and symbolic. Explaining how and why can provide understanding of human behavior and organizational life generally as well as more specifically the relationships within these offices and between this department and corporate headquarters. Demanding that the production room not be used as a hallway flies in the face of the human propensity to economize motion. Because attempts to dictate behavior often fail, especially when edicts go against human nature or deprive individuals of their autonomy, other means of influencing behavior are required. The second sign recognizes that people will use the room as a passageway; it requests that in doing so an individual extend a common courtesy to others. Before stating the injunction PLEASE CLOSE THE DOOR! the sign reminds one of the situation using metaphor from a familiar expression. THIS IS NOT A BARN gives an explanation, therefore, of the reason for keeping the door closed; the incongruity of offices/barn provokes a ludicrous image likely to precipitate a knowing nod and perhaps the beginning of a smile. Crossing out the word "not" is a metastatement: the room (read departmental offices as a whole) is not a barn—but might as well be. The final act in the sequence of three creates a fundamental response in human beings, laughter, even if it is

"gallows humor." By thus "humanizing" the work place, the sign proves effective. When someone does not close the door, others joke and banter with the transgressor, which leads to appropriate action while also producing a degree of fellowship and community rather than conflict.

There is more. In spite of the crowded quarters (or perhaps in part because of them), relations in the department are generally cordial. The image of "family" prevails in speech and stories. Further testifying to the spirit of fellowship is the frequency with which department members have parties, especially birthday celebrations. Some tension exists, however, between the department and corporate headquarters. Upper management has not always been consistent in its treatment of employees, or fair; stories give details and express the effects on morale and therefore productivity and quality. Rumors have it that at corporate offices people are distant, cordiality is rare, and there are few parties—a certain indication, it is thought, of little fellowship and a lack of personal satisfaction.

To return to the signs on the production room door: The final act of crossing out "not," thus communicating in an amicable way the intended message about closing the door, seems to characterize the feelings, attitudes, and style of the Management Development Department as remarked upon by members themselves. Note, however, that the first sign was not removed, although the injunction DO NOT USE THIS ROOM AS A HALLWAY is irksome. Rather, the first sign remains juxtaposed to the (altered) second one. Why? Leaving the first sign up provides the history of the process by which the message evolved. The two signs and one alteration taken together poignantly remind that all people in an organization are in fact "organizational participants" and human beings engaged in a common enterprise, and they take the reader of the signs through the steps required to achieve this understanding and appreciation; in this regard, their influence far exceeds that of causing someone to close the door on noise. More speculatively, the juxtaposition of signs may also be read by some people on occasion as expressing the difference between corporate headquarters (upper management) and the department in their treatment of people; it might strengthen the resolve of department members to be humane rather than insensitive; or perhaps it expresses the anxiety felt about the imminent move to corporate headquarters.

Experiencing Organizations

Susan Montepio, a student in the Ph.D. program in folklore and mythology at UCLA, provided me with the information above concerning signs, space, stories, and celebrations. She took a graduate seminar from me recently called Organizational Symbolism and Corporate Culture. Whether history

and economics majors, folklore students, or individuals in the MBA program (with concentrations variously in marketing, planning and strategy, and human resources), all 15 who took the course were required to submit a paper describing and analyzing expressive behavior in an organization. Most focused on stories and speech forms, and some on rituals and cere-monials—in about the same proportion found in the growing body of litera-ture on organizational symbolism. Only Ms. Montepio included information about material culture, in part perhaps because the cramped space was an issue for department members. For all the attention being paid by researchers now to stories as an index of values and attitudes, however, it is the use and decoration of space, the physical facilities, and other objects that a visitor immediately perceives on entering an office and from which is gained an initial (and sometimes lasting) impression of the ambience, philosophy, and preoccupations of the organization. Material culture in the form of memos, missives, and documents; office or other technology; and work surroundings may express or be thought to indicate relations among organizational participants, "the way things are done around here, and why," and how various levels conceive of and treat others. The way in which we decorate our personal space at work can symbolize who we are or wish we were or would like others to think we are. The nature of the information we put into written form, and the manner, may suggest much about our values, concerns, and conceptions—or be taken by others as revelatory.

I hope my interpretation of the signs on the production room door in the Management Development Department is defensible. Whether correct or not, my inference helps me make a point in this essay. By their nature, members of the species called *homo sapiens* are expressive. We seek to communicate messages in multiple and varied ways. In addition, whether a particular statement was intended or not, we often infer meaning. Sometimes the most poignant messages are communicated, or momentous meanings are inferred, from the most prosaic actions and mundane objects.

Behavior or Outputs of Behavior?

More research needs to be done on material culture. For tools, technology, and the built environment literally surround us. Perhaps the most overlooked realm of life in which to study objects is that of the workplace. It is here that most of us on an almost daily basis spend at least half of our waking moments. Because material culture is subject matter rather than perspective or discipline, it can and indeed should be examined by individuals in various fields; art historians, management theorists, and folklorists, to name only a few, could develop a transdisciplinary approach to material culture study enhancing the understanding and appreciation of human behavior. Essential

to such an endeavor, however, is the realization that the field of inquiry which focuses on material culture should not be limited to things alone. In the example above, people *made* the signs and *responded* to them; analyzing the signs as outputs of behavior requires knowledge of the situation and benefits from having other data such as stories, speech, and celebration. In addition, material culture studies, so called, should not make "society" or "culture" the prevailing or exclusive concern of investigation but ought to promote research as well that considers individuals and particular interactional networks. Finally, the potential for application must be realized. In this instance, members of the Management Development Department asked Susan Montepio to give a presentation at one of their meetings. She quoted some of the comments she had overheard or elicited earlier about the role of birthday parties in helping achieve fellowship, contributing to departmental functioning, and enhancing communication. She cited some of the themes of narratives, noting especially differences in attitudes of department members toward the former and present leadership. She remarked on the anxiety felt by department members about the prospects of moving to headquarters. The group vice president from the corporate office attended this meeting. Informed and impressed by the presentation, she promised that when the department moves to corporate headquarters the members will be permitted to continue their parties—a statement that itself is expressive, symbolizing to many the changing policy of management toward a more humanistic approach. Studies of material culture, then, not only offer insights into the human condition but can also serve as a basis for altering the situation to provide pleasant social and sensory experiences, purvey good will, and promote a sense of well-being, thereby achieving what many of us hope to derive from organizational life but rarely do.

Material Culture Audit

Formal statements of philosophy, policy manuals or rule books, and materials used for recruitment or distributed to customers state or imply, whether intentionally or not, values, assumptions, preoccupations, and a tone or feeling about the organization. In many corporations now, for example, a professed value is that of human welfare. Yet the typical statement of objectives given to employees is badly written and filled with jargon; few would be tempted to read it, fewer still would understand it, and probably no one would feel inspired. Moreover, in many instances people are not mentioned until well into the document, and then they are referred to as "human resources" or "assets" (on a par, presumably, with financial resources and raw materials).

More positively, in regard to materials distributed to employees, TRW Electronics and Defense has prepared an attractive portfolio consisting of

several readable and profusely illustrated items including "A Guidebook to How We Work" (unposed photos of ordinary people of different ethnic backgrounds, simple prose, and appropriate quotations from Oliver Wendell Holmes, Jr., Victor Hugo, John Ruskin, and others). Excellon Industries, producer of precision drilling machines for the printed circuit board industry, has a publication called "Hits & Chips," which details, through a homey personal narrative by its founder and chairman of the board, how "It All Started in the Garage..." "Inside Versatec," given to new employees, contains a section called "Our Traditions" describing festive and celebratory behavior as well as such material culture as the conference room table which several executives made by hand. The book notes, in obvious awareness of messages communicated by objects: "One thing everyone likes about Versatec is that management scorns the usual preferential reserved parking spaces and 'mahogany row' atmosphere. Instead, a comfortable friendliness prevails."

Not so many years ago, few companies considered what they were communicating in their annual reports to stockholders and the general public. Increasingly more, however, are trying for a highly individualistic, personalized style, one that purposely avoids banality and corporatese. Extremes in recent years (during the worst recession in decades) include Package Machinery's letter to shareholders that the preceding year was exciting, "if you like that hollow feeling of insecurity in the pit of your stomach." Tektronix used self-deprecating headlines including "A Swell Idea Backfires," and "Our Problems Mature."

When immersed in organizational life, we rarely note much of what we are conveying through our behavior and outputs. If one were to do a "material culture audit," however, it would have to include such matters as the amount of communication by memo (as opposed to firsthand interaction), and what this conveys or is inferred to mean; the length of some memos and the number of pages of reports and statements of company philosophy; and the kinds of information that are disseminated in written form, as well as the style. It would document the agenda of staff meetings and thus the priorities of some managers; the settings of activities; and the time devoted to various tasks or activities. Is there consistency between professed values and what is signaled? Is the organization alleged to be a "people company," for example, when in fact a material culture assessment reveals that communication is primarily through written rather than interpersonal form, that more time is spent behind closed doors than with people, and that interaction is impaired by the design of space? Material culture visibly supports, or detracts from, policy. It can be used as a tool by concerned and dedicated organizational participants wishing to create the kind of ambience that leads to fellowship and community. For example, the quality and quantity of tools, supplies, and raw materials often are symbolic of the importance

attributed to people, their skills and tasks; providing some individuals with the latest and best equipment may leave others disgruntled and disaffected. Speaking of "unskilled" or "semiskilled" tasks to someone about to engage in them, or referring to what someone does as "only," "merely," or "simply," rarely builds a sense of self-worth and self-esteem. Pride in skills and identification with others sometimes results from training that emphasizes not just how to do the task but the history, rituals, stories—the human element—surrounding the activity. Seemingly costly in the short run, setting aside "sacred" time and space from the "profane" in which to interact, talk, and celebrate can be uplifting and pleasing, transcending work and transforming organizational life.

Organizational Concepts

The questions posed by Simon Bronner for this symposium are organizational questions, calling for a discussion of purpose, philosophy, and objectives. In my research on the material culture of corporate life, I find a great deal of uncertainty among organizational participants as to what characterizes and distinguishes several phenomena. In my view, *objective* is immediate, an end or aim of action soon realized, whether it be the sale of a product, the preservation of a particular building, or the publication of an essay. *Goal* is striving towards the achievement of something, an end to which a larger design tends; in religion it might be the winning of converts, and in a game one of the bounds or stations towards which players attempt to advance. *Values* are principles and precepts held in high esteem and considered by us as precious. *Philosophy* in an organization is that body of principles governing conduct in regard to all matters; it includes values, and it is based on assumptions about right behavior. *Purpose* is an aim that we propose for ourselves; it is our resolve. *Mission* is a sending forth to proselytize; it is that special errand or commission that in the extreme is thought of as calling or destiny, for it gives ultimate purpose to our lives and activities transcending the mundane world.

Of all the concepts, mission seems to be the most important. Whether articulated or not, it permeates the successful enterprise, infusing it with a sense of distinct character and uniqueness around which organizational participants can rally their efforts, draw upon inner strength, and undertake courageous acts when confronting the untried and uncertain. While objectives sometimes are upgraded to the status of goals or purpose, and values to the philosophy, mission rarely is defined or discussed by organizational participants; when it is expressed, usually it is downplayed by being called something else. An example of a statement of mission comes from a Japanese-owned electronics component maker in California. Called

"Management Philosophy," it reads: "Our goal is to strive toward both the material and spiritual fulfillment of all employees in the Company, and through this successful fulfillment, serve mankind in its progress and prosperity." In what is referred to as "Management Policy," an elaboration of this mission is given that implies organization as human enterprise, namely, that "Our purpose is to fully satisfy the needs of our customers and in return gain a just profit for ourselves. We are a family united in common bonds and singular goals. One of these bonds is the respect and support we feel for our fellow family coworkers."

Material Culture Studies

Below I state what I conceive to be some of the objectives, goals, and so on of the professional association of material culture studies.

objective to study objects and their manufacture, functions, and use wherever we encounter them, including in the workplace and as a part of organizational life

goals to develop the concepts and methods appropriate for a multi- or transdisciplinary perspective in the things that people make and what they do with objects

values that the study of material culture benefits from the combination of research questions basic to many disciplines or fields of study and from the application of skills of such varied scholars as art historians, cultural geographers, folklorists, museologists, management theorists, and historians, among others

philosophy that while the focus may be on objects (the "material") as outputs of patterned behavior and expressions of values (the "culture"), research should include attention to the act of making and doing, to the conceptualizing of and responding to form, and to other activities engaged in by specific individuals in interaction with others that will help us understand the nature and reason for the existence of the objects

mission to understand human behavior, to enhance appreciation of what people make and are capable of accomplishing, and, when appropriate, to apply our insights to help improve the quality of life

Preaching What We Practice: Pedagogical Techniques Regarding the Analysis of Objects in Organizations

"If one direction is inward to the isolated self, then another direction is outward to the communal other. More than entailing a concern for groups—ethnic, occupational, or regional—the communal other is organizational. It exists in different organizations of social structure," writes Simon J. Bronner (1986:125). "The broader implication of *organization* was its vision of society," continues Bronner, "much as performance and function provided their own. . . . In a modern society that was noted for its increasing individualism, institutional settings define more identities: the office, the military, the city, the media, the school, the profession, the government. More cultural associations are voluntary and overlapping" (Bronner 1986:126).

Bronner concludes his book on intellectual currents in American folklore study by writing that "the organizational current is not the only investigation that is suited to problems of folklore, but it moves to the fore because it proposes to reveal what is of most concern in a future-oriented society—the present state of the modern world and its guiding structures for the future." Moreover, "as folklore studies increasingly moves outside the academy, as it becomes more subject to organizational differentiation, and as it lodges in governmental agencies, foundations, corporations, museums, and libraries, then the keyword *organization* may balloon into a prominent theory of folklore studies" (Bronner 1986:128).

A new field of study requires time to develop. Concepts need clarification, assumptions must be considered, and questions for research have to be articulated. During the early stages, ideas might be expressed and developed less in articles and books and more in working papers, conferences, reports and reviews of conferences, and even correspondence. So it has been with the field of organizational ethnography (see, for example, McCarl 1984b; Jones 1985b).

The concepts of "culture" and "symbols" (traditional, expressive forms or "folklore") were not used in any meaningful way or with particular significance in the

This article is a revision of a paper originally delivered at the American Folklore Society Meeting, held in Baltimore, Maryland, October 22–26, 1986.

literature on management and organizational science until the late 1970s. "Organization" and "organizational folklore" entered the lexicon of folklore studies in 1983 as a logical extension of some of the implications and ramifications of occupational folklife research of the preceding decade. In addition to papers being given at special conferences or at the annual meetings of professional societies, numerous works are being readied for publication.

Questions arise not only about the nature of such a field of study but also about ways to instruct students in carrying out organizational ethnography. In the mid-1970s I published papers on pedagogy, including (with Kenneth L. Ketner) "Folkloristic Research as a Pedagogical Tool in Introductory Classes" (1975) and "Films for Finals" (1976c). More recently, I was asked to contribute to *Art in a Democracy,* edited by Doug Blandy and Kristin Congdon. Because the book is to be published by the Teachers College Press and is intended for art educators, I wrote about "Making Work Art and Art Work: The Aesthetic Impulse in Organizations and Education." I also prepared "In Search of Meaning: Using Qualitative Methods in Research and Application," an essay to be included in a volume I am coediting. And a longer version of the article appearing below, called "Objects and Organizations: Material Culture Study at Work," will be published in the proceedings of the recent conference North American Material Culture Research: New Objectives, New Theories, jointly sponsored by the Winterthur Museum and Memorial University of Newfoundland, and directed by Gerald L. Pocius, who is editing the volume.

In recent years I have given courses on occupational folklore, applied folklore (focusing on medical research, museum work, and/or public sector folklife), and organizational folklore. Students are of varied backgrounds; they include folklore and ethnic arts majors but also those majoring in economics, industrial relations, arts management, human resources, and behavioral and organizational science. Often I have required students to carry out field studies (although the quarter system imposes some constraints not suffered by those who are on the semester system). To facilitate this, I have developed internships at a variety of organizations: companies in electronics, communications, home products, and health care; not-for-profit corporations including universities, churches, and government agencies; and also organizations that are not incorporated. Some of the internships carry a stipend; most do not.

Although perhaps desirable for certain purposes, it is not necessary for a course to be on a semester system or for students to carry out extended research projects. When she was a teaching assistant, for example, Susan Scheiberg (B.A. in folklore from Indiana University, and M.A. in folklore and mythology from UCLA), who is now in the Ph.D. program in folklore at UCLA, brought her students in an introductory American folklore class to the teaching assistants' office in our suite. Her purpose was to show the students examples of the teaching assistants' personalization of the office both outside and inside—including her own decoration of the area around her desk. Susan Scheiberg had students analyze what they saw and speculate about possible motivations and meanings.

In the paper below, I describe several techniques that I have used in classes on folk art and organizational folklore. The purposes of using these pedagogical

techniques are explained in the essay, which I gave at the American Folklore Society meeting in 1986. In some classes, the techniques prepared students to do field studies; in others, the techniques had different purposes. In the longer version of this essay, I consider not only pedagogical techniques but also the processes by which we make inferences from objects in an organization.

* * *

Although symbolic behavior abounds in organizations, we know less about it than we do folklore in other social settings. Are these forms expressive of values, attitudes, and opinions? If so, what do they express, to whom, and under what conditions? If they are not consciously intended to be symbolic, are they nevertheless "read" by people as clues to what the organization is, how members should behave, and why things are done the way they are? What, in sum, does organizational folklore study reveal about human behavior generally and about ways of doing things in particular organizations?

I address these and similar questions in a seminar on organizational folklore. To do so, and to teach observational and analytical skills to students, I employ a variety of methods. One is to show videotapes of a general manager and a president at work. Another is to distribute for examination printed materials given by firms to employees. Others include role playing and projective techniques.

In this paper, I describe such classroom exercises and pedagogical devices on the assumption that they might be useful to others who teach students how to identify, document, and interpret symbolic behavior in organizational settings.

Identifying Expressive Forms

Among the dozen courses I give, one is on organizational culture and another concerns folk art and technology. In the first class meeting of both I usually show two videotapes. One tape concerns a day with Fred Henderson, general manager of the Western Division of Xerox Corporation (Kotter 1981a, 1979). The other tape's subject is Renn Zaphiropoulos, president of Versatec, the world's largest producer of electrostatic printers and plotters (Kotter 1981b, 1980). The only introduction I give is to point out that neither tape isolates and identifies folklore but that both tapes might nevertheless be of interest to folklorists.

As we view the tape of Henderson, we see from his desk calendar that the day he was filmed began early and was given over to preparing for an awards ceremony that night honoring the division's sales people. Henderson, in a dark three-piece suit and white shirt, is shown in an expensively appointed conference room discussing in detail with his subordinates the agenda and

some of the sales facts and figures to be presented. He asks others their opinion of a film to be shown that night, which is intended to inspire sales personnel but which Henderson insists might not be as good as the previous year's. He commandeers someone's office to pursue the matter in private conference with one of his staff. At the end of the film, we see Henderson beginning his speech to the assembled sales personnel, perhaps less tense than earlier but no less "intense."

By contrast, Zaphiropoulos had nothing pending on his schedule, and jokingly admitted it; this is a "typical" day, he said. Dressed in a blue shirt and red tie without coat, he was seen wandering through the offices and plant—"managing by walking around"—kidding with secretaries and workers, commenting on the aesthetics of a poster that a staff member designed (and admonishing him not to distribute memos urging people to work harder), talking with a colleague about the coming holiday celebrations and vacations, dictating a letter regarding the mission of the company, and philosophizing to new employees at an orientation meeting. The company motto—"Be Bold!"—is often in evidence.

After showing the videotapes, I ask students a series of questions the answers to which are not given in the visual materials. For example, I list a dozen or more strengths cited by employees on other occasions (and summarized in a booklet accompanying the videotapes), asking students whether the individual described as "strong-willed," "competitive," "well-organized," "tough-minded," "precise," and so on is Henderson or Zaphiropoulos. Most correctly say Henderson. All agree that the person described as "very personable," one who "tends to be protective of the underdog," "a very strong person," and so on is Zaphiropoulos.

I also list several weaknesses according to the men's peers and subordinates. Students correctly identify Zaphiropoulos as the individual who "can be an optimist always, though sometimes I wish he were more of a realist" and "can be too forgiving at times." They agree unanimously that Henderson is the one about whom others said he is "too intense," he does "not delegate enough," and he "manages conflict by being very confrontational."

When I read memos by each man, students identify Henderson as the author of the one with turns of phrase such as "our key challenge," "accountability and demonstrated leadership," and "competitive and cost effective environment." They correctly attribute to Zaphiropoulos the authorship of a memo referring to his view of management as "an art," to his thinking of himself "as a gardener, as an arranger, as a creator of climate," and to his notion of managing as a process of helping people "grow."

"A plaque hangs in each man's office," I tell students. "In whose office will we find the one that reads 'Excellence is a state of mind'? In whose office

is the plaque that says 'Do not follow where the path may lead. Go instead where there is no path and leave a trail'?" The students are correct: the first plaque mentioned is in Henderson's office, the second is in Zaphiropoulos's.

"Which man's office is likely to have numerous photos of his wife, children, and boat; to have many signs and pictures; and to appear somewhat 'cluttered'?" I ask. "Zaphiropoulos!" they respond. "Whose office is best described as 'modern', 'tasteful', uncluttered?" The answer is obvious.

Having seen only a few minutes of videotape of each man at work, the students are able to attribute to him the strengths and weaknesses articulated by others, identify which person wrote which memo, predict which plaques will appeal to which individual, and ascertain without ever having seen them the way in which the offices are decorated. How?

In the discussion that ensues, it becomes apparent to students that their inferences are based on certain expressive forms and communicative processes they have perceived, to objects and the ways in which they are used, to physical settings, and to the social environment that affects and is affected by the tangible surroundings. Dress and appearance, the décor and appointments of rooms, language, ritual interaction, ceremonies, joking, festive events, storytelling: these and other forms and processes in everyday life, captured on a few minutes of videotape (without conscious effort to do so), provide the cues for understanding behavior, inferring values and concerns, and predicting actions. Words, actions, and things: all are capable of conveying meaning, or may be responded to as meaningful.

Interpreting Documents

In order to put students in a course on organizational folklore into the shoes of new employees, and also to begin to prepare them for doing fieldwork, I distribute materials that several firms give to those recently hired. These items include, variously, company newsletters, an employee newsletter, promotional or commemorative publications, and/or handbooks containing rules and regulations or guides to behavior in the organization. We consider each company in turn. Without telling them so, I begin with a company not historically preoccupied with its employees' welfare and end with one many of whose members proclaim it to be "people-oriented."

I say little by way of introduction to the materials, only noting that here are some items distributed to newly hired employees. After students have examined a firm's newsletters and other documents, I ask them a series of questions, including the following:

> Is there a sense of the organization's core mission or ultimate function in society? What does the organization seem to value?

Is there an appreciation of the history, ethos, and uniqueness of the organization, and of individuals' contributions to it?

Are interaction and communication in the organization likely to be principally through a status system that maintains role boundaries, a hierarchy of authority, and strictly defined lines of communication? Or is the organization probably more equalitarian in nature, with open communication and participatory decision making?

Are people likely to be trusted, and treated as "adults"?

Will individual achievement be recognized—often and informally as well as on formal occasions?

Is the work environment likely to be competitive or cooperative?

Are organization participants likely to remark on the meaningfulness of their experiences, fellowship they feel with others, and personal satisfaction they enjoy at work; or are they more likely to complain about the lack of respect, rewards, or caring?

Do you want to work for this company?

One item, for example, is a full-color 8½-by-11-inch booklet identified as the firm's 1981 review for employees. There is much to respond to, note, and analyze in its 48 pages. For the moment I will mention only a couple of features.

There are numerous graphs and charts. To many of us, statistics and graphs are "cold, hard facts." They are certainly precise, succinct, and highly logical and rational; they do not evoke feelings of warmth, sociability, the free reign of imagination, or play.

For the most part, the drawings and photos are of company products. If people are shown with the products or in labs, they occupy only a small section of the frame, thus seeming to be subordinated in importance to technology. The few full-page photos of people depict vice presidents apparently visiting their respective divisions.

Students perceive the deference to titles and status, the dependence on hierarchy and a vertical chain of command, and the lack of public recognition of and attention to individuals who are not corporate officers. Reference throughout the booklet to "the Company" with a capital "C" seems to reinforce an image of the organization as an entity in its own right that is beyond the capability of anyone to affect it. Some students notice that in a photo near the end of the booklet of the company "team"—depicting what presumably is a representative sampling of lower-level employees—the 15 individuals are not interacting with one another but are walking en masse,

each independent of the other; the fact that they are *leaving* the premises is sometimes remarked upon for what it implies.

To some extent, overall impressions are confirmed by on-site research that has been done by others. Stories about the founder emphasize his penchant for secrecy, obsession with control, and manipulation of others. He is remembered as a technological genius in quest of engineering perfection who had little time for people. There is not much celebration in evidence in some areas, or festive feeling.

But there is also a cycle of stories about a third generation leader evincing a very different set of themes. This man is portrayed as sympathetic to employees, understanding, and concerned: something of a father figure rather than a trickster, like the founder. And certainly many individuals derive a degree of personal satisfaction in what they do and from their work group; one lab, in particular, is marked by great camaraderie. Moreover, many of the mid-managers and their superiors express a desire to change the organization. The booklet's reference to an opinion survey in 1981, "first in Company history," was indeed a step in the direction of ascertaining what the concerns and expectations of organization members are.

Through this exercise of examining materials from *both* organizations that are not particularly noted for their people-orientation and those that are, students begin to consciously consider the importance to organizational participants of recognition and rewards, meaningfulness, fellowship, and personal satisfaction. They gain greater appreciation of how and why they make the inferences they do. They also begin to realize that first impressions, though important and telling as hypotheses, are not sufficient; understanding complex situations requires amassing more information, bringing to bear more concepts, and examining circumstances in increasingly greater detail.

Inventories, Observations, and Projective Techniques

No one object or a few individuals' behavior represents the whole of an organization. We have to consider how objects are used variously by different people, ways in which they are altered or manipulated, when they are emphasized and by whom and for what reasons, and how they are reacted to on varied occasions. We must appreciate that there are contradictions between what people say and what they do or what the material culture over which they have control communicates. We must realize, too, that not everything is intended to be expressive—although nearly everything is capable of being interpreted by someone some time—and that what is expressed may correspond to reality or it may be a projection.

To teach these concepts, I take students in small groups to nearby offices to observe and compile inventories. They note especially how chairs are

arranged at or near desks, what information is publicly posted on walls or bulletin boards and how the materials are arranged and displayed, and ways in which people personalize their space with cartoons, photographs, slogans, and posters. They compare one office with another in the same unit; sometimes I have them compare their own records and interpretations with one another.

I have also had people draw maps of their units. One can assume that familiarity breeds accuracy; one's own work space and other areas one frequently uses are well in mind, their general dimensions and their relationships to each other clear. But some objects or spaces are rendered larger or smaller than is in fact the case, or they are drawn with attributes they do not possess. One person whose office is noisy to distraction drew the walls very thick—a matter of wishful thinking.

Summary and Conclusions

Of course, students in the seminar on organizational folklore also read and discuss Bell's "Tending Bar at Brown's: Occupational Role as Artistic Performance" (1976), Dandridge's "Organizational Symbolism: A Topic to Expand Organizational Analysis" (1980), McCarl's "Describing the Critical Center: Approaching Work Cultures from an Applied Ethnographic Perspective" (1979), and other articles and papers on organizational folklore and occupational folklife.

The purpose of these and other pedagogical techniques is to help students develop skills at isolating, documenting, and interpreting material culture and expressive behavior at work. The process of instruction also helps students understand their own behavior. In addition, attention to data from and about particular organizations results in the students appreciating more fully the nature and concept of "organization" generally. They realize, for example, that "organization" has its structural, formal, rule-oriented dimension; and they appreciate that "organizing" is a fundamental human endeavor and need, one that evokes expectations of meaningfulness, fellowship, and personal satisfaction as people cooperate and communicate to carry out common goals and objectives.

In conclusion, I would note that every organizational participant functions in terms of two models—the first, the experience of and assumptions about the rule-driven "formal organization," and the second, the experience of and expectations generated by the informal or "spontaneous organization" and of "organizing" as a phenomenon frequent in everyday life. The study of expressive behavior in organizations can lead to a fuller understanding of both aspects of organization, reveal participants' expectations of and about the

particular organizations of which they are members, and perhaps generate inferences about how to design, manage, or change organizations so that they fulfill their mission and participants' expectations.

Given the pervasiveness of organizations in our lives, there is much organizational folklore to study. And there are compelling reasons to do this research—precisely because organizations *are* so pervasive, serving as a work place for most of us and in other ways affecting our lives for good or ill.

Epilogue

Some of my publications and papers grew out of my teaching experience at UCLA. During the year and a half that I worked on my dissertation after leaving Indiana University, for example, I presented in folk art classes many of the ideas I was developing. *People Studying People: The Human Element in Fieldwork* resulted from Georges's and my having taught research methods, realizing as we did so that there was much more to the fieldwork experience than had been treated in the publications we asked students to read. But it was administrative responsibilities and service that intensified my interest in organizational folklore as well as aesthetics and material culture at work.

Because I began the prologue on a personal note and in introductions to the 11 articles in this volume I try to give some of the context in which the papers were written, it seems in keeping with the book as a whole to provide information regarding the directions in which my research is now moving. In 1982 I was appointed vice chairman of the UCLA Folklore and Mythology Program, an interdepartmental program empowered in 1965 to offer the M.A. degree (and in 1978, the Ph.D. degree) in folklore and mythology. Serving more than 60 graduate students, the Folklore and Mythology Program is composed of eight core faculty and two dozen adjunct faculty who teach more than 70 courses in folklore and mythology. In 1983 I was acting chairman of the program when Robert A. Georges, chairman, was on leave. In 1984 I was appointed director of the Center for the Study of Comparative Folklore and Mythology, an organized research unit founded in 1960. In order to promote and facilitate interdisciplinary research on folklore and mythology, the center maintains a large library and five major archives; staff include an administrative assistant, a librarian, an archivist, and several research assistants. The center organizes and sponsors workshops, symposia, and conferences; oversees a publication series; seeks funding for research projects and administers grants and contracts; and develops special programming both on campus and off.

As an organizational participant whose appointment is in one unit (the History Department) but whose teaching and research responsibilities lie in

another (the Folklore and Mythology Program), as an administrator (first of a teaching program and then of a research unit), and as one whose activities are supervised by others, I have had a particular interest in organization design, culture, and management. This personal involvement finds expression in some of my teaching, research, and administrative activities.

To give one example, I am a member of the UCLA Administrators and Supervisors Association (ASA), a diverse group of staff and faculty. On 20 November 1985, the ASA held a panel composed of faculty, staff, and administrators who addressed the question, "Can UCLA Adopt Lessons from America's Best-run Companies?" No consensus emerged. Remarks by panelists and some of the 90 or more attendees suggested that, on the one hand, many individuals and units in this large and complex organization evince a sincere concern about members but, on the other hand, sometimes organizational goals are unclear, people feel they are not trusted or given the necessary resources to carry out their tasks and responsibilities, and individual accomplishments are not always recognized.

If the panel in November of 1985 articulated some of the concerns, then another panel on 20 February 1986 suggested some solutions. Called "The Staff Role at UCLA: Strictly a Job or Part of the Family?" the panel was composed of representatives of labor and employee relations, supervisors, a department chair, a vice chancellor and the campus ombudsman. A consultant to Employee Relations, Staff Personnel, identified several "pockets of excellence" at UCLA. Noting that many individuals and even units as a whole attempt to achieve a family feeling and to provide recognition—often through rituals and celebrations—he insisted that "we need to *dramatize* excellence and good performance." By the end of the discussion, many of the panelists and audience were describing examples of traditions attending to social, aesthetic, and symbolic needs and expectations of organization members. Moreover, they were suggesting that such traditions need to be documented and communicated in order to encourage their continuation where they exist and development where presently they are lacking.

At the time, I was coediting a volume on organizational ethnography; completing an article for Blandy and Congdon's *Art in a Democracy* called "Making Work Art and Art Work: The Aesthetic Impulse in Organizations and Education"; preparing "Objects and Organizations: Material Culture Study at Work" for the Conference on North American Material Culture Research: New Objectives, New Theories, directed by Gerald J. Pocius; and writing "In Search of Meaning: Using Qualitative Methods in Research and Application" for the book I was editing. As director of the Folklore and Mythology Center, I was administering contracts and grants, supervising staff, and seeking funding in support of a symposium and other events celebrating the twenty-fifth anniversary of the founding of the center and the twentieth anniversary of the

establishment of the teaching program in folklore and mythology. I was also teaching a graduate seminar on organizational folklore, and, with other members of the Organization Studies Group (one of several research groups under the auspices of the Folklore and Mythology Center), giving a series of public workshops in a local library on organizational culture and symbolism. In other words, I was immersed in the subject of organizational life and therefore attuned to the February ASA panel.

One of the messages of both panels seemed to be that many people at UCLA were aware of and wanted information about networks of support generated and sustained largely through traditions (stories, rituals, kidding relations, celebrations, customs of cooperation, and so forth). What appeared to be called for was a folkloristic study. Accordingly, I prepared a proposal.

"Bringing Out the Best in Us": A Research Project on Organizational Traditions

What traditions at UCLA provide individuals with recognition, fulfill needs of belonging, demonstrate trust, convey a sense of caring, generate the feeling of family and community and reward excellence and creativity?" I asked in the proposal I prepared following the panel on the staff role at UCLA. "Why should these practices be perpetuated where they already exist and instituted where presently they are absent?" In addition, "How can behaviors, traditions and ways of doing things that we perceive as 'bringing out the best in us' be documented and then communicated campus-wide as models of 'positive management practices'?"

The proposal was only a preliminary one, of course. During the next five months I met individually and in small groups with nearly 60 people in a wide range of job titles to discuss and develop the proposed research on traditions and expressive forms in our organization that articulate or fulfill social and aesthetic needs of members. They in turn talked to their supervisors or, if they were in supervisory roles themselves, to their staff (and also to those at administrative levels above them). Participants ranged the gamut from clerks, bibliographers, and secretaries to their immediate supervisors as well as representatives of labor relations, consultants in employee relations, faculty, department chairs, trainers, administrative assistants, management services officers, assistant deans, assistant vice chancellors, and vice chancellors.

A final proposal for research was generated out of this extensive cooperation and collaboration, one that set forth a pilot study with objectives of compiling and disseminating information about traditions and expressive forms but also of developing and testing several hypotheses. The pilot project offered an opportunity to explore the assumption that feelings of self-worth

and dignity at work and in an organization are linked to a supportive social context, ascertaining for future study what factors might bear on the development and maintenance of networks of support; what universals obtain regardless of the effects of a unit's size, functions, overall style, clients or other factors; and what the social and aesthetic needs of organization participants are that are met by various traditions as well as why, when, and how these traditions function in this way.

Although only a pilot study, the research is extensive enough to require assistance. Funding from the Academic Senate (which provides faculty with small grants for research) in combination with additional support from Research Programs and also the Office of the Administrative Vice Chancellor made possible the hiring of part-time research assistants, beginning in late July. The assistants are students in the Ph.D. program in folklore and mythology. They include Susan Montepio (who is combining folklore studies and applied anthropology), Susan Scheiberg (who is majoring in folklore and communications), and Peter Tommerup (who is taking behavioral and organizational science as an allied field with folklore studies). The three have had previous experience in organizational ethnography, having carried out research at Hughes Aircraft, TRW, American Medical International, Kaiser Permanente, several small businesses, and numerous ethnic organizations and not-for-profit corporations.

An advisory committee has been assembled. Composed of a dozen members, this committee, like the research and everything else about the project, represents as broad a spectrum of interests as possible. As I write this (the end of December, 1986), the pilot project is well under way although by no means complete. The assistants and I have interviewed several dozen people in a variety of units, met frequently to confer among ourselves and discussed the research in progress with individual members of the advisory committee. We have given feedback to those we interviewed. In January we will have lengthy meetings with the advisory committee as a whole, not only to describe the research to date but also to seek advice and recommendations for both future study and additional means and manner of disseminating information.

Besides making presentations to individuals and units directly involved in the research, we are scheduled in April to constitute a panel at a meeting of the Administrators and Supervisors Association, which will be widely announced on campus, an arrangement made months ago when the pilot study was being developed and shaped by various participants. We have also been invited to discuss the use of qualitative methods in the study of organizations at the annual meeting in April of the American Association of College Registrars and Admissions Officers; our session will be called "Doing Ethnography in Organizations: Methods and Techniques of Applied Qualita-

tive Research." Also in April we will be participating in the annual meeting of the Western Academy of Management in a session called "Performing Well: The Impact of Rituals, Celebrations, and Networks of Support." Our presentations, based on research at UCLA and other organizations, concern the range and variety of expressive forms manifested in organizational settings, the personalization of work space, rituals and celebrations, and the concept of "self-management." Rather than ignoring organizational problems, we seek solutions to them from within as offered by members themselves.

"The stories that people tell, the ways they decorate their work space, ceremonies in which they take part, and ritualistic interaction provide data essential to understanding human concerns and the culture of an organization," I wrote in the booklet *Folklore/Folklife* (1984b:14). "Forms of expressive behavior and aspects of organizational culture may play an important role in clarifying and communicating organizational philosophy and objectives, enhancing managerial styles and methods, and improving life in the workplace."

In other words, forms of folklore generated in organizational settings or about organizations constitute a source of information regarding attitudes, values, and concerns of organizational participants. These might be favorable, of course, or unfavorable. Stories, language, and other expressive forms may also suggest the conditions and relationships desired by organizational participants and even provide models for instituting them. Celebrations, rituals, personalization of space, and so forth may help fulfill organizational participants' needs, desires, and expectations for recognition, reward, personal satisfaction, fellowship, meaningfulness, pleasant ambience, and so on.

Recently a call for papers was distributed by the American Studies Association. The annual meeting of this organization in November of 1987 will be devoted to the topic Creating Cultures: Peoples, Objects, Ideas. The Program Committee emphasizes *material culture* and various subthemes or topics including the "culture or material culture of institutions, occupations, or situations"; "governmental or private sector cultural policy"; and organizational culture. There is recognition, then, of the importance of material culture as well as the fact that the lives of all of us are affected daily by organizations and their representatives, policies and procedures, and products or services. For the 90% of us who are not self-employed, some organizations are vital to us as the workplace, which in turn may constitute our social life and expressive world. If our lives and livelihood—not only materialistically but also socially, aesthetically, and spiritually—depend on organizations, then it seems appropriate to study organizations in order to understand them, and, if necessary, to recommend ways of improving them. Such work can be done through research on material culture as well as other

expressive forms and communicative processes. It also needs to be informed by concepts that have been evolving in recent years in the study of folk art.

On the Future of Folk Art and Material Culture Studies

To many people 20 years ago (and perhaps in some circles still today), "folk art" was epitomized by nineteenth-century samplers, the easel paintings of itinerant artists, duck decoys, and quilts (all of which, even if done during leisure, are products of domestic industry and work life and some of which are the outputs of organized effort). Research in the 1970s and 1980s on traditions and the aesthetic impulse in the home, at work, and during leisure demonstrate that "art" is not restricted to a certain class of objects and that the term "folk" applies to more than a particular category of people. This research also makes us aware that "the aesthetic" (as an attitude, and also as a desire for pleasant sensory and social experiences) pervades our lives at home and at work as well as in organizations. It reveals that traditions may communicate our perceptions and perpetuate our values, thereby helping us cope, expressing our joys, and providing us with bases for interaction, sources of identity, and a sense of continuity.

Explorations of "folk art" in the future undoubtedly will include studies of textiles, paintings, and sculpture of an earlier era. But this research will entail different questions, or solutions to age-old problems will be based on newly generated assumptions. And studies of contemporary craft, aesthetics, and work probably will involve increasingly more participatory and collaborative investigations as well as "action research," that is, suggestions for applying, or the actual application of, hypotheses and inferences to consciously affect the conditions that have been documented and analyzed. Both kinds of research are needed, lest we forget where we have come from or ignore where we are going.

Research on folk art is only one aspect of material culture studies, of course. Sometimes traditional and expressive forms that folklorists document and analyze are examined by cultural geographers, architectural historians, and specialists in American studies. When this happens, these forms may or may not be referred to as "folk" or "vernacular," and they may be combined with other (high-style or mass-produced) forms rather than treated in a separate category. Folkloristic perspectives and hypotheses occasionally influence analysis in other disciplines, just as folklorists derive ideas and inspiration from other fields of inquiry.

Material culture studies is interdisciplinary. If material culturists have a common bond, then it is their conviction that research on objects and their manufacture and use can reveal much about historical, sociocultural, psychological, and behavioral states and processes. Although the term

"material" suggests a preoccupation with artifacts and the word "culture" connotes a commitment to identifying general social values, in fact material culture studies is enlivened and enriched by attention to the intangible and to the individual. Similarly, folk art research enlarges understanding of the human condition when it includes the notion of tradition and the aesthetic impulse as fundamental aspects of our day-to-day struggle to survive—physically, socially, emotionally, and spiritually.

In conclusion, it seems to me that as significant as objects, artifacts, and things are, they should not be elevated to supremacy over the people who made and used them. If the tangible products of human imagination become a center of attention, and the ideas, feelings, needs, and desires manifested by them are ignored, then both appreciation and understanding of those very artifacts are, ironically, diminished. Therefore, material culture studies and folk art research might achieve their purposes most fully when the makers and users as well as the processes of conceptualization, implementation, and utilization—rather than the artifacts per se—are the object of inquiry.

References

Ames, Kenneth L. 1980. *Beyond Necessity: Art in the Folk Tradition.* New York: W.W. Norton.

——. 1985. The Stuff of Everyday Life: American Decorative Arts and Household Furnishings. In *Material Culture: A Research Guide,* ed. Thomas J. Schlereth, pp. 79–112. Lawrence: University Press of Kansas.

Anonymous. 1977. Meaning Unclear: Study Shows Major Increase in Unwed Couple Households, *Journal of Commerce Review* 64:35 (19 February):1.

Anonymous. 1977. "Recycled" Home Program to Get under Way in South-Central L.A., *Los Angeles Times* (14 May), Pt. 2:5.

Anonymous. 1977. Profile of the Single-Family Home Buyer, *Realtors Review* (June):8–14.

Anonymous. 1977. 3-Day Camp-Out to Buy Homes Friendly Queue, *Journal of Commerce Review.* 64:123 (22 June):1,2.

Anonymous. 1977. Homebuyers Spur Renovation Trend across Country, *Journal of Commerce Review* 64:133 (6 July):1,24.

Anonymous. 1977. Student-Rehabilitated Home Open to Public, *Los Angeles Times* (14 August), Pt. 7:11.

Armstrong, Robert Plant. 1971. *The Affecting Presence.* Urbana: University of Illinois Press.

Bachelard, Gaston. 1969. *The Poetics of Space.* Trans. Maria Jolas. Boston: Beacon Press.

Barnard, Chester I. 1938. *The Functions of the Executive.* Cambridge, Mass.: Harvard University Press.

Barnett, James H. 1958. Research Areas in the Sociology of Art. *Sociology and Social Research* 42:401–5.

Bauman, Richard. 1972. The La Have Island General Store: Sociability and Verbal Art in a Nova Scotia Community. *Journal of American Folklore* 85:330–43.

Becker, Howard. The Professional Dance Musician and His Audience. *The American Journal of Sociology* 57:136–44.

Bell, Michael J. 1976. Tending Bar at Brown's: Occupational Role as Artistic Performance. *Western Folklore* 35:93–107.

——. 1983. *The World from Brown's Lounge: An Ethnography of Black Middle Class Play.* Urbana: University of Illinois Press.

Berkhofer, Robert F., Jr. 1979. The Americanness of American Studies. *American Quarterly* 31:340–45.

Bethke, Robert D. 1974. Old-Time Fiddling and Social Dance in Central St. Lawrence County. *New York Folklore Quarterly* 30:164-84.

Bidney, David. 1967. *Theoretical Anthropology.* New York: Columbia University Press.

Blumenreich, Beth and Lynn Polonsky. 1974. Re-evaluating the Concept of Group: ICEN as an Alternative. In *Conceptual Problems in Contemporary Folklore Study,* ed. Gerald Cashion, pp. 12–17. Bloomington: Folklore Forum Bibliographic and Special Series, No. 12.

Boas, Franz. 1955. *Primitive Art.* New York: Dover Publications. Originally published 1927.

Boerick, Art and Barry Shapiro. 1973. *Handmade Houses: A Guide to the Woodbutcher's Art.* San Francisco: Scrimshaw Press.

Boyarsky, Bill. 1977. Buyers Camp Out in Search of a Home: Line Forms Early for Houses Yet to Be Built, *Los Angeles Times* (17 July), Pt. 2:1, 6.

Brann, Donald R. 1975. *How to Rehabilitate Abandoned Buildings.* Rev. ed. Briarcliff Manor, N.Y.: Direction Simplified, a division of Easi-Bild Pattern Co., Inc.

Braverman, Harry. 1974. *Labor and Monopoly Capital: The Degradation of Work in the Twentieth Century.* New York: Monthly Review Press.

Briggs, Charles. 1980. *The Wood Carvers of Cordova, New Mexico: Social Dimensions of an Artistic Revival.* Knoxville: University of Tennessee Press.

Brillat-Savarin, Jean Anthelme. 1978. *The Physiology of Taste, or Meditations on Transcendental Gastronomy.* Trans. M.F.K. Fisher. New York: Harcourt Brace Jovanovich.

Bronner, Simon J. 1983. Manner Books and Suburban Houses: The Structure of Tradition and Aesthetics. *Winterthur Portfolio* 18:61–68.

_____, ed. 1985a. *American Material Culture and Folklife.* Ann Arbor: UMI Research Press.

_____. 1985b. Visible Proofs: Material Culture Study in American Folkloristics. In *Material Culture: A Research Guide,* ed. Thomas J. Schlereth. Lawrence: University Press of Kansas, pp. 127–53.

_____, ed. 1985c. Material Culture Studies: A Symposium. Special double issue of *Material Culture* 17 (Summer-Fall).

_____. 1986. *American Folklore Studies: An Intellectual History.* Lawrence: University Press of Kansas.

Brooks, Cathy A. 1980. The Meaning of Childhood Experiences: A Dialectical Hermeneutic. Unpublished dissertation, University of Pennsylvania.

Brown, Linda Keller and Kay Mussell, ed. 1984. *Ethnic and Regional Foodways in the United States: The Performance of Group Identity.* Knoxville: University of Tennessee Press.

Brunvand, Jan Harold. 1986. *The Study of American Folklore: An Introduction.* 3rd ed. New York: W.W. Norton.

Bunzel, Ruth. 1972. *The Pueblo Potter, A Study of Creative Imagination in Primitive Art.* New York: Dover Publications. Originally published 1929.

Burns, Thomas A. 1974. Aesthetic Judgement: The Interpretive Side of the Structure of Performance. *Keystone Folklore* 19:61–94.

Byington, Robert H., ed. 1978. Working Americans: Contemporary Approaches to Occupational Folklife. Special issue of *Western Folklore* 38.

Carey, George C. 1965. A Collection of Airborne Cadence Chants. *Journal of American Folklore* 78:52–61.

Carpenter, Edmund. 1969. Comments. In *Tradition and Creativity in Tribal Art,* ed. Daniel Biebuyck, pp. 203–13. Berkeley and Los Angeles: University of California Press.

Cobb, Hubbard H. 1977. *The Dream House Encyclopedia.* New York: Peter H. Wyden.

Collins, Camilla. 1978. Twenty-Four to the Dozen: Occupational Folklore in a Hosiery Mill. Unpublished dissertation, Indiana University.

Country Furniture, a Symposium. 1968. *Antiques* 93:342–71.

Cromley, Elizabeth. 1982. Modernizing: Or, "You Never See a Screen Door on Affluent Houses." *Journal of American Culture* 5:71–79.

Crowley, Daniel J. 1958. Aesthetic Judgment and Cultural Relativism. *Journal of Aesthetics and Art Criticism* 37:187–93.

_____. 1966. An African Aesthetic. *The Journal of Aesthetics and Art Criticism* 24:519–24.

Dandridge, Thomas C., Ian Mitroff, and William F. Joyce. 1980. Organizational Symbolism: A Topic to Expand Organizational Analysis. *Academy of Management Review* 5:77–82.

Daniels, Theodore. 1985. The Grammar of Kindness: The Exchange of Homemade Gifts in Folklife. Unpublished dissertation, University of Pennsylvania.

Deal, Terrence E. and Allan A. Kennedy. 1982. *Corporate Cultures: The Rites and Rituals of Corporate Life.* Reading: Addison-Wesley.

Dewhurst, C. Kurt. 1984. The Arts of Working: Manipulating the Urban Environment. *Western Folklore* 43:192–202.

Dorson, Richard M. 1971. Applied Folklore. In *Papers in Applied Folklore,* ed. Dick Seterlitsch. Bloomington: Folklore Forum Bibliographic and Special Studies, No. 8, pp. 40–42.

Drucker, Peter F. 1954. *The Practice of Management.* New York: Harper.

Dubin, Robert, ed. 1976. *Handbook of Work, Organization, and Society.* Chicago: Rand McNally College Publishing Co.

Dundes, Alan and Carl Pagter. 1978. *Work Hard and You Shall Be Rewarded: Urban Folklore from the Paperwork Empire.* Bloomington: Indiana University Press.

Eff, Elaine. 1984. The Painted Screens of Baltimore, Maryland: Decorative Folk Art, Past and Present. Unpublished dissertation. University of Pennsylvania.

Evans-Pritchard, Deirdre. 1985. Vehicles for Expression: Two Decorated Cars in Los Angeles. *Folklore and Mythology Studies* 9:1–15.

Fahy, Christopher. 1975. *Home Remedies: Fixing Up Houses and Apartments, Mostly Old But Also Otherwise.* New York: Charles Schribner's Sons.

Fairfield, Roy P., ed. 1974. *Humanizing the Workplace.* Buffalo: Prometheus Books.

Faulds, Sara Selene. 1981. "The Spaces in Which We Live": The Role of Folklorists in the Urban Design Process. *Folklore and Mythology Studies* 5:48–59.

Ferguson, Francis. 1975. *Architecture, Cities and the Systems Approach.* New York: George Braziller.

Ferris, William R. 1970. "If You Ain't Got It in Your Head, You Can't Do It in Your Hand": James Thomas, Mississippi Delta Folk Sculptor. *Studies in the Literary Imagination* 3:89–107.

———. 1975. Vision in Afro-American Folk Art: The Sculpture of James Thomas. *Journal of American Folklore* 88:115–31.

Fife, Austin E. 1957. Folklore of Material Culture on the Rocky Mountain Frontier. *Arizona Quarterly* 13:101–10.

Fine, Gary Alan. 1984. Negotiated Orders and Organizational Cultures: Qualitative Approaches to Organizations. *Annual Review of Sociology* 10:239–62.

———. 1985. Occupational Aesthetics: How Trade School Students Learn to Cook. *Urban Life* 14:3–31.

Firth, Raymond. 1929. *Primitive Economics of the New Zealand Maori.* New York: E.P. Dutton and Company.

———. 1936. *Art and Life in New Guinea.* London and New York: The Studio Publications, Ltd.

Friedmann, John. 1973. *Retracking America: A Theory of Transactive Planning.* Garden City, N.Y.: Doubleday, Anchor Press.

Frost, Peter J. et al., ed. 1985. *Organizational Culture.* Beverly Hills: Sage.

Garson, Barbara. 1975. *All the Livelong Day: The Meaning and Demeaning of Routine Work.* Garden City, N.Y.: Doubleday.

Georges, Robert A. 1969. Toward an Understanding of Storytelling Events. *Journal of American Folklore* 82:313–28.

———. 1983. Folklore. In *Sound Archives: A Guide to Their Establishment and Development,* ed. David Lance, pp. 134–44. Milton Keynes, England: International Association of Sound Archives.

———. 1984. You Often Eat What Others Think You Are: Food as an Index of Others' Conceptions of Who One Is. *Western Folklore* 43:249–56.

Georges, Robert A. and Michael Owen Jones. 1980. *People Studying People: The Human Element in Fieldwork.* Berkeley and Los Angeles: University of California Press.

Gerbrands, Adrian A. 1957. *Art as an Element of Culture.* Leiden: E.J. Brill.

———, ed. 1967. *The Asmat of New Guinea: The Journal of Michael Clark Rockefeller.* Greenwich, Conn.: New York Graphic Society.

Getze, John. 1976. Abandoned Homes: Idle U.S. Resource: Restoration Could Be Key to Solving Urban Problems, Experts Say. *Los Angeles Times* (22 September), Pt. 1:1, 26, 28.

Glassie, Henry. 1966. The Wedderspoon Farm. *New York Folklore Quarterly* 22:165–86.

———. 1968. *Patterns in the Material Culture of the Eastern United States.* Philadelphia: University of Pennsylvania Press.

———. 1973. Structure and Function, Folklore and Artifact. *Semiotica* 7:313–51.

———. 1974. The Variation of Concepts within Tradition: Barn Building in Otsego County, New York. In *Man and Cultural Heritage: Essays in Honor of Fred B. Kniffen,* ed. H.J. Walker and W.G. Haag, pp. 177–235. Baton Rouge: Louisiana State University School of Geoscience.

———. 1975. *Folk Housing in Middle Virginia: A Structural Analysis of Historic Artifacts.* Knoxville: University of Tennessee Press.

———. 1978. The Types of the Southern Mountain Cabin. In *The Study of American Folklore: An Introduction,* Jan H. Brunvand. 2nd edition. New York: W.W. Norton, pp. 391–420.

Glassie, Henry and Betty-Jo Glassie. 1971. The Implications of Folkloristic Thought for History Zoning Ordinances. In *Papers in Applied Folklore,* ed. Dick Sweterlitsch, pp. 31–37. Bloomington: Folklore Forum Bibliographic and Special Studies, No. 8.

Gotshalk, D.W. 1962. *Art and the Social Order.* New York: Dover Publications.

Graburn, Nelson H.H. 1967. The Eskimos and "Airport Art." *Trans-Action* 4:28–33.

———, ed. 1976. *Ethnic and Tourist Arts: Culture Expressions of the Fourth World.* Berkeley and Los Angeles: University of California Press.

Gray, Virginia, Alan Macrae, and Wayne McCall. 1976. *Mud Space and Spirit: Handmade Adobes.* Santa Barbara: Capra Press.

Green, Archie. 1978. Industrial Lore: A Bibliographic-Semantic Query. In Working Americans: Contemporary Approaches to Occupational Folklife. Special issue of *Western Folklore* 37:213-44.

Greenfield, Verni. 1985. *Making Do or Making Art: A Study of American Recycling.* Ann Arbor: UMI Research Press.

Grosse, Ernst. 1897. *The Beginnings of Art.* New York: D. Appleton and Company. First published 1894 as *Die Anfänge der Kunst.* Freiburg: J.C.B. Mohr.

Grover, Lewis. 1979. Farewell, My Lovely Gumshoe. *New West* 4:16 (30 July):34.

Gyllenhammar, Pehr G. 1977. *People at Work.* Reading, Mass.: Addison-Wesley Publishing Co.

Haddon, Alfred C. 1895. *Evolution in Art: As Illustrated by the Life-Histories of Designs.* London: W. Scott, Ltd.

Hand, Wayland D. 1960. American Folklore after Seventy Years: Survey and Prospect. *Journal of American Folklore* 73:1–9.

Haring, Lee. 1974. "...And You Put the Load Right on Me": Alternative Informants in Folklore. In *Conceptual Problems in Contemporary Folklore Study,* ed. Gerald Cashion. Bloomington: Folklore Forum Bibliographic and Special Series, No. 12.

Harmon, A.J. 1966. *The Guide to Home Remodeling.* New York: Holt, Rinehart & Winston.

Haselberger, Herta. 1971. Method of Studying Ethnological Art. *Current Anthropology* 2.

Hauser, Arnold. 1963. *The Philosophy of Art History.* Cleveland and New York: World.

Heimsath, Clovis. 1977. *Behavioral Architecture: Toward an Accountable Design Process.* New York: McGraw-Hill Book Co.

Himmelheber, Hans. 1963. Personality and Technique of African Sculptors. In *Technique and Personality,* ed. Margaret Mead, Janis B. Byrd, and Hans Himmelheber, pp. 79–110. New York: Museum of Primitive Art.

Himmelheber, Robert, Robert Redfield, and Melville J. Herskovits, ed. 1963. *Technique & Personality in Primitive Art.* New York: Museum of Primitive Art.

Holm, Bill. 1983. *Smoky-Top: The Art and Times of Willie Seaweed.* Seattle: University of Washington Press.

Homebuyers Spur Renovation Trend across Country. 1977. *Journal of Commerce Review* 64: 133 (6 July):1, 24.

Howell, Benita J. 1984. The Tribal Artist as Individual. *Reviews in Anthropology* 11:139–43.

Hugill, Stan. 1969. *Shanties and Sailors' Songs.* New York: Praeger.

Humphrey, Linda T. 1979. Small Group Festive Gatherings. *Journal of Folklore Institute* 16:190–201.

Hurst, David K. 1984. Of Boxes, Bubbles, and Effective Management. *Harvard Business Review* (May-June):78–88.

Ice, Joyce A. 1977. Folklore among the Employees at Grand Canyon National Park. *Southwest Folklore* 3:85–107.

Ingwerson, Marshall. 1983. Corporate Culture: The 'Very Life' of a Business. *The Christian Science Monitor* (22 March).

Jacobs, Joseph. 1893. The Folk. *Folk-Lore* 4:233–38.

Jacopetti, Roland, Ben Van Meter, and Wayne McCall. 1977. *Rescued Buildings: The Art of Living in Former Schoolhouses, Skating Rinks, Fire Stations, Churches, Barns, Summer Camps and Cabooses.* Santa Barbara, Calif.: Capra Press.

Jelinek, Mariann, Linda Smircich, and Paul Hirsch. 1983. Organizational Culture. Special issue of *Administrative Science Quarterly* 28.

Jones, Louis C. 1977. The Winterthur Folk Art Conference: Some Afterthoughts. *Antiques and the Arts Weekly* (23 December).

Jones, Michael Owen. 1967a. Soda-Fountain, Restaurant, and Tavern Calls. *American Speech* 42:58–64.

———. 1967b. The Study of Traditional Furniture: Review and Preview. *Keystone Folklore Quarterly* 11:233–45.

———. 1967c. A Traditional Craftsman at Work. *Mountain Life and Work* 63:10–13. Reprinted in *The Whole Earth Catalogue,* 1970.

———. 1968. Two Directions for Folkloristics in the Study of American Art. *Southern Folklore Quarterly* 32:249–59.

———. 1969. Review of Gerbrands (ed.), *The Asmat of New Guinea. Southern Folklore Quarterly* 33:361–66.

———. 1970a. Chairmaking in Appalachia: A Study in Style and Creative Imagination in American Folk Art. Unpublished dissertation, Indiana University.

———. 1970b. Folk Craft Production and the Folklorist's Obligation. *Journal of Popular Culture* 4:194–212.

———. 1971a. The Concept of "Aesthetic" in the Traditional Arts. *Western Folklore* 30:77–104.

———. 1971b. "I Bet That's His Trademark": "Anonymity" in "Folk" Utilitarian Art Production. *Keystone Folklore Quarterly* 16:39–49.

———. 1971c. "They Made Them for the Lasting Part": A "Folk" Typology of Traditional Furniture Makers. *Southern Folklore Quarterly* 35:44–61.

———. 1972a. "For Myself I like a *Decent,* Plain-made Chair": The Concept of Taste and the Traditional Arts in America. *Western Folklore* 31:27–52.

———. 1972b. "There's Gotta Be New Designs Once in Awhile": Culture Change and the "Folk" Arts. *Southern Folklore Quarterly* 36:43–60.

———. 1972c. *Why Faithhealing?* Ottawa: National Museums of Canada.

———. 1972, 1973. "If You Make a Simple Thing, You Gotta Sell It at a Simple Price": Folk Art Production as a Business. *Kentucky Folklore Record* 17:73–77; 18:5–12, 31–40.

———. 1973a. The Useful and the Useless in Folk Art. *Journal of Popular Culture* 7:794–818.

———. 1973b. Violations of Standards of Excellence and Preference in Utilitarian Art. *Western Folklore* 32:19–32.

_____ . 1974. The Well Wrought Pot: Folk Art and Folklore as Art. In *Conceptual Problems in Contemporary Folklore Study,* ed. Gerald Cashion, pp. 82–87. Bloomington: Folklore Forum Bibliographic and Special Series, No. 12.

_____ . 1975. *The Hand Made Object and Its Maker.* Berkeley and Los Angeles: University of California Press.

_____ . 1976a. Alternatives to Local (Re-) Surveys of Incidental Depth Projects. *Western Folklore* 35:217–26.

_____ . 1976b. Doing What, with Which, and to Whom? The Relationship of Case History Accounts to Curing. In *American Folk Medicine: A Symposium,* ed. Wayland D. Hand. Berkeley and Los Angeles: University of California Press, pp. 301–14.

_____ . 1976c. Films for Finals. *Folklore Forum* 9:9–17.

_____ . 1976d. The Study of Folk Art Study: Reflections on Images. In *Folklore Today: A Festschrift for Richard M. Dorson,* ed. Linda Dégh, Henry Glassie, and Felix J. Oinas, pp. 291-304. Bloomington: Research Center for Language and Semiotic Studies, Indiana University.

_____ . 1977. In Progress: Fieldwork—Theory and Self. *Folklore and Mythology Studies* 1:1–22.

_____ . 1980a. A Feeling for Form, as Illustrated by People at Work. In *Folklore on Two Continents: Essays in Honor of Linda Dégh,* ed. Nikolai Burlakoff and Carl Lindahl, pp. 260–69. Bloomington: Trickster Press.

_____ . 1980b. G.I. Joe and the Germs: Conceptualizing Form. *Southwest Folklore* 4:1–10.

_____ . 1980c. L.A. Add-ons and Re-dos: Renovation in Folk Art and Architectural Design. In *Perspectives on American Folk Art,* ed. Ian M.G. Quimby, pp. 325–63. New York: W.W. Norton.

_____ . 1980d. Perspectives in the Study of Eating Behaviour. In *Folklore Studies in the Twentieth Century: Proceedings of the Centenary Conference of the Folklore Society,* ed. Venetia J. Newall, pp. 260–65. Totowa, N.J.: Rowman and Littlefield.

_____ . 1982a. Another America: Toward a Behavioral History Based on Folkloristics. *Western Folklore* 41:43–51.

_____ . 1982b. A Strange Rocking Chair. . .The Need to Express, the Urge to Create. *Folklore & Mythology* 2:1 (November):1, 4–7.

_____ . 1983. Organizational Folklore and Corporate Culture. *American Folklore Society Newsletter* 12:5 (October):3–6.

_____ . 1984a. Corporate Natives Confer on Culture. *American Folklore Society Newsletter* 13:5 (October):6, 8.

_____ . 1984b. *Folklore/Folklife.* Washington, D.C.: American Folklore Society.

_____ . 1985a. Folkloristics and Fieldwork. In *American Material Culture and Folklife: A Prologue and Dialogue,* ed. Simon J. Bronner, pp. 147–50. Ann Arbor: UMI Research Press.

_____ . 1985b. On Folklorists Studying Organizations: A Reply to Robert S. McCarl. *American Folklore Society Newsletter* 14:2 (April):5–6, 8.

_____ . 1985c. [The Material Culture of Corporate Life]. In Material Culture Studies: A Symposium. Special double issue of *Material Culture* 17:99–105.

Jones, Michael Owen, Bruce S. Giuliano, and Roberta Krell. 1981. Foodways and Eating Habits: Directions for Research. Special issue of *Western Folklore* 40.

Jones, Michael Owen and Verni Greenfield. 1984. Art Criticism and Aesthetic Philosophy. In *American Folk Art: A Guide to Sources,* ed. Simon J. Bronner, pp. 31–50. New York: Garland.

Jones, Michael Owen and Kenneth L. Ketner. 1975. Folkloristic Research as a Pedagogical Tool in Introductory Classes. *New York Folklore* 1:123–48.

Joyce, Rosemary O. 1986a. "Fame Don't Make the Sun Any Cooler": Folk Artists and the Marketplace. In *Folk Art and Art Worlds,* ed. John Michael Vlach and Simon J. Bronner, pp. 225–41. Ann Arbor: UMI Research Press.

_____ , ed. 1986b. Marketing Folk Art. Double issue of *New York Folklore* 12.

Jung, Carl G. 1957. *Memories, Dreams, Reflections.* New York: Viking.

_____. 1964. *Psychological Types, or the Psychology of Individuation.* Trans. H. Godwin Baynes. *Collected Works* 13. New York: Pantheon Books.

Kern, Ken, Ted Kogon, and Rob Thallon. 1976. *The Owner-Builder and the Code: Politics of Building Your Own Home.* Oakhurst, Calif.: Owner-Builder Publications.

Kilmann, Ralph H., Mary J. Saxton, Roy Serpa, and Associates, ed. 1985. *Gaining Control of the Corporate Culture.* San Francisco: Jossey-Bass.

Kotter, John P. 1979. Fred Henderson. Case study 480–043. Cambridge, Mass.: Harvard University Press.

_____. 1980. Renn Zaphiropoulos. Case study 480–044. Cambridge, Mass.: Harvard University Press.

_____. 1981a. A Day with Fred Henderson. Videotape 991–002, color, 3/4," 30 min. Cambridge, Mass.: HBS Case Services, Harvard Business School.

_____. 1981b. A Day with Renn Zaphiropoulos. Videotape 881–001, color, 3/4," 20 min. Cambridge, Mass.: HBS Case Services, Harvard Business School.

Kreman, Bennett. 1973. Search for a Better Way of Work: Lordstown, Ohio, *New York Times* (9 September):Pt. 3:1,4.

Kubler, George. 1962. *The Shape of Time, Remarks on the History of Things.* New Haven and London: Yale University Press.

Lewis, Peirce F. 1985. Learning from Looking: Geographic and Other Writing about the American Landscape. In *Material Culture: A Research Guide,* ed. Thomas J. Schlereth, pp. 35–56. Lawrence: University Press of Kansas.

Lockwood, Yvonne R. 1984. The Joy of Labor. *Western Folklore* 43:202–11.

Lomax, Alan, recorder. *Negro Prison Songs: Mississippi State Penitentiary.* Tradition Records TLP 1020.

McAllester, David P. 1960. The Role of Music in Western Apache Culture. In *Selected Papers of the Fifth International Congress of Anthropological And Ethnographical Sciences,* ed. Anthony F.C. Wallace, pp. 468–72.

McCarl, Robert S. 1974. The Production Welder: Product, Process and the Industrial Craftsman. *New York Folklore Quarterly* 30:243-53.

_____. 1976. Smokejumper Initiation: Ritualized Communication in a Modern Occupation. *Journal of American Folklore* 89:49–67.

_____. 1978. Occupational Folklife: A Theoretical Hypothesis. *Western Folklore* 37:145–60.

_____. 1979. Describing the Critical Center: Approaching Work Cultures from an Applied Ethnographic Perspective. Paper delivered at the Conference on Workers' Culture, Michigan State University.

_____. 1980. *Good Fire/Bad Night: A Cultural Sketch of the District of Columbia Fire Fighters as Seen through Their Occupational Folklore.* Riverdal, Md.: N.P.

_____. 1984a. *The District of Columbia Fire Fighters' Project: A Case Study in Occupational Folklife.* Washington, D.C.: Smithsonian Institution.

_____. 1984b. Letter to the Editor. *The American Folklore Society Newsletter* 13:6 (December):2, 5.

MacIver, R.M. 1964. *Social Causation.* New York: Peter Smith. Revision of 1942 edition.

Martin, Charles E. 1983. Decorating the Appalachian House. In *Appalachia and America: Autonomy and Regional Dependence,* ed Allen Batteau, pp. 14–27. Lexington: University Press of Kentucky.

Mayo, Edith. 1980. Introduction: Focus on Material Culture. *Journal of American Culture* 4:595–604.

Meissner, Martin. 1976. The Language of Work. In *Handbook of Work, Organization, and Society,* ed. Robert Dubin, pp. 205–79. Chicago: Rand McNally College Publishing Co.

Mencken, H.L. 1948. *The American Language, Supplement II.* New York: Knopf.

Merriam, Alan P. 1964a. *The Anthropology of Music.* Evanston: Northwestern University Press.

──────. 1964b. The Arts and Anthropology. In *Horizons of Anthropology,* ed. Sol Tax, pp. 224–36. Chicago: Aldine Publishing Co.

Messenger, Betty. 1976. *Picking Up the Linen Threads: A Study in Industrial Folklore.* Austin: University of Texas Press.

Mills, George. 1959. *Navaho Art and Culture.* Colorado Springs: Taylor Museum of the Colorado Springs Fine Arts Center.

Milspaw, Yvonne J. 1983. Reshaping Tradition: Changes to Pennsylvania German Folk Houses. *Pioneer America* 15:67–84.

Morris, Rudolph E. What Is Sociology of Art? *American Catholic Sociological Review* 19:310–21.

Mullen, Patrick B. 1979. *"I Heard the Old Fisherman Say": Folklore of the Texas Gulf Coast.* Austin: University of Texas Press.

Munro, Thomas C. 1956. *Toward Science in Aesthetics.* New York: Liberal Arts Press; Bobbs Merrill Co.

──────. 1967. *The Arts and Their Interrelations.* 2nd revised edition. Cleveland: The Press of Western Reserve University.

Musello, Christopher. 1980. Studying the Home Mode: An Exploration of Family Photography and Visual Communication. *Studies in Visual Communication* 4:23–42.

──────. 1986. Family Houses and Social Identity: Communicational Perspectives on the Homes of Ridge County. Unpublished dissertation, University of Pennsylvania.

Nash, Dennison J. 1956–57. The Socialization of an Artist: The American Composer. *Social Forces* 35:307–13.

Nickerson, Bruce. 1976. Industrial Lore: A Study of an Urban Factory. Unpublished dissertation, Indiana University.

Pauchant, Thierry. 1985. Review of *The Functions of the Executive,* by Chester I. Barnard. *New Management: The Magazine of Innovative Management* 2 (Winter):60–61.

Peters, Thomas J. 1978. Symbols, Patterns and Settings: An Optimistic Case for Getting Things Done. *Organizational Dynamics* 7 (Autumn):3–27.

Polsky, Ned. 1964. The Hustler. *Social Problems* 12:3–15.

Pondy, Louis R., Peter J. Frost, Gareth Morgan, and Thomas C. Dandridge, ed. 1982. *Organizational Symbolism.* Greenwich: JAI Press.

Pope, LeRoy. 1979. Americans Spend 45 Percent of Work Day Doing Nothing, Consultant Says. *Journal of Commerce Review* 66 (4 May):1.

Profile of the Single-Family Home Buyer. 1977. *Realtors Review* (June):8–14.

Prosterman, Leslie. 1982. The Aspect of the Fair: Aesthetics and Festival in Illinois County Fairs. Unpublished dissertation, University of Pennsylvania.

Prown, Jules David. 1982. Mind in Matter: An Introduction to Material Culture Theory and Method. *Winterthur Portfolio* 17:1–20.

──────. 1985. (Comments in) Material Culture Studies: A Symposium. *Material Culture* 17:77–79.

Pye, David. 1964. *The Nature of Design.* London: Studio Vista.

Ray, Dorothy Jean. 1961. *Artists of the Tundra and the Sea.* Seattle: University of Washington Press.

Regan, Arthur. 1983. Myth, Symbols and Folklore: Expanding the Analysis of Organizations. *Folklore & Mythology* 2:3 (December):3, 7.

Riordan, John Lancaster. 1945. Soda Fountain Lingo. *California Folklore Quarterly* 4:50–57.

"River." 1974. *Dwelling: On Making Your Own.* Albion, Calif.: Freestone Publishing Co.

Roberts, Warren E. 1985. (Comments in) Material Culture Studies: A Symposium. *Material Culture* 17:88–93.

Roueché, Berton. 1977. Annals of Medicine: "All I Could Do Was Stand in the Woods." *The New Yorker* 53:30 (12 September):97 ff.

Roy, Donald F. 1959–60. "Banana Time": Job Satisfaction and Informal Interaction. *Human Organization* 18:158–68.

Rudofsky, Bernard. 1964. *Architecture without Architects: A Short Introduction to Non-Pedigreed Architecture.* Garden City: Doubleday.

Santino, Jack. 1978. The Outlaw Emotions: Workers' Narratives from Three Contemporary Occupations. Unpublished dissertation, University of Pennsylvania.

_____. 1986. The Folk *Assemblage* of Autumn: Tradition and Creativity in Halloween Folk Art. In *Folk Art and Art Worlds,* ed. John Michael Vlach and Simon J. Bronner, pp. 151–69. Ann Arbor: UMI Research Press.

Sayce, R.U. 1963. *Primitive Arts and Crafts, An Introduction to the Study of Material Culture.* New York: Biblo and Tannen. Reprint of 1933 edition.

Scarborough, Chuck. 1977. How *Not* to Do It Yourself. *American Home* 80:9 (September): 31.

Schein, Edgar. 1985. *Organizational Culture and Leadership: A Dynamic View.* San Francisco: Jossey-Bass.

Schlereth, Thomas J., ed. 1985a. *Material Culture: A Research Guide.* Lawrence: University Press of Kansas.

_____. 1985b. Material Culture and Cultural Research. In *Material Culture: A Research Guide,* ed. Thomas J. Schlereth, pp. 1–34. Lawrence: University Press of Kansas.

_____. 1985c. Social History Scholarship and Material Culture Research. In *Material Culture: A Research Guide,* ed. Thomas J. Schlereth, pp. 155–95. Lawrence: University Press of Kansas.

Schneider, Harold K. 1956. The Interpretation of Pakot Visual Art. *Man* 56:103–6.

Sergiovanni, Thomas J. and John E. Corbally, ed. 1984. *Leadership and Organizational Culture: New Perspectives on Administrative Theory and Practice.* Urbana: University of Illinois Press.

Shay, Philip W. 1977. *The Need for a Unified Discipline of Management.* New York: Amacom.

Shuldiner, David. 1980. The Art of Sheet Metal-work. *Southwest Folklore* 4:37–41.

Sieber, Roy. 1965. The Visual Arts. In *The African World: A Survey of Social Research,* ed. Robert A. Lystad, pp. 442–51. New York: Praeger.

Smircich, Linda. 1983. Concepts of Culture and Organizational Analysis. *Administrative Science Quarterly* 28:339–58.

Stanforth, Deirdre and Martha Stamm. 1976. *Buying and Renovating a House in the City: A Practical Guide.* New York: Alfred A. Knopf.

Stoeltje, Beverly J. 1979. Rodeo as Symbolic Performance. Unpublished dissertation, University of Texas.

Strauss, George. 1974. Is There a Blue-Collar Revolt against Work? In *Humanizing the Workplace,* ed. Roy P. Fairfield. Buffalo: Prometheus Books.

Swanson, Catherine and Philip Nusbaum, ed. 1979. Occupational Folklore and the Folklore of Working. Special issue of *Folklore Forum* 11:1–65.

Terkell, Louis [Studs]. 1975. *Working.* New York: Avon. Originally published 1974.

Thompson, Robert Ferris. 1968. Esthetics in Traditional Africa. *Art News* 66:44–45, 63–66.

Toelken, Barre. 1969. The "Pretty Language" of Yellowman: Genre Mode, and Texture in Navaho Coyote Narratives. *Genre* 3:211–35.

Trent, Robert F. 1986. Legacy of a Provincial Elite: New London County Joined Chairs 1720–1790. *The Connecticut Historical Society Bulletin* 50:15–35.

Trice, Harrison M., James Belasco, and Joseph A. Alutto. 1969. The Role of Ceremonials in Organizational Behavior. *Industries and Labor Relations Review* 23:40–51.

Turpin, Dick. 1977. Another Buying Barrier Falls. *Los Angeles Times* (19 June):Pt. 7:1.

Upton, Dell. 1985a. (Comments in) Material Culture Studies: A Symposium. *Material Culture* 17:85–88.

_____. 1985b. The Power of Things: Recent Studies in American Vernacular Architecture. In *Material Culture: A Research Guide,* ed. Thomas J. Schlereth, pp. 57–78. Lawrence: University Press of Kansas.

Upton, Dell and John Michael Vlach, ed. 1986. *Common Places: Readings in American Vernacular Architecture.* Athens: University of Georgia Press.

Vlach, John Michael. 1976. Philip Simmons: Afro-American Blacksmith. In *Black People and Their Culture,* ed. Linn Shapiro. Washington, D.C. Smithsonian Institution, pp. 35–57.

_____. 1978. *The Afro-American Tradition in Decorative Arts.* Cleveland: Cleveland Museum of Art.

_____. 1981. *Charleston Blacksmith: The Work of Philip Simmons.* Athens: University of Georgia Press.

_____. 1985. (Comments in) Material Culture Studies: A Symposium. *Material Culture* 17:81–84.

Walker, Charles R. and Robert H. Guest. 1952. *The Man on the Assembly Line.* Cambridge, Mass.: Harvard University Press.

Warshaver, Gerald A. 1971. *Schlop* Scholarship: A Survey of Folkloristic Studies of Lunchcounter and Soda Jerk Operatives. *Folk Forum* 4:134–45.

Wells, Camille, ed. 1986. *Perspectives in Architecture, II.* Columbia: University of Missouri Press.

West, James. 1946. *Plainville, U.S.A.* New York: Columbia University Press.

What Is American Folk Art? A Symposium. 1950. *Antiques* 57:355–62.

Whyte, William Foote. 1961. *Men at Work.* Homewood, IL: Dorsey Press.

Williams, Christopher and Charlotte. 1974. *Craftsmen of Necessity.* New York: Random House.

Williams, Michael Ann. 1985. The Social Use and Meaning of the Folk Dwelling in Southwestern North Carolina. Unpublished dissertation, Indiana University.

Wise, Gene. 1979. "Paradigm Dramas" in American Studies: A Cultural and Institutional History of the Movement. *American Quarterly* 31:293–337.

Wolfe, William B. 1974. *The Basic Barnard: An Introduction to Chester I. Barnard and His Theories of Organization and Management.* Ithaca: Cornell University Press.

Work in America: Report of a Special Task Force to the Secretary of Health, Education, and Welfare. 1973. Reprinted 1978. Cambridge, Mass.: MIT Press.

Works of Art, Art as Work and the Arts of Working. 1984. Special section of *Western Folklore* 43:3 (July).

Yoder, Don. 1963. The Folklife Studies Movement. *Pennsylvania Folklife* 13:43–56.

_____. 1972. Folk Cookery. In *Folklore and Folklife: An Introduction,* ed. Richard M. Dorson, pp. 325–50. Chicago: University of Chicago Press.

Young, John. 1976. Hooked on Hardware: How the Author, in Need of a Fix, Picked Up Some Tools and Repaired His Life. *Esquire* 86:6 (December):97–101, 144–50.

Index